spanish
folk
ceramics

spanish folk ceramics of today

j. llorens artigas
j. corredor-matheos

photographer

f. català roca

watson-guptill publications
new york

First published in the United States in 1974 by Watson-Guptill Publications,
a division of Billboard Publications, Inc.,
One Astor Plaza, New York, New York 10036

Copyright ©1970 by Editorial Blume
First published in 1970 in Spain by Editorial Blume
Tuset, 17 — Barcelona-6
Dep. legal B. 47.621 - 1974
Printed in Spain by I.G.F. Casamajó,
Aragón, 182, Barcelona

Manufactured in Spain

Library of Congress Cataloging in Publication Data

Llorens Artigas, José.
 Spanish folk ceramics.
 English.
 Bibliography: p. 235
 1. Pottery, Spanish. 2. Folk art-Spain.
I. Corredor Matheos, José, 1929- joint author.
II. Title. III. Title: Cerámica popular española.
NK4123.L47 738.0946 74-3296
ISBN 0-8230-4880-2

contents

preface

The appearance of the second edition of a book is always accompanied by a feeling of satisfaction for everyone involved. As authors of this book, we are naturally pleased that the editor is confident of continuing to find new readers. Our purpose in writing was to call attention above all to the cultural testimony of this art, never fully appreciated, that is fast disappearing. And it must be added that, in the meantime, something beneficial has been obtained. Various circumstances have coincided in such a way that a wide interest has suddenly been awakened in the more simple pottery; and various people have exerted themselves, in as far as possible, in supporting it. The first edition of this book, which sought to be a modest first probe in the terrain, has permitted many to continue along the roads of clay; there have been increasing visits to the pottery sites by outsiders interested in the ancient art of ceramics. Potters are again making some of the articles that had appeared to be forgotten in history, such as the "caracola" from Villafranca de los Caballeros. More than one pottery center has found the possibilities of its survival increased, and some centers have been encouraged to continue the tradition abandoned in other places such as Vera. All of these are motives of satisfaction. But we would insist on the fact that in reality this is a collective task in which other factors, other interested people, and, in particular, a generally favorable atmosphere have intervened. Until the oft-promised official aid arrives —we hope it is not merely a promise but will one day be a reality— it is fortunate that these efforts exist in an attempt to save, as much as possible, this wealth of art that will perhaps only be discovered when it is too late.

Various pottery centers have been included in this second edition that were unable to be incorporated in the first, and further information has been added to that covering some of the other centers. All of this has been duly reflected in the noticeably improved photography.

One important event occurred after the printing of the first edition of this book: the appearance of *Töpferei in Spanien,* written by Rüdiger Vossen, director of the Euroasian Section of the Ethnographical Museum of Hamburg, in which is compiled part of the important work (without a doubt the most extensive until now) carried out by this researcher. We also have news of an as yet unpublished thesis on folk ceramics in New Castile, the author of wich —Natacha Seseña—, has shown signs of a profound knowledge and precision in her other various writings.

The authors would like to acknowledge their gratitude to those persons who were of most help to us, through their observations and information on various pottery centers: María Antonia Pelauzy, Natacha Seseña, Rüdiger Vossen, Augusto Panyella, the Canary Island architect José Manuel Hernández and the professor Rafael González from La Laguna. Above all we would thank the potters, who in truth have done everything, with the hope that they will continue with their miraculous art.

J.LL.A. – J.C.–M

introduction

This book does not spring from a preconceived design, but rather from a mixture of chance and necessity. It is the aftergrowth of an interest in popular ceramics, samples of which we have observed in the course of the last few years, which has finally prompted us to write a book about it. We have thus taken up the idea of a similar project started by the American ceramist, Antonio Prieto, of Spanish origin, which, because of the untimely death of the author in 1967, was never realized.

It has not been our desire to present a scientific study, but rather to acknowledge the vestiges of this ancient art. In many cases, the superb pictures of Catalá Roca will illustrate this better than words. Through our observations we hope, in as much as is possible, to increase the interest in this activity. If this brief survey of ceramics is capable of that, perhaps it will give rise to other initiatives, and the wealth buried in the insignificant clay will not be hopelessly lost.

The examination of this complex and contradictory country has caused us, in as far as ceramics is concerned, more surprises than we had at first anticipated. After the first sporadic visits we made to several of the pottery centers, the systematic trips that we later realized made it possible to accumulate material as diverse and contradictory as the earth and its people. At the same time it has permitted us to have an over-all vision which gives us a base for observation of the whole.

The surprising fact that until now not even a limited exposition had been undertaken, had a decisive influence on our desire to realize such a work. As is well known, several important books have been written on the history of ceramics. The names of towns such as Manises, Teruel, Muel, Talavera etc., are heard repeatedly and their ceramic deposits have been unearthed; the museums have been minutely examined and important works published. This has been the work of specialists in the history of our ceramics, and such a concern obviously yields results. The present day popular art, that which the people create before our eyes, apparently interests only a very few. The people in Spain who are attracted by these topics can be counted on the fingers of the hands, or even less. Catalonia and the Basque Country are the only areas in the complex Iberian Peninsula where scientific and systematic studies of ceramics had been made until now; works, such as that of Joan Amades, are very explicit, indeed. Today the names of men such as Caro Baroja, who examine the very heart of the people with as much reliability as feeling, and Augusto Panyella, whose efforts are consumed in the direction of the Ethnological Museum of Barcelona are rare and isolated cases. It is sad and painful that in Spain, the scholars have not granted the service or attention that the people deserved. Within the specific area of folk ceramics there remains one exception: Natacha Seseña (author of a documental thesis on New Castile), who has collaborated with Rüdiger Vossen (Director of the Euroasian Section of the Ethnographical Museum of Hamburg) in an extensive field work on present-day Spanish pottery carried out by the German specialist in mention during two trips made to Spain in 1971 and 1973.

Upon occasion, we have said, in mentioning the project we were undertaking, that what we were doing in effect was issuing the death certificate of our popular ceramics. This was meant as a joke, exaggerating what we knew to be a reality. It is a fact that this very ancient art is disappearing before our very eyes. We have personally been witnesses to this when, on our second visit to a certain area, we realized what had been lost in two or three years. One pottery, one of the most remarkable, in Vera, the province of Almería, had ceased to exist in the interval between our visit and the writing of this book —nine months. We were able to view the articles, put out to dry, that comprised the last bake. This has happened in the case of Vera, which produced, without doubt, some of the most beautiful ceramics of our day; and it has happened in other cases, too. In its place has arisen the so-called artistic ceramics which, through its uniformity, has left the stamp of conventionality and bad taste and has the indubitable merit of reaching a public which is more and more badly informed and alienated. Any initiative, along the cultural order, is necessarily preconditioned. It is possible to save the popular ceramics by

keeping it under wardship; however, it would then cease to be a popular art. In spite of this, it is the only solution we are afforded.

The potters should know, and not forget, the importance that their work has. This importance will be recognized one day when their work has been abandoned. Within a few years, the traditional pottery containers will only be made on order, and at an exceedingly higher price, for today they still, in the majority of cases, fulfill a useful role. But for this to be possible, the craftsman must maintain skillful hands and not forget even the simplest secrets which, never-the-less, can be forgotten.

We should not deceive ourselves; popular ceramics is the fruit of a society which is not ours. As such an art, it has come to an end. Its inmediate purpose has disappeared: its usefulness; this type of pottery vessel has been substituted by mass-produced ones. The art, and not this alone, has lost its obvious value. Logically, a well versed artist will be in a better position to apraise a "cántaro" precisely because of the "modern" equivalences which, due to his understanding

of art, reveal themselves. By this we mean that the popular ceramics can continue to exist only if sufficient interest is aroused in this ancient art and its authenticity. The people who will best realize this are those, artists or not, who are interested in the present, and thereby in the future. In our society, a place can be found for popular ceramics, though it will not, at present, be among the people, because ceramics was fashioned for a different people. Although the future is important to us, we are not going to try to foretell it. Perhaps "popular" ceramics will once again have its moment of recognition and splendor. It is true that then it will not be a "popular" craft, and it is certain that these future objets will not be valued as highly as the present ones, which are today so scorned. It is very probable that this craftmanship, and all of them, will come to a permanent end today. What is produced henceforth, will be estimable, historic reproductions, "copies", but nothing else. Once having lost ingenuousness, it is difficult, if not impossible, to recover it.

In spite of this, there is no doubt that the present day Spanish ceramics deserves much consideration. Is is the last link of a chain begun thousands of years ago, almost when man first appeared on earth. If man first began to develop by performing work, ceramics can best tell us of it. The greatest joy afforded the student of prehistory is doubtlessly that of finding human bones accompanied by fragments of baked clay. All of history fits into this chain of vessels which is coming now to its end.

We wish to establish our recognition of all the potters we have met in our trips in search of pottery. They have always received us warmly, almost gratefully, surprised by the interest they saw aroused by their simple art. This friendly welcome dissolved the fear, awaken in some, that we were revenue agents. We wanted to show them, with this book, that that was not our mission, though, it is a worthy one, but rather to help them. We suggest that, instead of an economic burden too great for their possibilities and their work at this moment, they be helped in a more effective way. This help cannot be, in any case, through maintaining a cultural and social ghetto, as if they were oysters from which we were awaiting marvelous clay pearls. It is only asked that it be made possible for them to live decently from this work, which they so dearly love.

We wish to insert just a few details about the circunstances under which we have prepared this book. Aside from a few previous trips, the journeys were realized, according to the plan we had outlined to gather material, and carried out between August 1968, when we first entered the lands of Aragón, and March 1969 when we finished visiting Catalonia. In general, we limit ourselves to what we have observed in these excursions, aside from the investigations we later carried out for this second edition. In a few cases, when a certain tradition had just recently been lost, we were unable to avoid the temptation of taking pictures and notes of some of the objets already "antique". We try to avoid all historical references which are not necessary to illustrate a certain point, primarily because we feel that this book would lose the direct and clear character we hope to give it.

The reader has then before him a report on a subject that is as old as it is new. We are going to discuss pottery vessels, some of which you may have come across in excursions to the small towns or even in the streets and squares of the big cities or in the celebrations on the eve of certain saint's day such as the ones in Madrid to honor San Isidro and San Antonio de la Florida. If you had asked just a few years ago, for exemplè, the price of a certain jug, it is quite possible that you were told: twelve pesetas, fifty céntimos. In the cities it is possible to sell the objects without having to lower the price somewhat, but in the small towns, if the price is raised by only two "reales" (a half of a peseta), no one would buy them. Twelve pesetas and fifty céntimos in exchange for: the preparation of the clay; the formation of it on the lathe; the drying; the baking in very old Arabic ovens; the transportation (and some of the pieces are certain to break). But all of this is precisely what we will be discussing in the suceeding pages.

the technique

The process which is used from the time the clay is extracted to the time it is baked, is still, in general, a rudimentary and ancient one. It deals with procedures more or less common to all the pottery centers, although it is worth noting the distinguishing characteristics of a few of the places. As it is not our intention to present an exhaustive technical frame, we are going to refer only to technical aspects in a very general way, taking note of a few of the variations we have observed. There is no doubt that an investigation, on the spot, of how the ceramics is executed in Spain is necessary. This undertaking is extremely urgent, for, as we have already mentioned, this activity is rapidly disappearing.

The Clay. The basic element, the clay, is extracted from wells, caves, or from the ground itself. It is normally taken from locations not far from where it will be worked. The sites from which it is extracted are given different names, according to the area or town: "cantera" (Agost, Traiguera, Ubeda), "barrero" (Mota del Cuervo, Salamanca), or "terrero" (Daroca). The wells are at times very shallow, and at other times very deep, and even spread out in galleries; in Mota del Cuervo the "barreros" have some galleries 130 or 160 feet long. In Miravet, refractory earth is mixed with slime left by the Ebro River. Upon occasion, as in Villafranca de los Caballeros, the clay is obtained from lands bordering on lagoons.

It is frequent that the potters are the proprietors of the lands from which they take the clay. There is, however, great variation in this. There is the curious case of what happens in Pereruela: Cortés Vázquez recounts in his study entitled *La alfarería en Pereruela* (The Pottery in Pereruela) how the women potters in that area obtain one of the two clays that they need from lands surrounding the town; this extraction is carried out secretly, without permission of the landowners, in order not to have to pay the small amount that the latter would exact. When the landlords surprise them, they demand payment, although this has more the character of punishment than the actual collecting of the value of the land. This clandestine extraction of the clay is done with the help of their husbands, or, if they are not married, alone; if the latter is the case, the women must unaided, carry the earth in "a little basket on their back." Generally clay taken from the same area is used. At times this clay needs some substance that will remove the grease, and sand or chalk, or some element that regulates the plasticity, is employed. There are many places that use only one such substance: La Mota del Cuervo, Agost, Calanda, Bailén, Cortegana... Two are used in such places as: Llamas de Mouro, Salvatierra de los Barros, Arroyo de la Luz, Pereruela, Alhama de Aragón, Vera, and Albox.

There are many diverse circumstances which cause a change in "barrero" or "cantera": they may be exhausted (this rarely occurs), they may have caved in or been converted into irrigated land; the loss of the "cantera" may be caused by a change in the quality of the earth, the new being inferior to the old, and this may cause variations in the characteristics of the objects themselves.

The next phase is the softening of the clay, which gives it more plasticity. This operation is carried out in a pit in the form of a well or pool where the clay is extended and later irrigated. After that the clay is strained or beaten, generally with a board. It was explained to us in Salvatierra de los Barros as follows:

"The clay is put in a mortar and strained with the help of boards; as the boards are moved, the clay gives off water, and afterwards the clay is left to settle." One can also macerate the clay with a stick and grind it; some use a grinder moved by animal (Arroyo de la Luz). In Priego, the clay is put in a "tanda" and macerated with a "rulo", which is moved in a circle by a donkey, as in a treadmill. In La Mota del Cuervo, on the other hand, "a board is not used to move the clay, but rather a hammer for the work is done by women potters; afterwards it is dampened and then the water is allowed to run off. This last process is done by seven and eight year old boys. The impurities in the soil can complicate even further this work; in Mula the clay, which has a lot of pebbles in it, is prepared, water is added to it, and then stirred with a board so that the pebbles fall to the bottom." When two types of clay are to be used, it is at this point that they are added.

The clay is spread out on the floor so that it can dry; it is

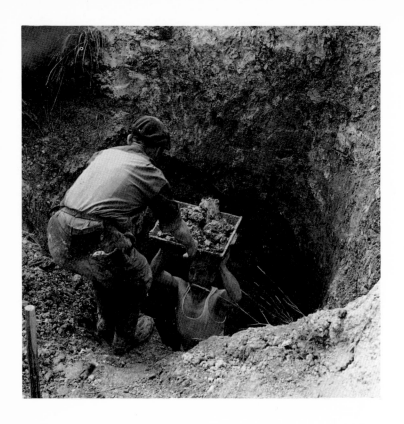

then time to knead it, to give consistency to the paste. It is normal that the clay be packed down by bare feet, at the same time adding water. The clay can also be macerated by hand and in some places it is done first by one method and then by the other. In the last few years, some potters have begun to knead the paste with electrically run devices. The clay is then put out to dry in the sun; this may be done by pasting it to a wall. When it is dry, it is stored with dirt placed on top of it; it·is left like this for a while so that it can form the paste. When this is almost ready, it must be kneaded again: this is what is called the "sobao" and for this they take from the pile of clay bit by bit. Then, with the paste, is made what is known as "loaves" which are kept in a damp storage space and covered with wet rags so that the water will not evaporate. These "loaves" are then carried, as they are needed, to the lathes.

The lathe or potter's wheel. The lathe, a rudimentary machine which the potters use to give form to the clay, consists of two wheels, joined by a vertical axle. The lower wheel, where the foot rests in order to move it, is known as the "vuelo" (flight), "volante" (steering-wheel), "volandera" (grindstone) or "rueda" (wheel) and the disk where the clay rests is the "cabezuela" (little head), "cabecera" (headboard) or "rodal" (a cart with solid wheels). "Estribo" (stirrup) is the place where the foot that is not to be used,

rests. The axle has the name "árbol" (tree). The potter works seated at the same level as, or a little lower than the upper wheel. In some places the lathes are sunk in a pit and the potters work at ground level.

On the impulse of the foot, the lathe turns; the potter can then, with his hands, give the clay the desired form. It is first necessary, to center the bolus, to lay open the paste, and to stretch the clay. The lathe operator has at his side a small vessel of water to dampen his hands. Aside from the hands, a piece of wood, known as the "caña" (cane), "tacón" (heel), "soleta" or "tiradera" (a long horn-tipped Indian arrow), is also used to shape the clay. The "alpañata", "vaqueta" or "pelleja" is a piece of sheepskin or leather that is used to shine the clay and remove the finger marks on the smaller objects and to give it more "polish." Other small pieces of wood or cane, known as "alpetije" or "cuchillo" are used to cut the leftover part (which is later used for handles if there are to be any) and to make the border, for the bottom of the vessel, more pronounced; this is cut with a very fine filament or wire.

The object is then taken to a suitable place in order to settle and harden; in some areas it is covered so that it will not dry out. This place should not be affected by the sun or air. At this point it is filed to make the base and to correct the neck of the vessel if necessary. The next step is the actual drying; if an ordinary object is being dealt with, it is

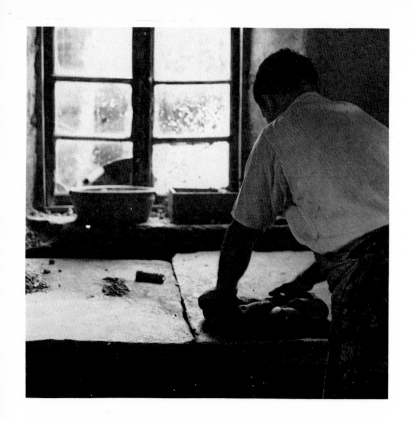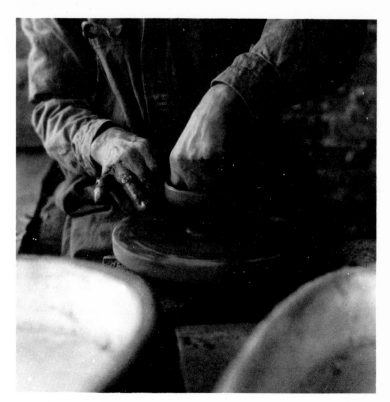

placed in the sun, but if it is a delicate object, it is kept in the shade or inside. As they dry out completely, they are carried to the ovens.

This then is the traditional procedure of pottery making, explained in a very succinct manner. This technique has suffered some transformations. In general, we have found lathes operated by foot; there are, however, many places which now use an electric motor, so as not to have to work the pedal. Some of the latter were found in such distinct places as: Tamarite de Litera, Verdú, Quart, Agost, Vera, Sorbas, La Rambla, Triana, and Portol. Some pottery centers, which are at the half way point, use both systems: Breda, Piera, Santamaría, Alcora, Bailén, Granada, Salvatierra (only in small proportion), Magallón, and Teruel. There are vessels made with a mold (in Ribesàlbes and the majority of the pieces produced in Manises), but this book is not concerned with them.

Some of the archaic customs still found in Spain, deserve to be mentioned, for example the ceramics made on a hand lathe by women in Moveros and Pereruela, in ha Mota and Villarrobledo or the pottery made completely by hand in Calanda and various Canary Islands centers.

The baking or firing. The traditional kiln, which we have found almost everywhere, is the so called "Arabic" or "Moorish" one which has a direct flame. These kilns have

14. Extracting clay
The clay being beaten in a mortar
15. The clay being macerated
Turning up on a lathe
16. Vessels placed in kiln

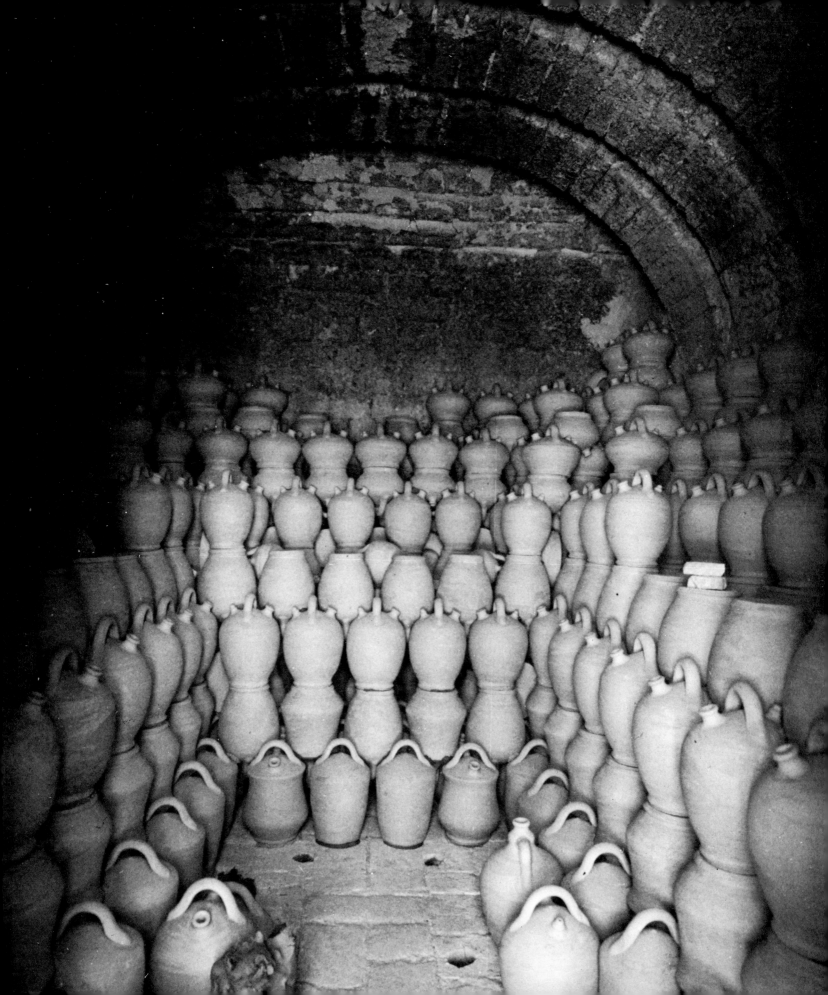

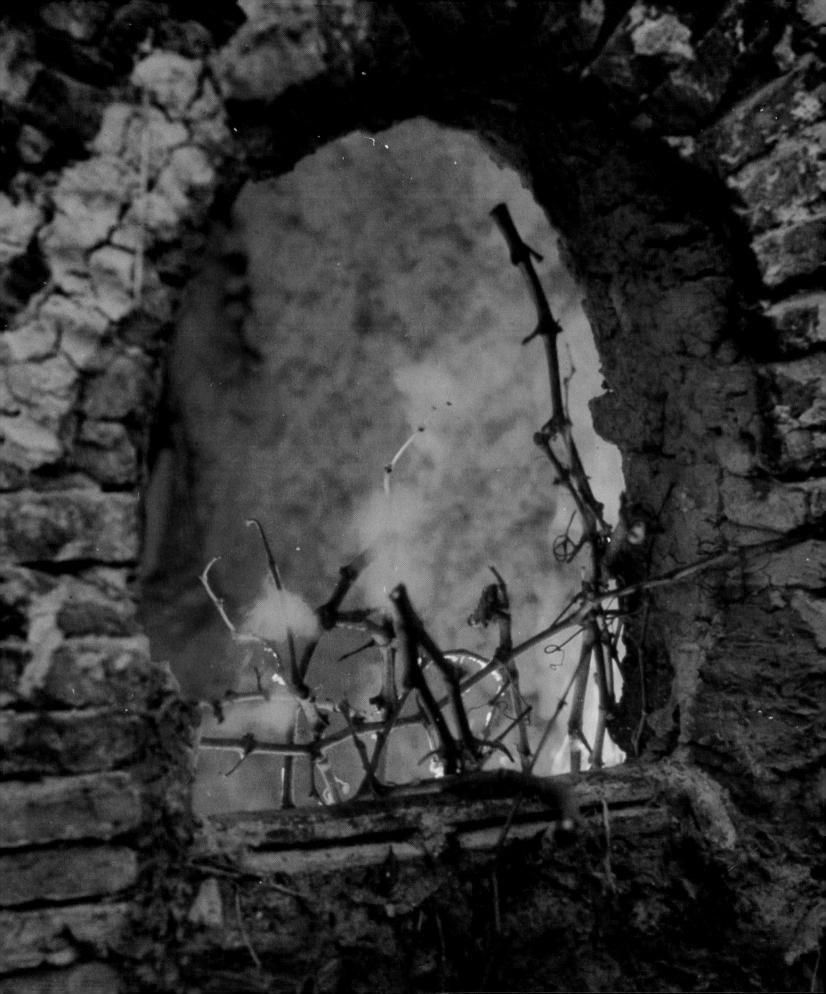

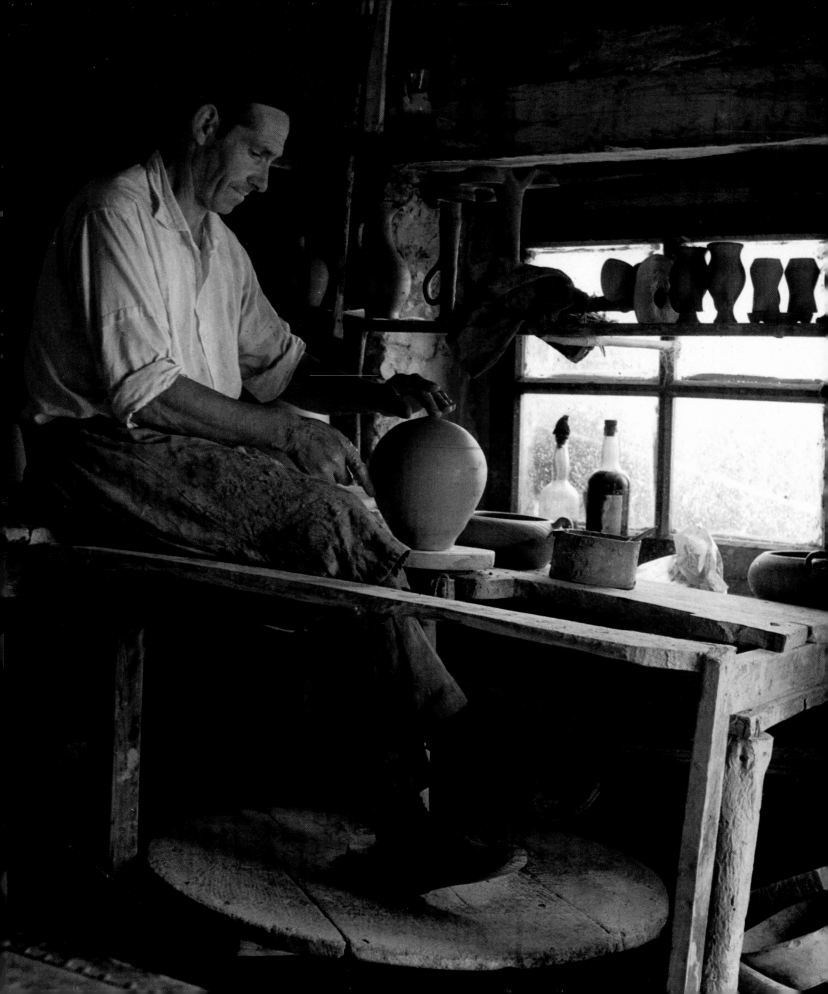

the advantage of possessing great capacity; naturally the size of the oven and the pieces, determines the amount that can be fired at one time. In Salvatierra de los Barros, an average of three hundred pieces in some kilns and four hundred in the others can be fired simultaneously. In Priego we were told that some 80 "cántaros", 400 "botijos", 100 flowerpots and 100 piggy banks for the children could be fired at the same time. The ovens in Guadix are big; it is sufficient to mention that each bake consists of 1700 "cántaros".

The firing time varies greatly, according to the oven capacity and the contents; it is normally between seven and forty-eight hours. Some areas where there is a great deal of production and the kilns are large, as in Agost for example, the firing may take as long as a hundred hours. In still another locality, Moveros, the firing time is relatively short; they could not tell us exactly how long, but rather, in an amusing way, answered: "How do I know, a nice long time." In Llamas de Mouro, where the vessels are smoked while they are being fired, the length of time employed is "five days, minimum" and normally six or seven.

In order to know when the pieces are fired, the most primitive system is still generally used: that of the sight. It is a simple method, but in this type of ceramics, with the experience they have, sufficient. In some places when dealing with glazed ceramics, though coarse, we were told that they were also guided by hearing: "When the shine starts to appear, you can hear it boiling."

Still others, as in Bonxe, place an iron bar in the kiln and "when it is red hot, ('hace lume') the glaze on the crockery pieces brightens, they are baked." A similar technique is employed in another Galician town, Buño, "this system" they explained to us, "is very remote." When treating glazed

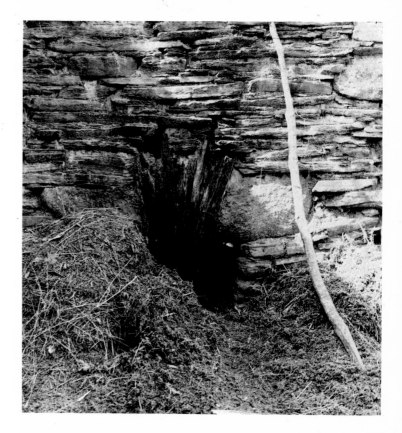

19. Mouth of a kiln
 Direct sale of the pottery production in Barcelona

objects, samples of the pottery are generally, though not always, removed from the oven.

In order to separate the pieces from the floor of the kiln, and at times, depending on the object (for example plates), to separate them from each other, small triangular pieces are used. When the articles have been fired and removed from the kiln, the fragments of the triangles which may have stuck are filed. When a certain piece needs special care, because of its delicacy, it is normally protected by putting it in a "box" before placing it in the kiln; in this way a direct flame does not reach it during the firing. A lead bath or "leaf alcohol", almost always from Linares, is often used for

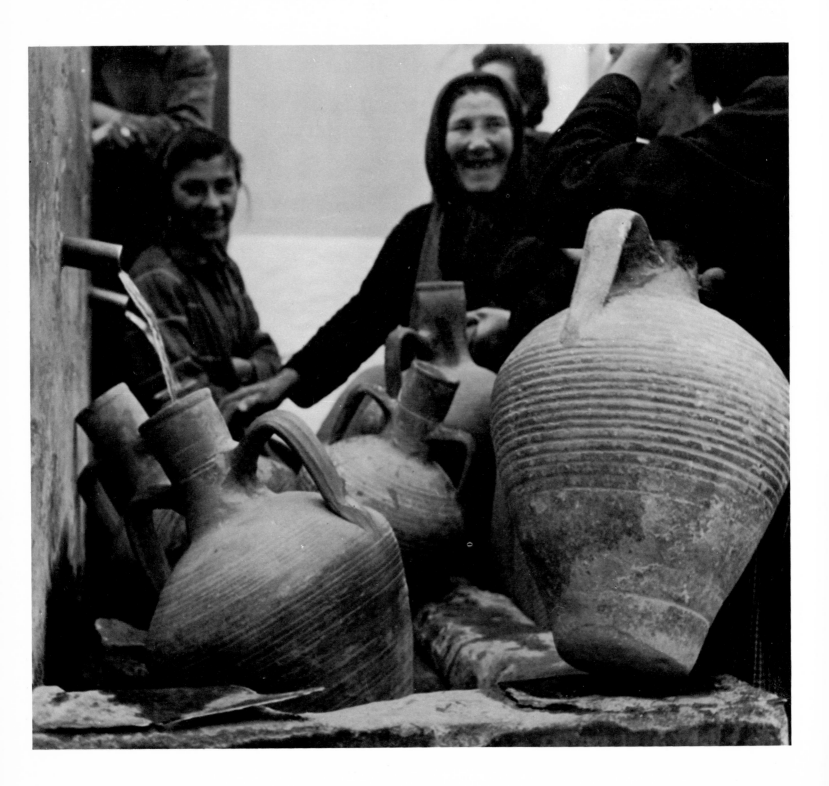

kitchen crockery and for certain types of earthenware known as "coarse". This varnish —the "shine", as the potters call it— is transparent and lets the color the earth has taken after firing show up. A coating of white or colored clay, mixed with water, is given completely, or in part to certain types of objects. Fuller's earth is often used for the red, and the "juaguete" for a yellowish orange coloring. To obtain the desired color, the articles are submerged in a washtub containing the mixture. In some places, this painted part of the vessel is later decorated.

In some towns, the kilns were formerly communal, as in Traiguera and Niñodaguia; all the potters, in turn, used them. Another characteristic to be added to the many concerning Pereruela is that, there, the kilns are simple holes in the ground. In some places the "Arabic" ovens had been substituted for one with a muffle, though generally only for certain pieces: Manises, Talavera, and Triana; that is to say, in the pottery centers devoted to delicate objects produced in quantity and where the process is modernized, at least in some of its phases. The temperature should fluctuate between 1400° and 1600° Fahrenheit, though at times it can be a little lower. The higher the temperature, the less porous the vessel; for that reason the "cántaros" and "botijos" should be fired at a relatively low temperature, so that they may be able to breathe and keep the water cool.

The firewood used varies according to the regions and provinces. It is, naturally, what the potters have closest at hand and the thing which is the cheapest for them. In Galicia, for example, the furze ("because it doesn't cost anything") and the pine are used. In Asturias, oak ("which is very strong and withstands more"), brush and kindling from the mountains are used. La Bisbal employs cork and oak which are abundant in the surrounding area, and the same occurs in the lands of Extremadura. In many different places shrubs, such as rosemary, furze, rockrose, Spanish broom, and tyme, are burned. In the areas where there are olive groves, the wood of the olive tree, with, and at times exclusively, the residue from the olives, are used. The residue from other fruits are available to the potters in different areas, as, for example, the almond shell. In La Mancha, the vines provide vine shoots; the pine is also used a great deal, and in even greater quantities, pine needles.

aragon

Aragón is a land of old ceramic tradition; but, as in the other regions of Spain, little remains today of the old splendor. Aragón could summarize all the circumstances that have marked this ancient art. Although ceramics in this area is, in general, unindustrialized, the most rustic forms have been maintained reasonably well until recently, when they began to rapidly disappear.

In **Tamarite de Litera,** part of the province of Huesca, we found the two most elementary forms of the "cántaro" and "botijo", forms which throughout our trips we would continue to find on the point of being lost. There remains in Tamarite only one kiln and only one potter, Florencio Maull. The old family tradition will apparently be broken by his son who does not wish to carry on the craft. The father tells us that he has known of ten or eleven potteries which have disappeared in the last few years. The future of ceramics does not appear very hopeful. Maull sell his objects in the nearby regions and towns, and specially in places where there is no water.

The objects made by Florencio Maull are limited to "botijos" and "cántaras". The former have two handles and a spout; the "cántaras" are white, unglazed and with little decoration: a few lines painted an occasional piece or two with plastic paint! In spite of the difficulties, Tamarite is maintained in a state of practical, artistic purity, over which hovers, the occasional threat of losing this purity; if this should happen, we would be the last to criticize, for we understand the conditions under which these people work. Nor can we condemm the fact Florencio Maull has installed a small electric motor to operate his lathe, which until now was worked by pedal.

Huesca, the capital of the province, also had until recently its ceramist. The story is similar to that of Tamarite. The shape of the "cántara" was the same in both places: somewhat big-bellied, white with simple lines of manganese oxide, in addition to being decorated with outliners of flowers. Both places made the same "botijo", as well as another one which was the most common and had only one

handle, and jars in various sizes. Ricardo Carrás, the potter in Huesca, had known of only five kilns that had existed before the Civil War; and even that number was reduced to two about 10 years ago. When we visited the last kiln in existence, we had the impression that it too was destined to disappear, for the potter had no sons; and there was no sign that anyone wished to continue the craft. At that time he continued to sell the objects throughout the area and in a store in Huesca where goods from other parts were also sold, including crockery from Breda. We must add now that this last kiln has disappeared, and with it Huesca as a pottery center, for Ricardo Carrás closed down his kiln in 1970.

In this same area, there was also pottery production in **Benabarre**, where pots and casserols were made; but with the death of the last potter, a little more than a year before we were in that region, the production stopped.

Naval still has one potter, Francisco Buetas Buil, who makes a large number of vessels, for the kitchen as well as for the table: casseroles, kettles, colanders, and jars, as well as flowerpots toy items.

In **Fraga** the work continues and seems to be going well. It is wealthy city; the fundamental element of this wealth is the agriculture which is very productive due to the waters from the Cinca and the Ebro Rivers. In addition to this several industries are becoming more and more interested in the town. One of the kilns still in existence is that of José Arellano Castelló, known as "Jaumeto", a pleasant, cordial man without any sons. He is conscious of the situation through which ceramics is passing, and he has studied the craft and its possibilities as much as he has been able to. He continues to make the usual objects: the "cántaros" and "botijos", similar to those seen in the places previously mentioned, with simple linear decoration. To these pieces must be added the "botijo fragatino", as they call it, resembling an amphora.

The technique in Fraga has been somewhat modernized,

although the foot lathe has been maintained to make the traditional objects; "comercial" articles are also produced, but this is outside our realm of interest. These commercial objects are of imported shapes and decorations, the origin of which we found to be principally the green ceramics from Quart. The potter, naturally, is not to be blamed, for he must make what is asked for, in order to earn a living. In this, Arellano shows signs of perception and talent, and even creative faculty. Our attention was particularly drawn by his sculptures, reliefs, and Christ-figures which stem exclusively from a self-taught basis.

The other potter, Arturo Margallo Longán, produces unglazed vessels for water, such as "botijos", water troughs, and vases, as well as flowerpots.

We found our way to **Almonacid de la Sierra,** which aroused some of the strongest feelings of our trip. According to our information, it had been, even in recent times, a very big

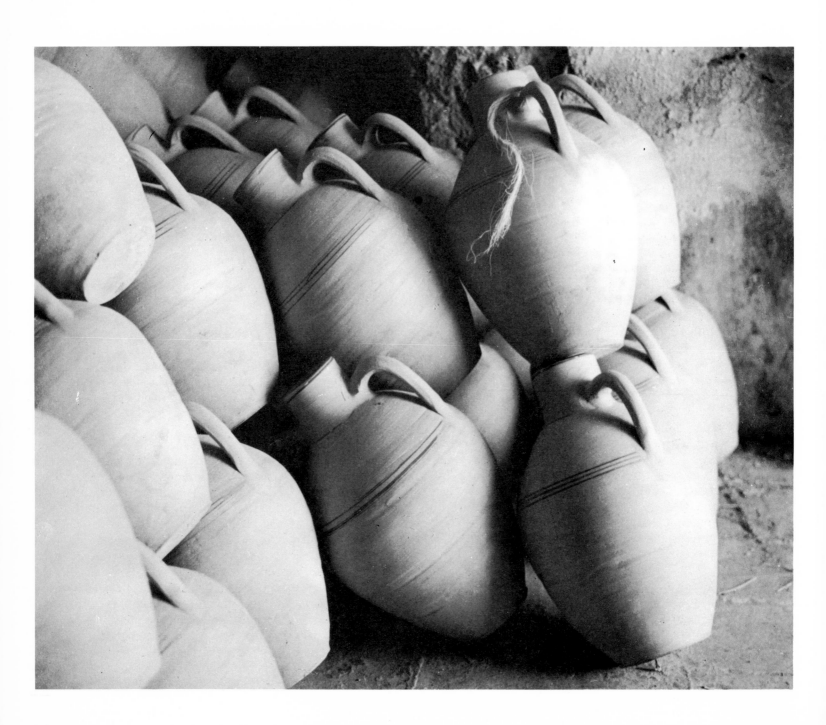

24

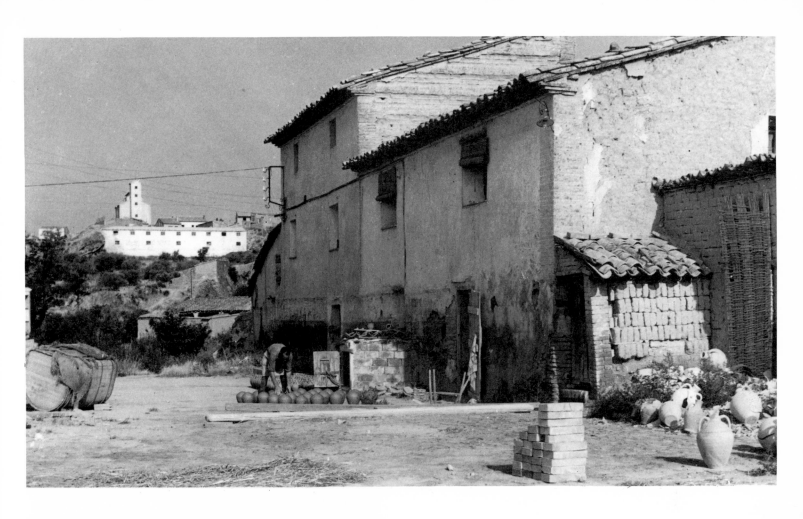

24. Cántaros, *Tamarite de Litera*
Pottery, *Tamarite de Litera*
26. Pouring water in the mortar to soften the clay, *Huesca*

25

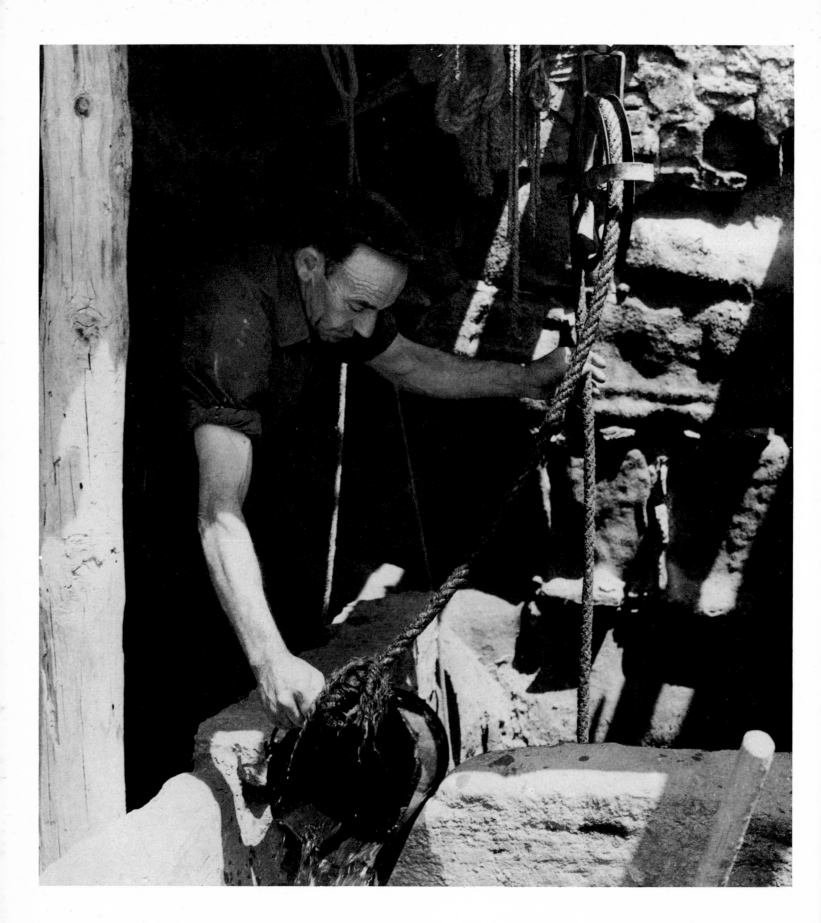

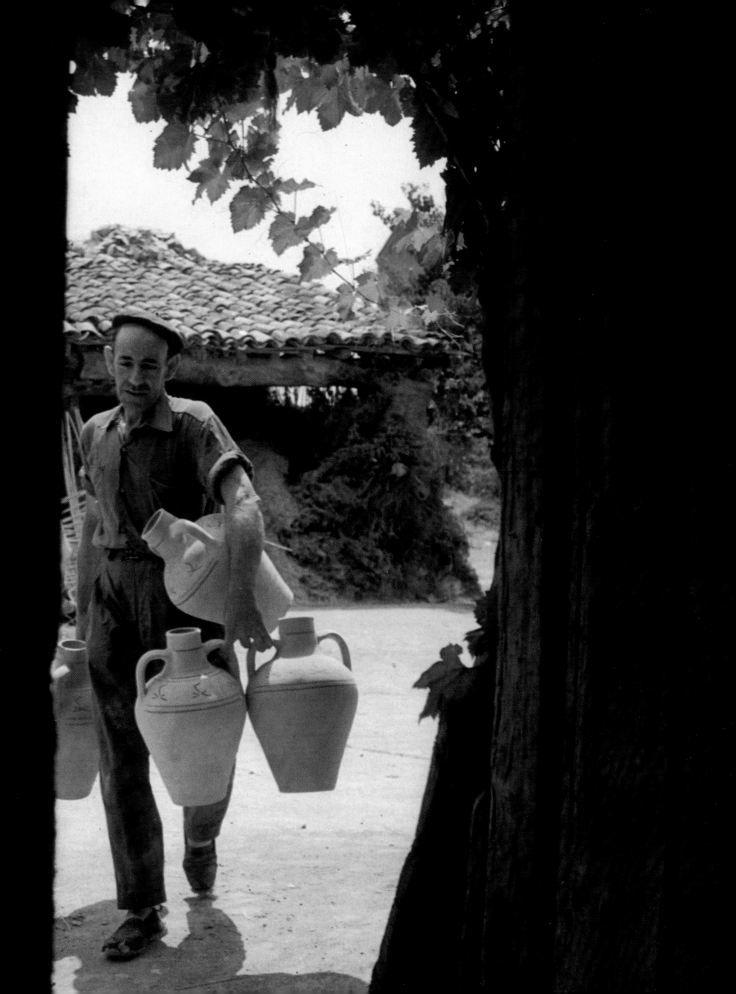

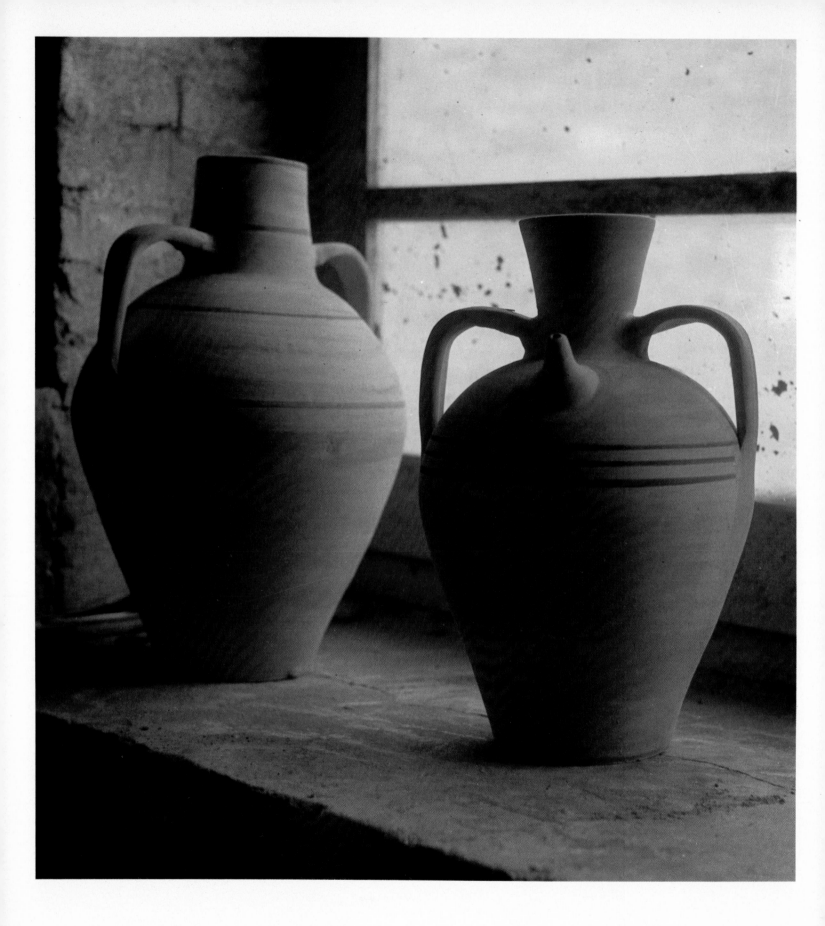

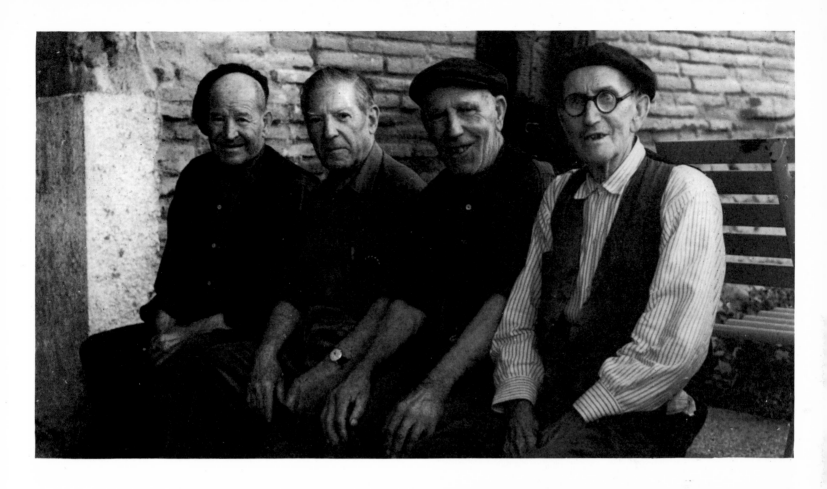

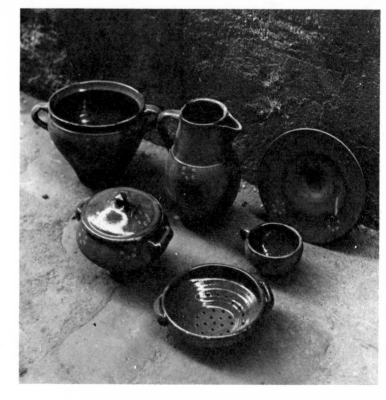

28. Cántaro and botijo, *Fraga*
29. Llorens Artigas with former potters, *Almonacid de la Sierra*
 Pot, pitcher, plate for turning tortillas, soup tureen, cup, and colander, *Naval*

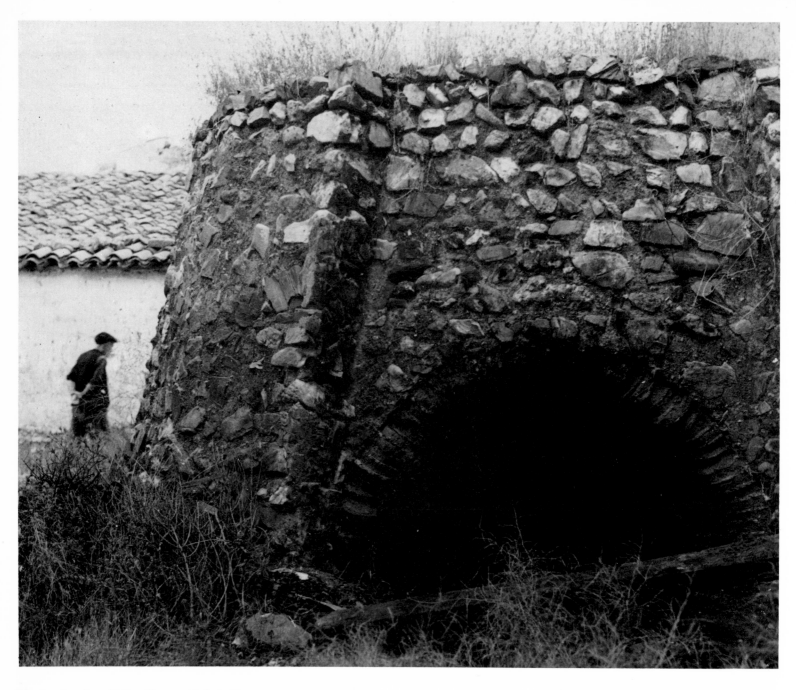

30. An abandoned kiln, *Almonacid de la Sierra*

pottery center, with numerous workshops. In the town itself, we discovered that, in effect, shortly before the Civil War, there were still more than twenty potteries. They produced, primarily, kitchen vessels: pots, casseroles, flat baking pans and lids. The reports that we collected during the trip, before and after our visit to Almonacid, indicated that the production had been very abundant and had reached the farthest points of Aragón.

We went first to the main square, for we had no idea where to turn. The square was big and sunny. Many old people were sitting placidly, talking. Old people and children: they seemed to be the only ones living in the village, as always occurs in these little country towns during work hours. We asked for the potter (as everyone knows each other): "He was one", indicated one old fellow, "but speak loudly, for he is deaf." We spoke as loud as we could, and

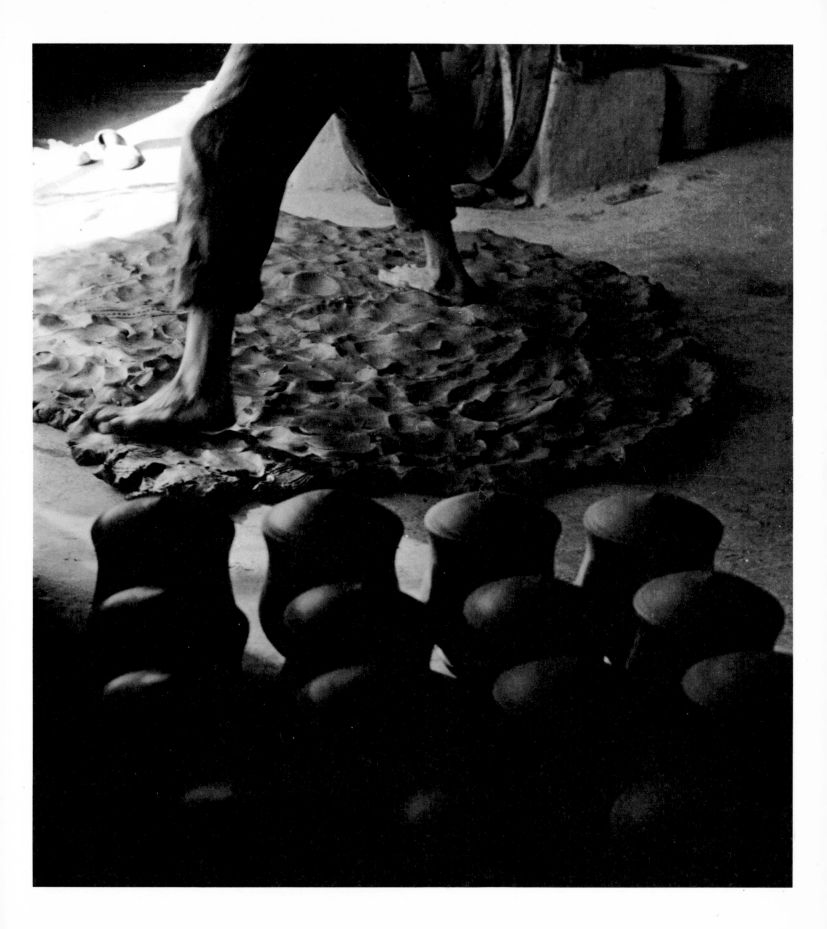

the interest that we aroused in the old man enabled us to bridge the distance between us, which was more than the difference of languages. "Are you a potter? " The answer came from far away, with the remoteness that deaf people put in their voices: "I was, but I don't work anymore". The old man spoke, very politely; and he was willing, in as much as he was able to, to satisfy what he thought to be mere curiosity. "No one works here. I doubt if anyone in Aragón is left." We explained to him the purpose of our trip and it excited him very much. "We have found potteries in Tamarite, Huesca and Fraga", we assured him. "I don't know where you'll find any more —he added, wishing to help. You'll find some in the province of Cuenca. You know where they still work? – in Santa Cruz del Moncayo" (though it turned out later that they had stopped production). Meanwhile all the other old people had begun to gather. It was a large audience that at times had the appearance of a chorus from the Greek tragedies. "If it suits you, we'll take a picture of you, for a book." He tells us his name: Luz Muela; 77 years old. Another old man explains that Luz left the craft in 1931, and was put in charge of the lights of the town until he retired. "When I left the ceramic work", the former potter tells us, "three others kept it up, but none had any success; one or another of them died". "Félix (one of the three potters)", explains another, "kept on working until the 1950's; now he's dead." We continue to talk about pottery. "No one has ever come here, attracted by ceramics", explains Luz Muela. "It's a poor and discredited craft."

He offers to accompany us as we walk around the town, in order to show us the abandoned stoves. ("... Of the quartz, the red was better than the white"... Luz was explaining). It is impossible to transcribe the trip through the town. "This was a workshop, and so was that." A long repeated series follows. "In this one, my brother has his farming equipment: carts, tools..." He shows us, on our request, the kiln that belonged to Félix. He explains that formerly it was a rich town, not because of the pottery, but because of the vineyards. "I was born and raised in this house, which was my uncle's workshop. And this door goes to my grandfather's barnyard, which was later my father's. This whole street was full of workshops and covered sheds. That was a stove, but it collapsed, and that a warehouse. Do you see that house? A pottery. And that other one, and those houses all along the street: potteries." It looks like a

32-33. Pasting the clay to the wall to dry in the sun, *Magallón*

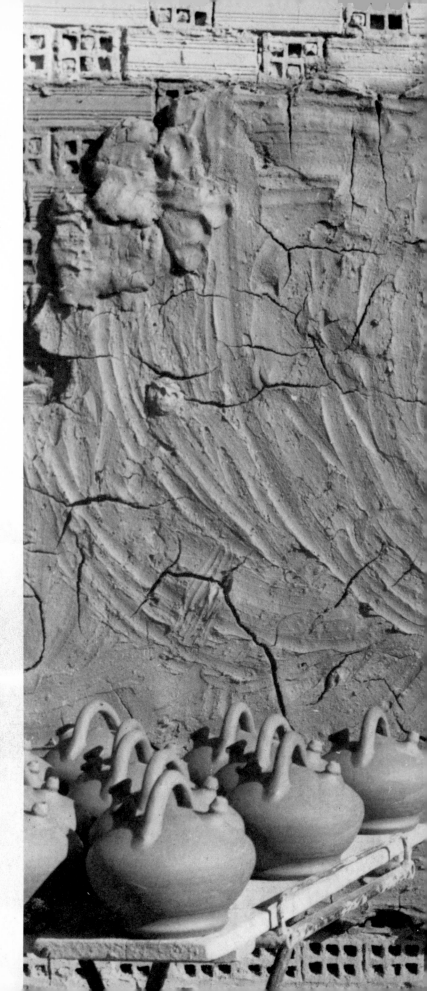

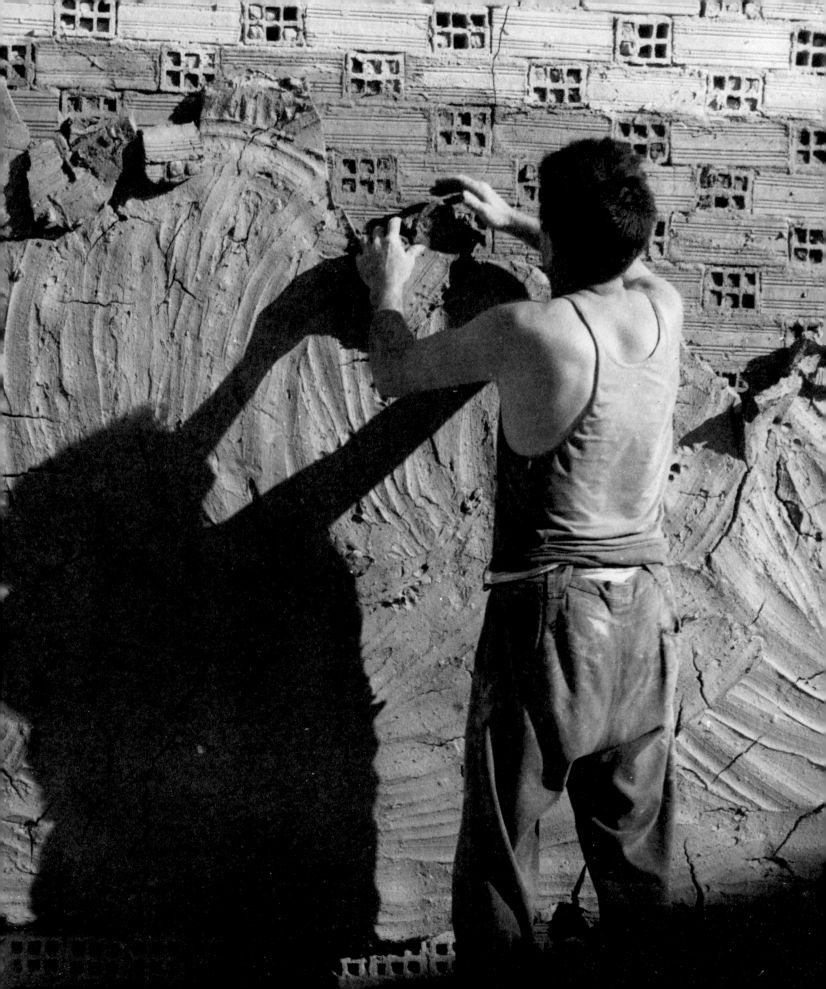

graveyard. Luz shows us his stove which is very well preserved. "I haven't had any other means of earning my bread, and I have a lot of affection for it. Here is another place, but it is full of my brother's alfalfa." There are quite a lot of washbowls covering the holes, in order to preserve the kiln. A cementery. "And these houses: potteries; but the owners made a little money, not with clay, but with grapes. And they abandoned the other. And these were basins to prepare the clay." Some of the materials were bought in Barcelona: lead, prepared earth, enamel, and tin. "I'm very glad that you have come. I'm very fond of the craft." The kilns are some of the most primitive that we have seen. "As long as I live, it won't collapse; I pay careful attention to my stove." The time had gone swiftly. We were given an affectionate farewell: "That's not a bad chore that you've got; I'd gladly go with you if I could. But around here you'll only find ruins, and in Villafeliche, the same."

There are two ceramists who work in **Magallón,** and to celebrate the happy event, we visit both of them. We find the first macerating the paste with his bare feet. "You are watching maceration with the feet, the oldest way of doing it; we don't generally do this any more. What possessed you to come today? We don't do this every day." A little later, when we had been talking a while, he put out clay to dry, pasting it to the wall. Manuel Salvador Aibar, the potter, does everything very diligently. He is a lively man, and seems extremely clever. He sits down to eat, and matter-of-factly invites us to join him, though without much insis-

tance. "Thank-you, we have already eaten." He continues to talk. "Write down", he tells us, on seeing us taking notes, "that the craft is being lost, because it doesn't pay well. Write it down. I know several potters in Spain, because when I was young (he is 47 now) I traveled, and almost nothing remains today." His conversation —or monologue, if you prefer to call it that— is sparkling, as if passed through an electric current. "As a family we have a certain amount of insight and ideas. We have force because of the work and skill required." The preceding seems to be meant as an explanation for the development of an object that he shows us and that later we see in other places: the "botijo" made for a refrigerator (stubby, in order to fit in the modern contraption). "This 'botijo-boina' was invented by me for the refrigerator, and all the potters in Spain appropriated it from me. And instead of patenting it, I explained on TV that we potters make what we see. But in spite of the fact that we adapt ourselves to the times, inventing a refrigerator 'botijo', this is disappearing, "It is a shame. Aren't your children going to keep it up? " we ask him. "I don't have any sons, only daughters. It's a pity, because this is the fourth generation. An uncle taught my grandfather; my grandfather, my father; and my father, me" "Well, marry your daughters to potters." "No, they are fed up with the craft; I make them work too hard. Look, of the four potteries that there were (the Borovia and Salvador families each had two), only two are left." But he seems satisfied when talking about the pottery sales: "The pottery from Magallón is so popular now, that we sell to tourist and a

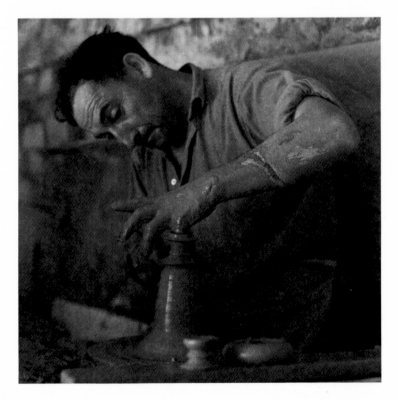

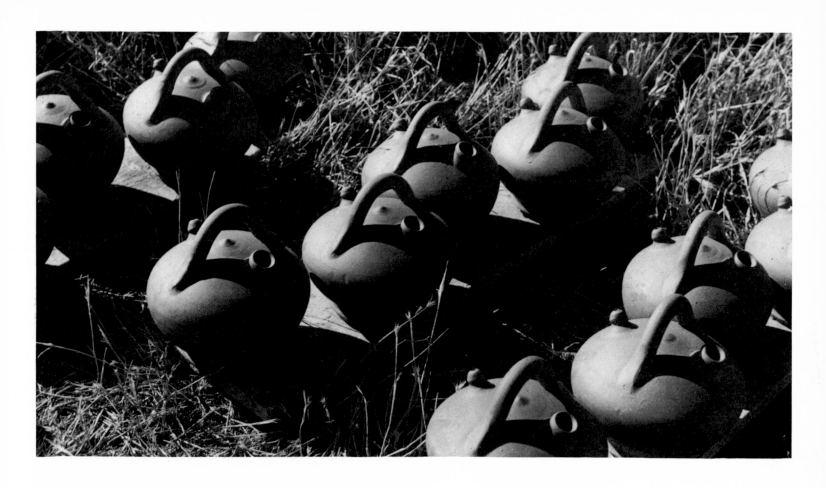

34. Botijo, *Magallón*
Turning up the clay, *Magallón*
35. Botijo-boina to be kept in the refrigerator, *Magallón*
Pottery, *Magallón*
36. Cántaros with two handles, and in background, botijos and
flowerpots, *Fuentes de Ebro*

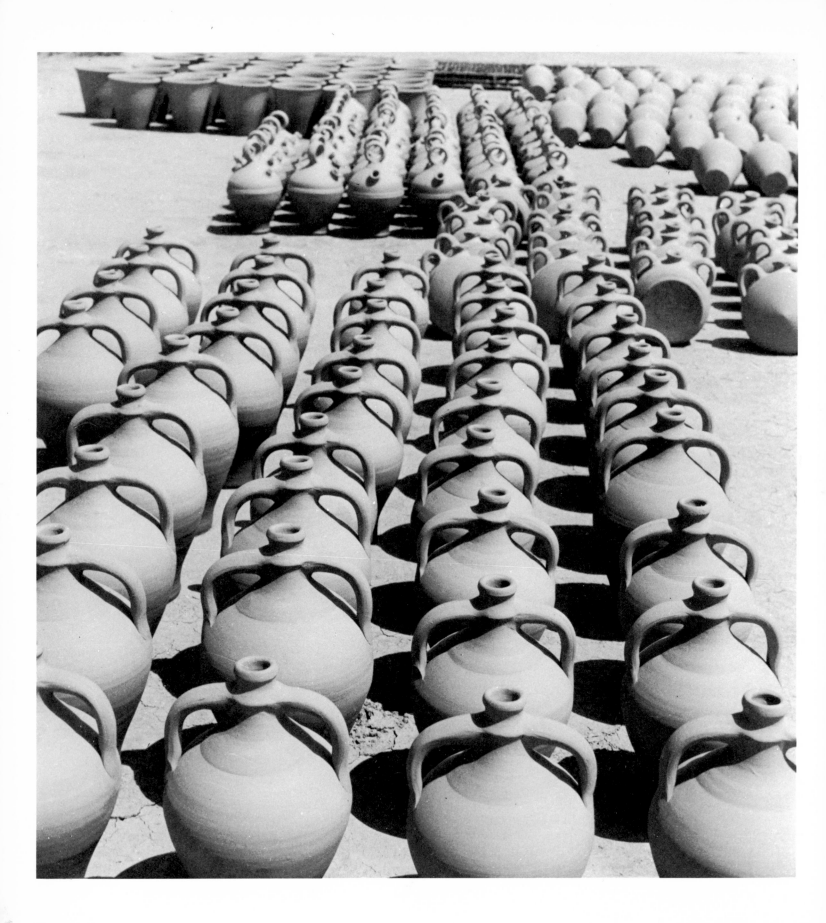

37. Flowerpots, *Fuentes de Ebro*

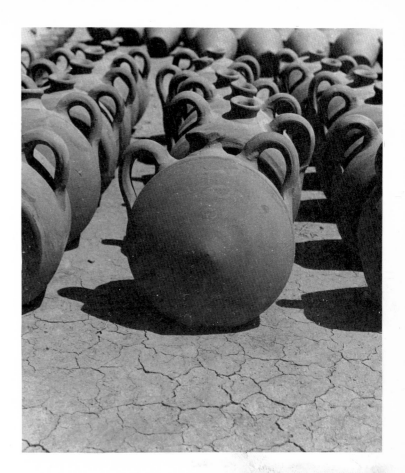

37. Botija chata, *Fuentes de Ebro*

retail without leaving the house. The 'botijo' from Magallón is very popular, and it is because of the clay. Do as we will, we can always put it out in the sun. It is porous and if you only let the 'cierzo' air it out a bit, it cools the water". The earth which is extracted from the lands surrounding the town is, in effect, good, very plastic. The objects are very attractive: "botijos", flowerpots, piggy-banks, feed and water throughs for pigeons and rabbits, but especially the "botijos", in various types, from the ones for children to the large ones for workshops.

We said good-bye to the last representative of the Salvador family and went to see Angel Borovia, who is, it is feared, the last of his family too, as far as ceramics is concerned, for this sons are not in the least interested in the craft. He is forty seven and seems to be a very good person; he received us very cordially. "By the time I was twelve, I had already begun to make a few little things... my father taught me what little he knew. Yes, the clay is good, from the mountains around Alberite de San Juan. Near here there is another type of clay, but it has impurities; you can't dissolve it; in the heart of the clay there always remains an undissolved nucleus." The man has a lot of curiosity and

reads a lot; on a table we found a book of formulas written by a Llorens Artigas, that we had already seen at a bookstand in Fraga. We discovered other things: he has corresponded with D. Jacinto Alcántara, who attended him well and answered his consultations. This curiosity leads him to introduce new forms which, we are happy to note because of the liking he has aroused in us, have considerable distinction: some small jars and amphoras, and even a Mexican "sombrero" for an ashtray which, like the other objects, is unglazed. We know through Borovia that there have been other innovations in form: "The oldest of these 'cántaros' was made until 1936-1938, though a few continued to be made later; at that time a man from Huesca provided us with two new models, one that was taller, and one with less fullness". The sales here in Magallón are relatively prosperous; they are generally made to wholesalers who come to pick up the goods in trucks, "and to retailers; there is a little of everything. Not much is sold at retail."

Around Zaragoza there are even more potteries: in Fuentes de Ebro, Daroca, Villafeliche, Alhama de Aragón —to which

37

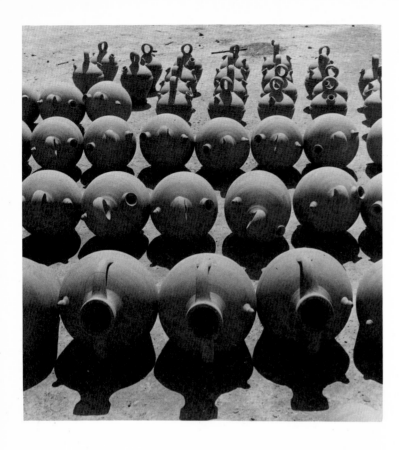

we will refer later—, **María de Huerva, Villanueva de Gálle-go**, and **Ateca**, which have been visited by Rüdiger Vossen. The last two towns devote most of their work to nontraditional vessels. On the other hand, the following potteries have recently ceased to exist: **Alpartir, Egea de los Caballeros, Santa Cruz del Moncayo, Jarque, Illueca**, and **Séstrica**.

Fuentes de Ebro, is an example of good organization. There is only one pottery left. Alfonso and Antonio Gazán Cerezo, the two brothers who are in charge of the work, tell us that they have known of as many as eight or ten potteries in the town, but that they are the only ones remaining. Three sons work with them, but it is doubtful if they continue. Alfonso is 65 and he has been working for many years: "So many", he says, "that they ought to give me the iron cross." They manage the work well; there are five foot lathes in the workshop, so even the execution of the pottery continues to be primitive. On the other hand, everything from the size of the pool to the planning of the sales, shows a realistic knowledge of the market possibilities. They sell to warehouses, shops, and at retail. "During the year, we have four months of a sell-out, four months of not very good sales, and four months when we can't even work. The articles are all very well "baked"; but in spite of that, they confess that they believe this to be coming to an end. Although they devote themselves almost exclusively to traditional objects, they also make, on order, a few "artistic" pieces in accordance with the sketches they have been shown. They make "cántaros" with two handles, five or six types of "botijos", among them the "botijo-chata" ("flat-nosed botijo") to be hung on the side of a donkey or in a wagon, and a "botijo" with several spouts; and also flowerpots and piggy-banks. The capacity of the "botijos" vary between ¾ and 2 gallons.

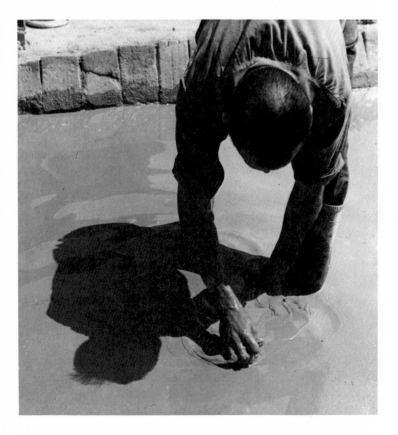

38. Two-handled cántaros with spout and in the background, carrier botijos and flowerpots, *Fuentes de Ebro*
Softening the clay with a pestle, *Fuentes de Ebro*
39. Cántaro, *Daroca*

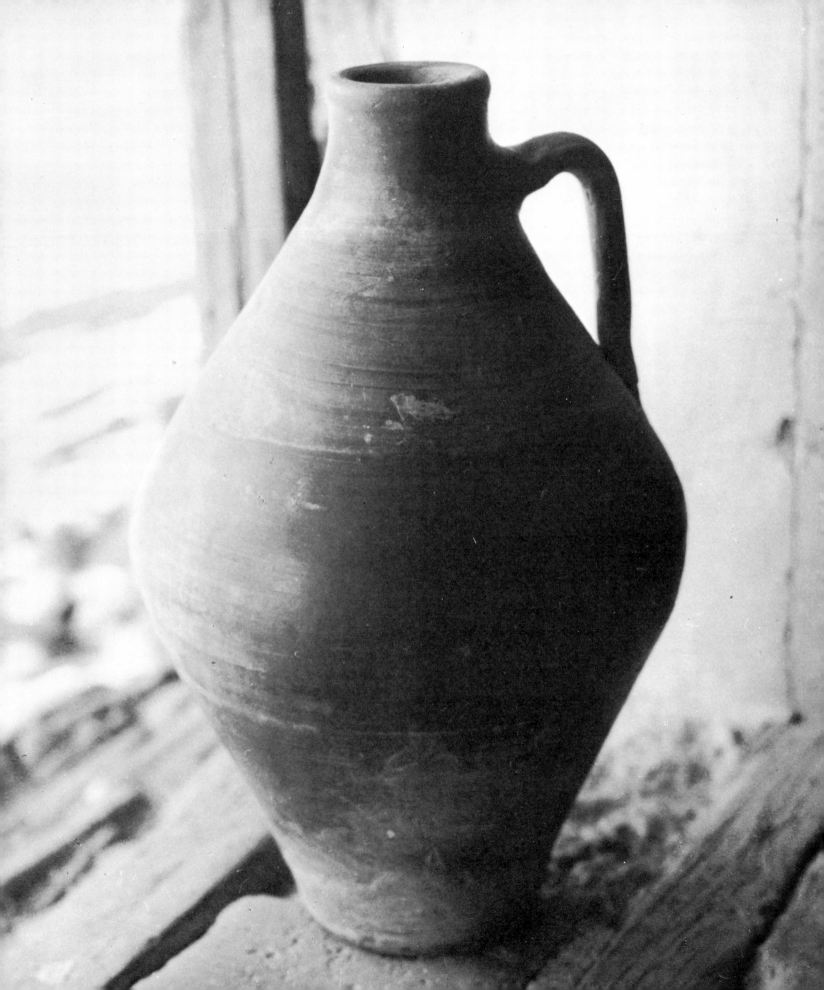

Daroca earns its living, like all of these places, by farming. It has a few industries, but none employ as many as twenty workers. In spite of this, the town has a rich history and beautiful buildings; and we find many outsiders here. Many tourists come through the area, and until recently, when they discovered that pottery was made on the outskirts of the town, they would stop to buy. This, together with the sales to stores and wholesalers, allowed them to devote themselves entirely to ceramics without having to alternate with farmwork. Although formerly there had been ten or eleven potters, in 1972 only one remained, José Pellés García, who has now quit the profession and moved to Zaragoza. The taste of the tourists, though not too important factor, had had an influence on the objects; some that appeared as an expression of this taste were the amphoras and "botijos" in the form of grotesque human figures. The latter, which were not traditionally made in the town, were appealing in a certain way and were related, through their awkwardness and simplicity, together with a natural flavor, to those of other places and times. Here they made "cántaros", "botijos" —including one with several spouts—, pigeon feed troughs, croks for preserving pork, basins for washing vegetables, kettles, and casseroles used for soup; all were undecorated and the parts to be fired were glazed with lead. Daroca had much in common with Villafeliche and Alhama de Aragón and also with two pottery centers that have also disappeared: **Tobed**, where work continued until shortly after the Civil War, and Almonacid de la Sierra, where virtually the same type of work was done. **Villafeliche** formerly produced ceramics of considerable importance. Today very little remains; all are glazed articles such as: kettles, casseroles, vases, piggy banks, ashtrays, and honey jars. The potter from Daroca told us that at one time he had known as many as seven or eight potters at Villafeliche. At present only one continues to work, José Villarmín from an old family of potters, but he has no children.

Alhama de Aragón, has two potteries, that of Eduardo Muela and that of Félix Vicente. The production is similar to that of the aforementioned places; and, as in Daroca, they are also beginning to make articles which they call "craftsmanship" in which tradition is corrupted and lost.

Still to be mentioned is the production in the region of Teruel. There remains only the magnificent pottery in Calanda, rustic and unassuming, which distinguishes itself from what we have seen in the provinces of Huesca, Zaragoza, and the city of Teruel. Our investigations of the other towns about which we had information, Alcañiz, Calaceite, Alcorisa, Benasal..., were all in vain; either there had never been potteries in these places or they had ceased to exist some time ago. We had to content ourselves with Calanda,

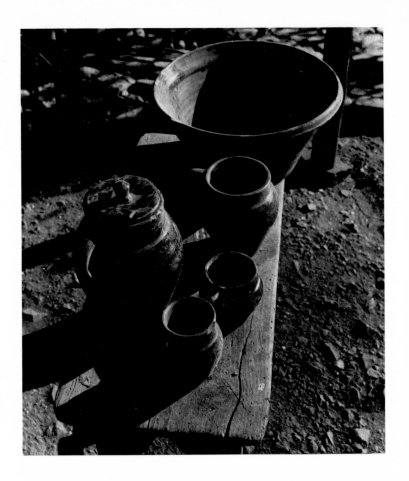

40. Pots (one of them with a lid), soup pots (the smallest vessels) and a dishpan for washing vegetables, *Daroca*
41. Cántaro, dishpan and "parreta", *Calanda*
42. Mortero, *Teruel*
43. Objects recently made by the potters of *Teruel,* the majority of wich are copies of the old forms and decorations

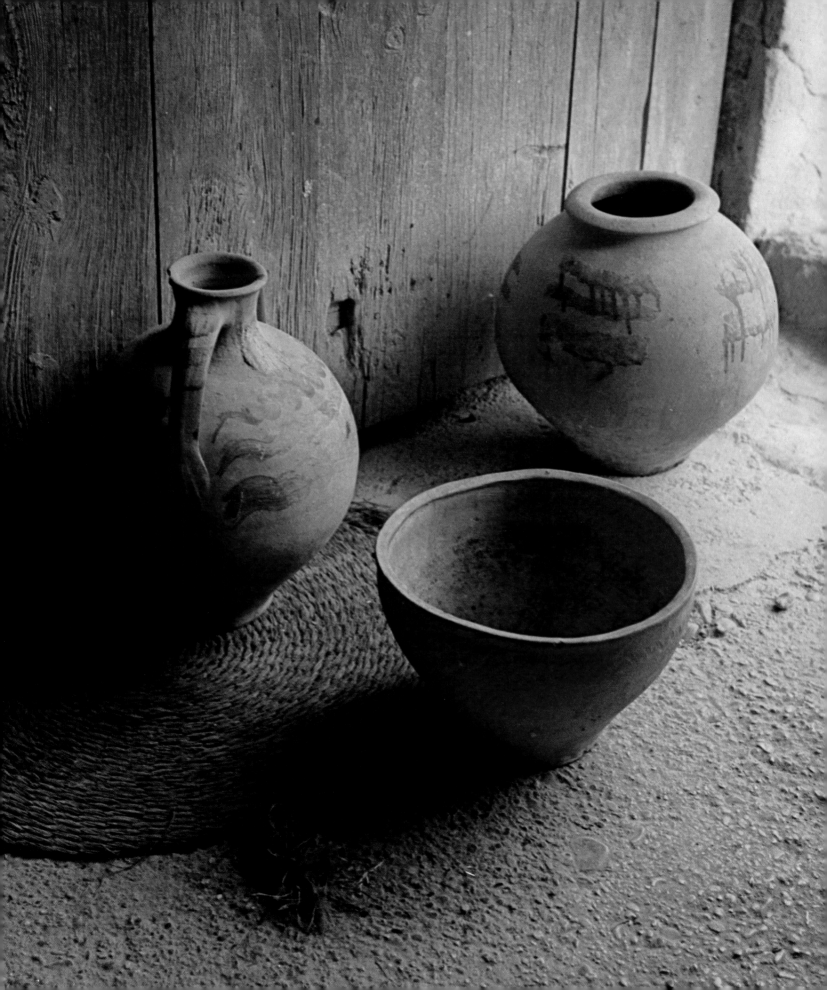

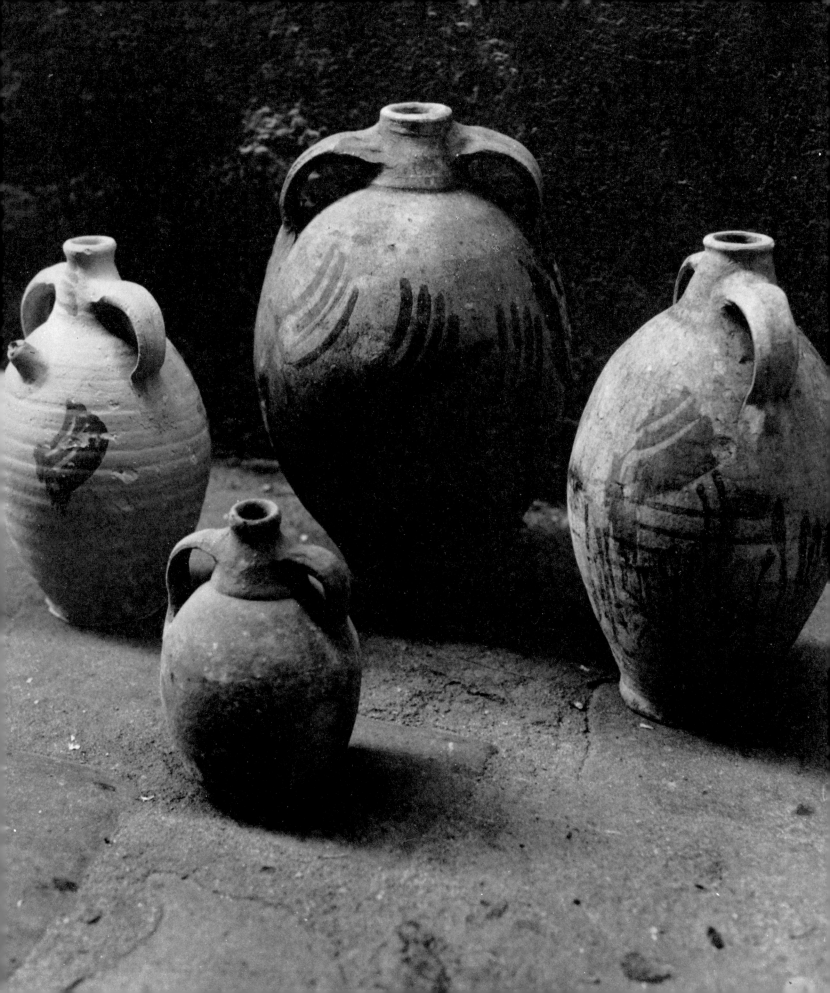

which caused an agreeable surprise through the primitiveness and sobriety of its forms and decorations. We will refer later to the glazed ceramics which is made at present in Teruel and Muel (province of Zaragoza), places which were previously famous for their ceramics and which they are trying now to revive.

Although we already knew what was produced in **Calanda**, the short visit to the town aroused personal emotions. The first was caused by the sight of its beautiful and coarse "cántaros" and "botejones" (large "botijos") and the realization that the objects were molded entirely by hand. It is a shame, but this will soon be lost. Pascual Labarías, the potter, who has no sons, works very little; "a few little things". And they do not ship anything out of the town, nor does anyone come to collect them. This is a relic which, by the logical passing of time, is condemned to die and actually will die from lack of backing, if something does not save it. They continue to make a few items, but the kiln has fallen into disuse, and the objects must be carried to the tile kilns, of which there are three in the town. The types of objects which can be found today, although in small quantity, are: the "cántaro" for water, the largest being for 3½ gallons; the "botejón" which is used to store olives, and the dishpan. The "parreta" and the "cántaro" are specially beautiful with their decoration of wide bands painted with a brush and, at times, a few simple flowers. According to what we were told during our trip in 1968, people form the

large cities used to come to this region; and this, together with the general bad taste of the buyers, had prompted the potters to create new forms and decorations. Later, however, there were new, well-oriented demands for the traditional forms. This pottery center, thus, continues to produce its beautiful "cántaros" and its short stout earthen jars known as "parretas". Caused by a certain awakening of ceramics, now that its loss is doubtlessly inevitable, some of the old pottery centers are reviving, by private impulse, as in Teruel, or by official insistence, as in the case of Muel, a center of old ancestry. Blessed be this work which lets us have today at least the reflection of two of the most illustrious pottery centers of our ceramic tradition.

Before going on to the pottery centers of Teruel and Muel, primarily characterized by what we could call a devotion to historical reproductions, we would mention two more centers dedicated exclusively to ceramics: **Rubielos de Mora** (where the only craftsman, Esteban Pastor Goicoa, produces "cántaros", "botijas", pots, and casseroles) and other, a very interesting, but rapidly disappearing center. The organizations and corporations that have, in such an admirable way, supported the attempts to recuperate the ancient traditions of Teruel, will doubtlessly turn their attention one day to the humble clay work in **Huesa del Común** an example of an almost miraculous survival of Iberian ceramics. The only remaining potter in the town, Pablo Benedicto, now finds himself in difficulties, as the chimney of his kiln has been destroyed; and there is the possibility that he will abandon his work with pottery. The "botija" in various sizes (one of which is called the "sieve botija") and the "botijo" constitute the only articles in production. Both are of great beauty, coarse in form and in its ocher, somewhat blurred decoration, rudely but gracefully applied on the white clay. There remains one other relic, Calanda, which we should strive to preserve while it is still possible.

There was in **Teruel** a workshop for coarse ceramics, the "ordinary" objects (to use their works), which made such things as: kettles, pots and "cántaros". In 1953 Antonio Bernad, a forestry engineer, and at that time president of the Teruel "Diputación", suggested to the brothers Ismael and José Goriz that they copy the old pottery pieces from Teruel. There was a similar proposition made to Florencio Punter and his son Domingo in 1955 by Manuel Agramunt, a professor of secondary education, and Martín Almagro. They searched the Valencia de Don Juan Institute and the Museum of Valencia and set about reproducing the old forms with great fidelity and at times, commendable artistic license. Once more from the kilns of Teruel came jugs with the beak of a stork, oil vessels, bowls in purple and green, and at times blue, on a white background; in addition to coffee services, ashtrays, etc. These objects were decorated

44. Beautiful ceramics of Iberian origin, *Huesa del Común*

with varied fauna: from bulls, rabbits, dogs and owls to hydras and dragons, soldiers on horseback, ladies with fish; all enclosed in a geometric scheme of Islamic characteristics. Aside from the craft which these two families had, by having formerly devoted themselves to coarse ceramics, they had acquired knowledge of new things. Domingo Punter, for example, was a restorer for eleven years in the Archeological Museum of the Province of Teruel, a work which gave him familiarity with the old pieces of pottery and its secrets. The Punters connected a small motor to the potter's wheel, while the others continued with the pedal. The sales are very good; considerable quantity is sold in the workshop and a great deal is shipped to other places. The Goriz family has participated in numerous expositions, such as the Country Fair and in exhibits abroad, in England, Germany, and France, representing the Craft Union. The Punters are not represented in any exhibitions or contests sponsored by the Craft Union. They did once and received so many orders that they could not attend to them all; so, in consideration of the success, they decided not to present themselves again. Goriz, in addition to the old forms, continues to produce simple ones: soup kettles, pots, drainboards, etc.

Another place where a lost tradition is being revived is **Muel**. Here, ceramics was at its high point between the sixteenth and eighteenth centuries. In 1964, the president of the "Diputación" in Zaragoza, Dr. Zubiri, decided to revive the kilns and put his private secretary, Enrique González y García-Mayorga, in charge of providing everything necessary. Since the beginning of the century, there has not been even one of the workshops left which formerly devoted itself to ordinary ceramics. Only a few older people retain a slight remembrance of the last pottery, belonging to the Soler family and shut down a little before 1930, through having known personally the potter. It is interesting to note that this work was aided during several centuries by the notes on pottery procedures taken in 1585 by Henry Cock, a dutch archer in the services of Philip II, while in Muel. After some difficulties, in March 1965 the kilns were, for the first time, relit. For this task, Señor González y García-Mayorga, who had himself been (in his words), "bitten by the ceramics bug", counted on the potter Manuel Herrero. The articles which we have seen on display in the "Diputación" in Zaragoza, the work of the Workshop-School of Muel, are excellent indications that the new workshops in Muel have been able to recover the old tradition. These objects have the same charm as the old ones which we have apraised in museums, a quality somewhere between ingenousness and refinement. The man responsible for this resurgence tells us that from 1964 till the present —January 1969— approximately 15,000 objects have been produced and sold. This is a worthy task which should be followed up with initiatives from other "Diputaciones" and important organizations.

46. Jar and candelabrum, *Muel*

the basque-navarre country

Though this is a populous region of rich land, there is very little to be said of it concerning ceramics. We were able to find two pottery centers, and even one of them has recently ceased to exist.

All the Basque Country seems to be represented, according to our investigations, by **Narvaja** in the Alava lands. During the Civil War the front was established in the town and as a result, the majority of the kilns were destroyed. Only one is preserved, from which continue to be produced the wine jugs, "botijos", small jars for curds (to make "requesón"), and small hors d'oeuvres plates and, in general, all the glazed crockery used in the typical little bars. The foot lathe is most often used and, upon occasion, an electric one. The sales are reasonable good because the production serves the whole region.

In **Lumbier** (Navarre) we were unable to meet any of the potters who had continued to work until just a few years ago. They made, with the traditional potter' "cántaros", pots, casseroles, "botijos", amphoras, chocolate pots and especially flowerpots. These workshops, which provided several families with work, began to slowly decline until finally they produced only the flowerpot.

asturias

We had often heard of the black ceramics from **Llamas de Mouro** and we were familiar with a few of the pieces and had heard many interesting accounts of how they succeeded in turning the objects black. Someone had told us, even while in Asturias itself, that the matter was being studied in order to demonstrate that formerly the pottery was made with black clay and that the present day ceramics from that region is an historical falsification.

We first passed through Cangas de Narcea, to whose municipality belongs the pottery nucleus, and then continued, by way of a beautiful, steep foggy road, to Llamas, about 13 miles away. The man who maintains the fire of this ancient ceramics is Jesús Rodríguez Garrido, who was 55 years old in 1968 when we made our trip to the area. He is helped by his oldest son, Marcelino, 21, who is about to enter the military service; the smallest of the children, 14 years old, is already very fond of the craft and is beginning to make a few little things. The father tells us that formerly the people worked very hard here; he had known of as

many as 16 or 17 potteries. Even last year there was another one, but it has not produced anything this year. The potter knows, by seeing the interest of the people who venture to come all the way up here to buy his ceramics, that this has merit because of its "antiquity". Jesús Rodríguez is an extremely cordial man with a type of politeness that only a few country people, and of course many potters, have. He clears up all our doubts, shows us his workshop, the potter's wheel, and the firewood; he then takes us to his house, invites us to have breakfast and talks to us about the supposed "secret" of the black pottery. He explains fully the matter: "We put the objects in the kiln and cover them with 'tapines' (pieces of sod). Later, when the objects are fired, the 'tapines' melt. Once the pottery is well 'baked', everything is covered with earth from the kiln itself, including the door from which the fire is poked. This makes the smoke accumulate inside, and turns the objects black."

The town, which is at an altitude of 2000 feet, lies 62 miles from Oviedo. It earns its living from farming, mainly

51. Three examples of the black ceramics, *Llamas de Mouro*

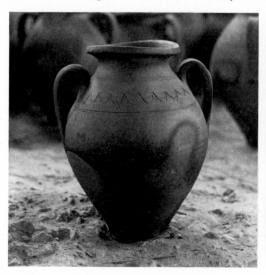 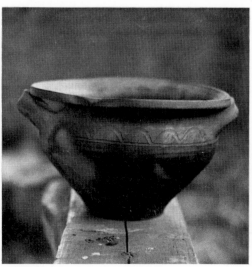 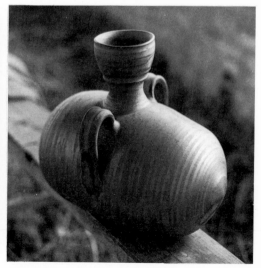

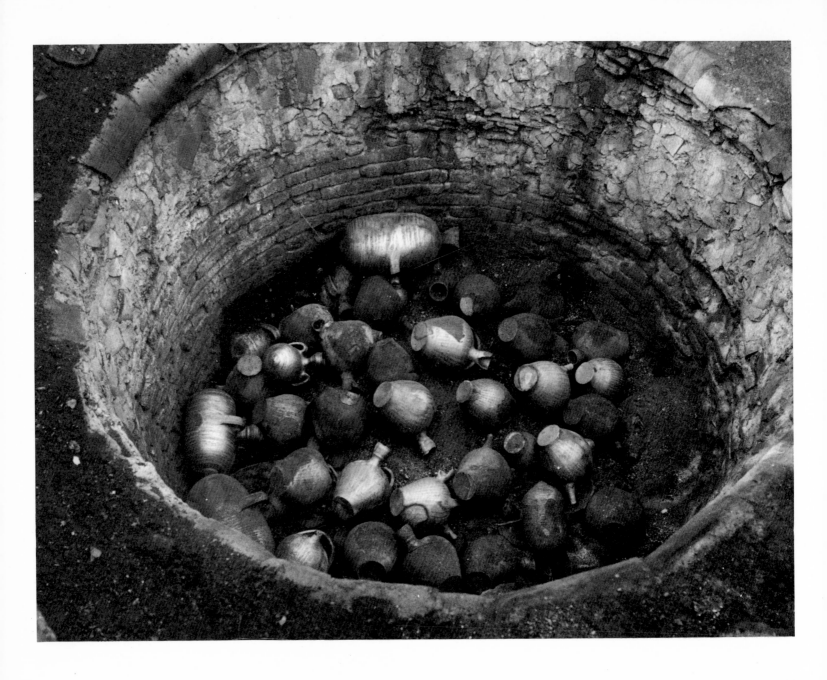

corn and wheat. The potter and his sons also have to devote themselves to farming. They live a very isolated life, although the father has been in Madrid and around Levante during the war. The trail by which we came up from the road below was made during the Civil War; formerly one could not even come up on horseback, only by mule. Another recent improvement is the fact that electricity was installed here some six months ago.

The potter shows us the objects he has made: "cántaros", wine jugs, kettles, pots, washtubs (the women make cheese in them), piggy banks, flowerpots, and wine cups. Not all the models derive directly from antiquity; Rodríguez has introduced a few new ones: jugs with one or two handles, amphoras, centerpieces, coffee services, beer sets, plates (formerly they ate and drank out of the wine cups), vases —a few were made before, but a different type—, and animal figures: primarily roosters and bulls (the latter being inspired by, though not the same as, the one Pedro Mercedes makes in Cuenca and from whom Rodríguez obtained a sample). This interesting production —we refer to the old

tradition— does not sell well. When an object is requested, the buyers almost always come to get it. Normally, part of the production goes to Pola de Siero. Llamas de Mouro does not participate directly in exhibitions of craftsmanship; what we had seen in the "Feria de Muestras" in Gijón —for which objects had been requested— had been supplied by people who owned the articles.

From Llamas de Mouro, one of the most interesting places that we encountered on our trips, we headed to Oviedo. Our immediate objective was not Oviedo, but an annex of it: **Faro,** part of the Limanes parish. Here the ceramics is not black, though it may have been at one time, but something distinct, according to what we were told; today it is a buttery color. "Botijos", jugs and many other types of vessels are produced. New ideas are often tested here and a short

while ago, they began to make glazed ceramics with a green design on a white background, in imitation of the Mexican, pre-Columbian ceramics. It was explained to us that the son has studied at the Escuela de Artes y Oficios: "That large vessel is a strawberry pot; the first one to exist in Spain, and it is an invention of his." The boy's father is named José Vega Suárez, and is now, excluding his son, the only potter in the town, where previously there had been eight. Formerly he made all the enamel himself. "This is the millstone that he used", the boy tells us. The enterprising character of the latter has prompted him to vary several of the ancient customs. It does not surprise us that to test the temperature of the kiln he uses Seger cones. The area covered by this ceramics is small: "Wholesalers come to collect the production and sell it here in Oviedo; some take the objects to Sama de Langreo and to expositions in Gijón."

54. Broken crockery pieces, *Llamas de Mouro*
55. Strawberry pot, *Faro*

galicia

There existed in Galicia, not long ago, great ceramic wealth. Even if we had not known of it, the vestiges left behind would have told us. But the disappearance is rapid, and what little does remain is steadily losing character and authenticity. In a matter of only four or five years, nothing will survive. Until recently there had been four pottery centers: Bonxe, Mondoñedo, Buño, and Niñodaguia, to which we must now add that of Meder, where a potter from Buño has just settled.

Bonxe belongs to the municipality of Otero de Rey, in the province of Lugo. Only a short while ago, in **Silvarrey**, another dependency of this municipality, there was still some potteries. On the road we encountered Manuel Villamarín González from Silvarrey, who gave up the craft two years ago. "I wasn't alone in leaving it; everyone here left it. Production was stopped because the objects were being substituted by plastic and porcelain ones." He attended us well, happy to be able to talk of his former craft.

In **Bonxe** we have a little trouble in locating some of the potters because everyone is working in the field. The wife of one of them helps us. She is wearing a scarf in her hair, and has a sickle in her hand. She runs to look for her husband without delaying further; for a long while we can distinguish her red scarf in the distance. They return together. "Manuel López Lombao, at your service." And we begin the interrogation. "In the town I have known of thirty or thirty-five kilns, and now six or seven are left, all independent ones. But, as you can see, I am a farmer, and I only work with pottery when someone requests an object; it happens to all of us..." As we talked about ceramics, little by little as has always happened, the lives of these people come to light. "I learned from my grandfather; my father had gone to the Americas, and the poor man never returned. My children won't ever devote themselves to the craft."

Traditionally, they make a circular "botijo" with flat top, barreños, "sella de agua" (whose form was taken from the wooden tub), jars in various sizes, plates, wine bowls, pots, pans, casseroles, flowerpots, and platters. In addition he has a "botijo", in which the traditional lines are more promi-

nent than normal, that is an invention of his and is extremely pretty. In general everyone in Bonxe makes the same thing, except an occasional item or two (as for example the object mentioned) which they ingeniously invent. The majority of the articles that we see are "unbaked"; with the simple light color of the earth and the white of the decoration, they are even more beautiful than baked.

Some attention has been devoted to Bonxe, though apparently not enough, and the town has been left with only promises. "I worked for America", Manuel tells us, "for the World's Fair in New York, and another time for a man from Madrid (I think he's a doctor) that I had seen in a store in Lugo, that's where I'm from". The old woman intervenes: "And he wanted to take him to America." "But it just didn't work out", he explains, "and I've sold a few things in a bazar in Madrid. The governor from Lugo also came once, and told me that all this is very pretty and that it was a shame that it will be forgotten". Such is the ceramics in Bonxe, in the crucial moment of being forgotten, with farm work, because they do not receive enough orders. They have a few steady clients who come to collect the requested goods in trucks.

In **Mondoñedo** there were two potters, both of whom we visited. The first was named Delfino Freire Díaz, known also by the nickname "Vendaval", as his grandfather was called before him. He was thirty-nine at the time of our trip. He was well-informed and had read many books on ceramics. He was devoting all his efforts to straightening out his business. If he succeeded in doing so, he was going to put his sons to work in the craft. "I don't want to see the craft's funeral," he told us. "I would like to work with it all my life." Later the news reached us that this intelligent, jovial man had died in 1970. He made vessels primarily for domestic use, "the ones which had always been made": "potas", "botijos", cheese dishes, flowerpots, jars, cups, platters; "everything that one uses in the kitchen." So that things would continue to go well, he used to make "artistic type ceramics", although he knew the importance of the traditional forms. He therefore made new types of jars; coffee, tea, beer and wine sets; and anything, he told us that he could imagine. "I make a vessel and what comes out is

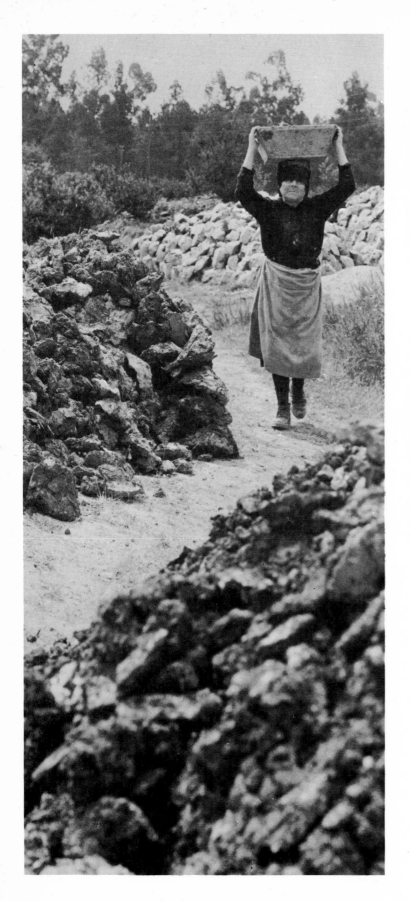

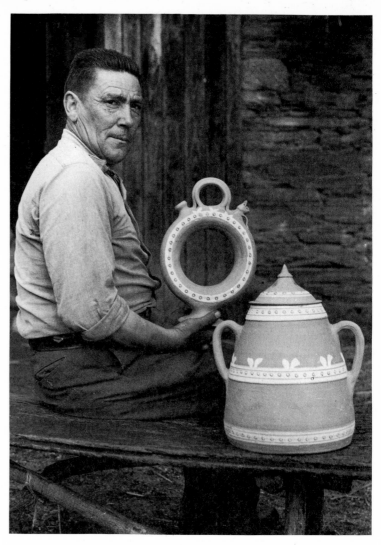

58. Carrying the clay, *Buño*
Botijo and "sella", *Bonxe*
59. Turning the clay on the potter's wheel, *Buño*
60. Piggy bank, serving bowl, bowl, and soup tureen, *Buño*
61. *Bonxe* ceramics

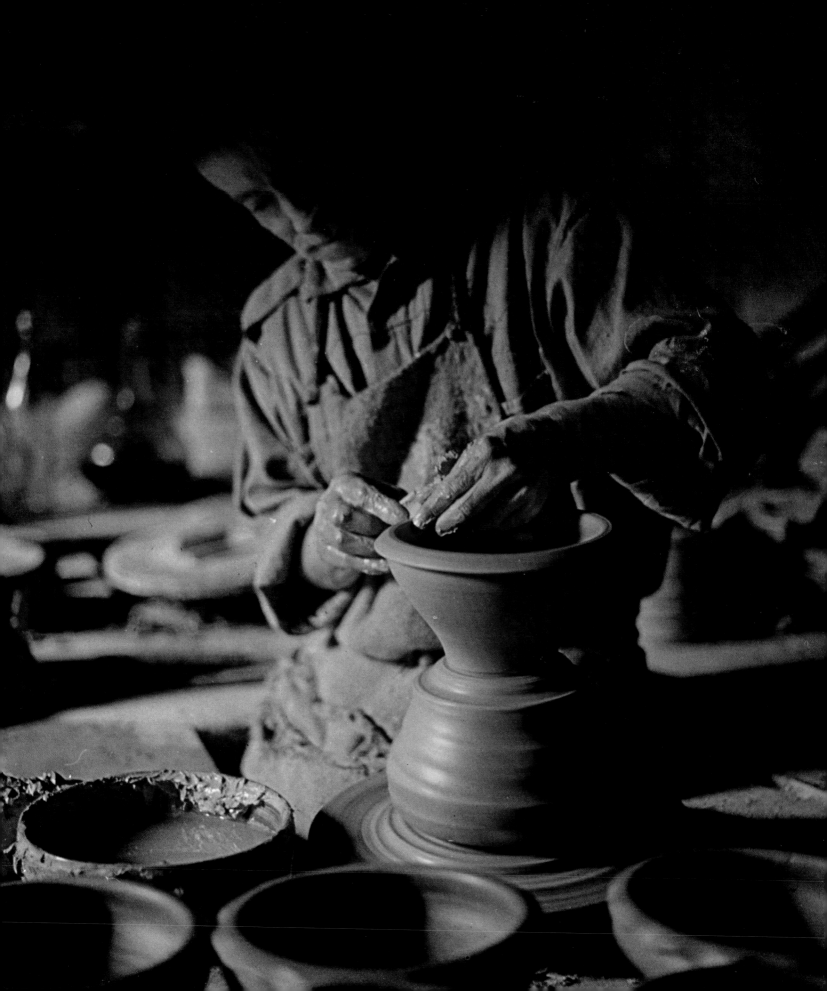

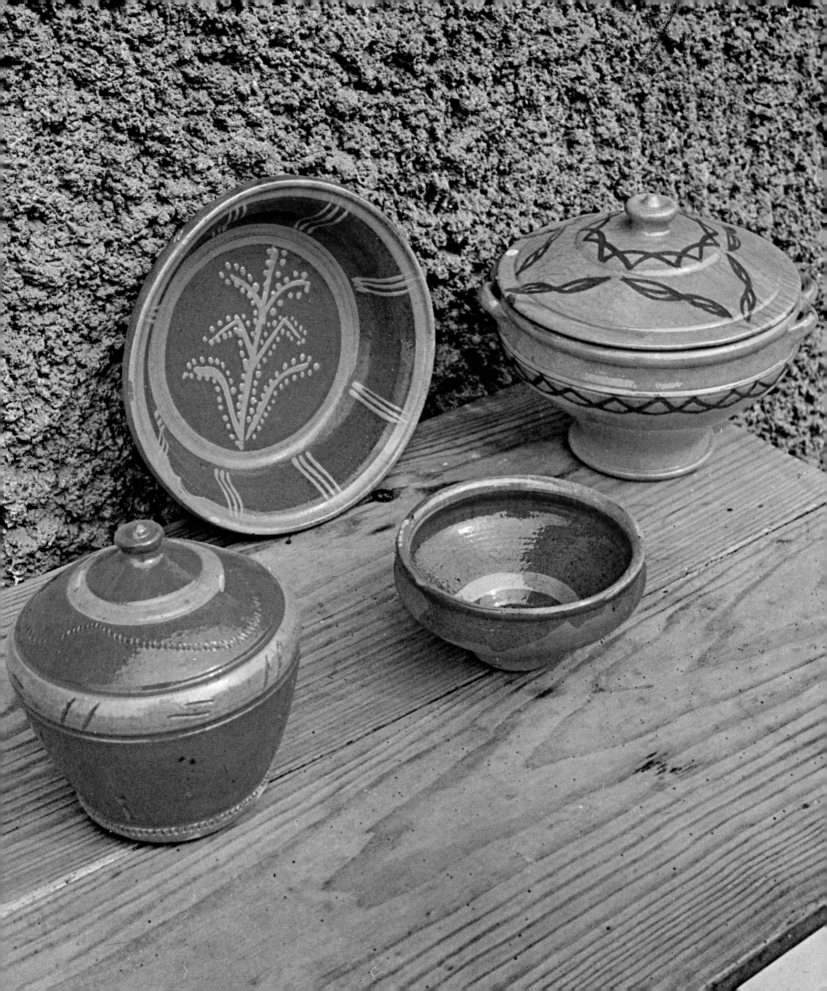

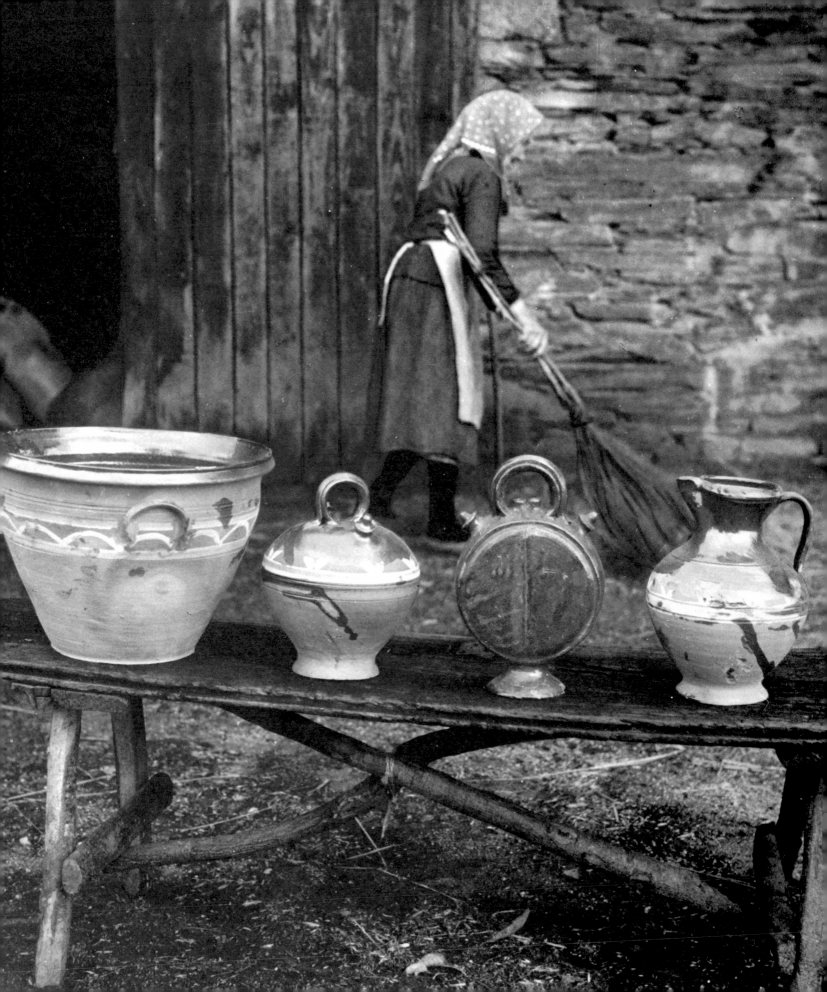

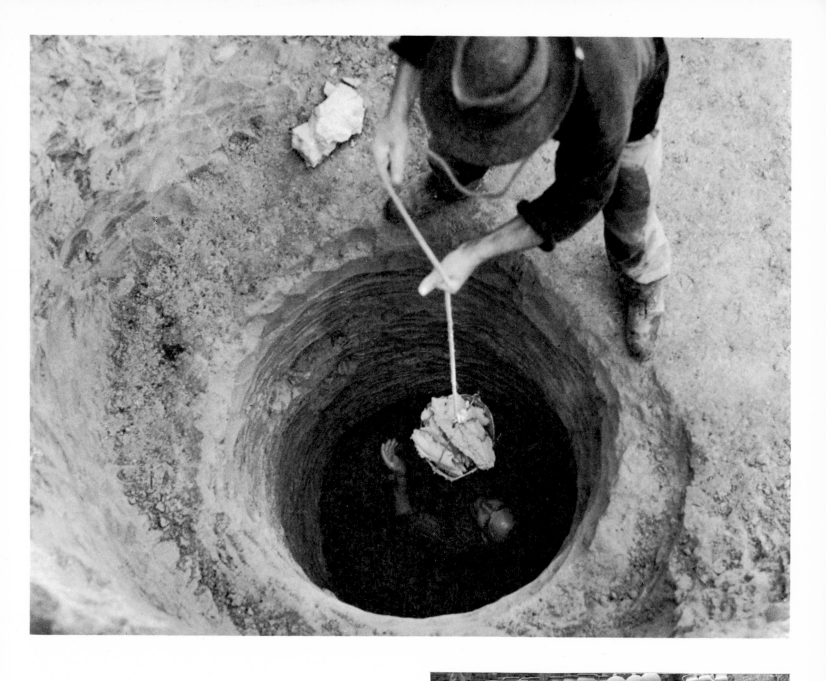

62. *Bonxe*
 Unfired jars, *Mondoñedo*
 Turning piggy banks on the potter's wheel, *Mondoñedo*
63. One of the wells from wich is extracted clay, *Buño*
 Unfired objects put out to dry, *Mondoñedo*

left to chance." He succeeded very well in selling all the articles: "the domestic type objects in the fairs throughout the province, and the artistic ones here for the foreigners and people from Madrid passing through". Mondoñedo has some industry —that of wood briquettes, a saw-mill—, but the fundamental basis of its economy is agriculture. The other potter, José Chao Varela, sixty years old, with no sons, devoted himself, as we were able to observe, exclusively to the production of objects for domestic use; he will probably abandon the craft, for the use of lead oxide has been forbidden in the province of Lugo.

Buño, of which we had heard a great deal, is on the Spanish border, in another "finisterre". It is a village of about a hundred families and their ceramic tradition is very old. Although its history has not been studied, sixteenth century documents are known of which refer to the potters of the town as descendents of an inmemorial tradition. Some of the remains of the old pieces suggest a possible Celtic influence. The present day ceramics is a mixture in which elements still preserving their purity are found side by side with others just recently innovated and in not very good taste. Some forty years ago, there were between ninety and a hundred potters here, while at present there are not even fifteen (which is not a bad number in any case). Some potters went to live in South America, with the intention of devoting themselves to other more profitable trades, but ended up by earning their living from the clay. There are still people working with clay, earning enough to get along on, thanks to this type of simple work, in Buenos Aires, Montevideo, and Brasil. As you can appreciate, by the number of people working in the pottery business and by the relation of this number to the number of inhabitants, this humble industry, alternated with farm work, is of utmost importance in Buño. In relation to the pottery sales it is helpful to make an explanation: "In the old days", says the potter Antonio Añón Montans, referring to . his childhood, "the production was sold to men who come by mule, and took the articles to distant places, as far as Padrón; and they used to come every eight days. At times, in places where there wasn't any money, they exchanged the pottery for other merchandise. At present there are two firms, which are like warehouses, that buy from us potters and they take care of selling the objects. Sometimes we make direct sales, but very few. We sell almost everything to these two firms in Buño". These sales are at a very low price. On the other hand, the enamel, which naturally they get from Jaén, does not reach them directly; they buy it from men here, "who, in turn, buy it in Linares and they sell it to us". The man does not mean to complain; but it is clear that the profit is shared by the providers of the enamel and the salesmen. Galena is used for the glaze, "minium is better, but it must be brought from La Coruña. Since we don't have any money at our disposal, we go to the same men and buy the galena."

Among the characteristic pottery pieces from Buño, already in general very spoiled, we find: the "cunca" (bowls

decorated with concentric circles), "terrines" (for flowers), wine bottles, soup bowls, "sellas", "botijos de rosca" (in the form of a wheel), basins for holy water, flowerpots; in addition to the innovated forms, some of which are made with a mold. There is a very pretty toy selection which imitates the forms for older people, but is not glazed.

As we have said earlier, a potter from Buño recently settled in **Meder,** where he continues the Buño ceramic tradition, although considerably adulterated.

The last place we visit in Galicia is **Niñodaguia,** in the municipality of Junquera de Espadañedo, Orense province. Of the seventy former potteries known to have existed by the people we interviewed in this "Eagle's Nest" (as the name means in English), there remain only seven, with eleven potters. Fidel Fernández Dorrego has just given up the work: "My health did not allow me to continue, and since one also has to devote himself to farming... The boys (referring to the young boys in the town), since they have the brick ceramics, no longer want to work with pottery. How is this going to survive, with the taxes that are inflicted on the people? The potters continue because they are old, but the young people are determined to leave the craft because it has little future."

Every type of coarse vessel is made here: pots or "cántaros", cups, platters, water kettles, butter pots, "botijos", bowls, and small flowerpots. "There is one person who makes other, very pretty, things here", says Fernández: "Hermesindo Alvarez Rodríguez; he is the only artist here." We went immediately to visit Hermesindo, who is a very wide-awake, clever man. He is constructing himself the building for his new pottery, on the highway where he will make and exhibit the articles. He is the only one who devotes himself exclusively to this work without having to alternate it with farm work. He took part in the Craftsmanship expositions in Orense, and at the Country Fair in Madrid, where he molded objects on a lathe "before the expectancy of big and small alike" (as the newspaper article that he showed us stated). In 1968 he made the table service for a medieval dinner celebrated in Verín, attended by the minister Fraga Iribarne.

This clearly is moving away from tradition and even the traditional pots and "cántaros" are fired, as always happens in these cases, not so that they may be used, but as ornaments.

We continue our conversation with Fidel Fernández Dorrego. He recalls: "Formerly we sold, not many years ago, through the fairs, any way we could. We went with our wagons and mules, as far as the provinces of Lugo and Pontevedra. Sometimes there were as many as fifty wagons, divided among the four Galician provinces in order to sell during the fair days. Now there is not anyone who does that anymore. And I remember having heard that people used to arrive in wagons drawn by cows and even carrying the articles on their backs. My parents and grandparents had gone as much as eighteen or twenty miles.

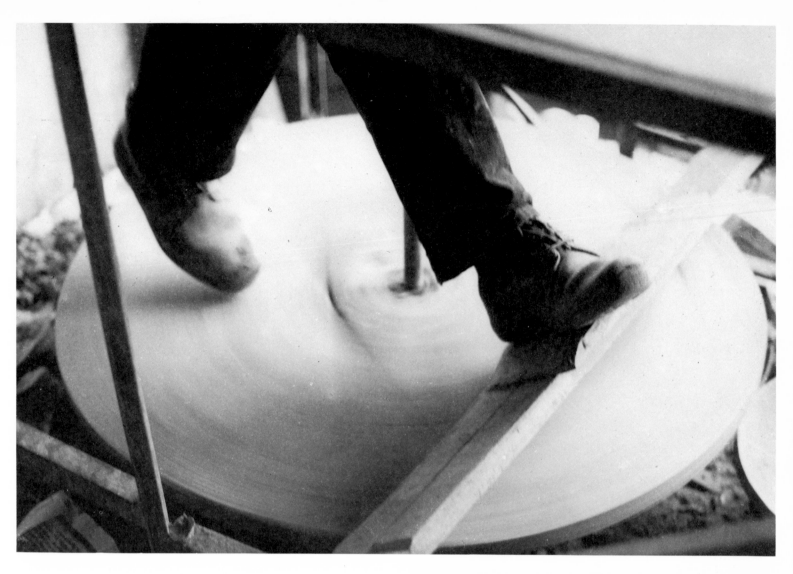

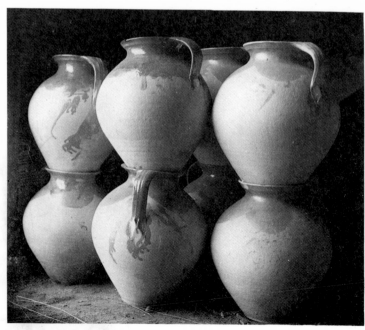

65. Potter's wheel, *Niñodaguia*
 Pots or cántaros for water, *Niñodaguia*

The Leonese lands preserve an important pottery wealth. In Salamanca there are numerous places where the clay is worked, and Zamora has provided us with the opportunity of seeing, in Pereruela and Moveros, women working a hand lathe.

Even before making our trip through Salamanca, we had acquired the only work of any length published until then on our contemporary folk ceramics, *La Alfarería popular salmantina* (Salamanca, 1953) by the professor Luis L. Cortés Vázquez. In reading the book one can observe the lengthy trip of the author through this area where he gathered considerable information. In Pereruela we were informed of another monograph by the same author, dedicated to the pottery making in this region, which we were able to acquaint ourselves with thanks to the kindness of the teacher from Pereruela, Manuel Cabezas. Both works are invaluable and, as such, surprising because of the almost complete lack of interest in present-day ceramics.

Of the pottery centers recorded by Cortés Vázquez in 1953, one has already disappeared: **Villavieja de Yeltes.**

Alba de Tormes is reputed to have the most beautiful decoration in the province. One can observe here something that is common to other places where the ceramics is becoming very striking—as for example in Granada and Triana. The quality and original flavor are maintained more easily than in the simpler objects which may be just as beautiful as the more ornate ones or more so. The people who look for objects to decorate their houses accept it as it is; the only thing that might occur would be that they suggest (as is already happening in Alba de Tormes) special designs which do not perceptibly change the over-all image, but adapt the fundamental aspects of them to the traditional decoration. The state of the vessels in this city is, thus, in general faithful to tradition, although it is not certain that it can be said of it now what Cortés Vázquez could at an earlier date: "pottery making in Salamanca is not at present 'fashionable' and therefore the owner of a beautifully decorated Albense (from Alba) vessel... can be certain of having an authenti-

cally popular object, created by the people and for the people." In general, the Albense potters maintain their fidelity to the traditional characteristics.

We found five workshops here instead of the twelve which the above mentioned author had the good fortune of finding. One of the things which most interested us was the production by Aniano Pérez Gómez. We had just recently seen his work displayed in the special section of the big department stores in Madrid. The merchandise from Alba goes primarily to Salamanca, Avila, and Zamora, but also to Madrid, Santander, and Talavera. Aniano has sent objects to Artesanía, which is the official shop or exhibitions of craftsmanship in Madrid, and to the Valencia Fair.

The most striking work produced here is the magnificent "filigree barrel". These kilns produce, above all, serving dishes: soup tureens, salad bowls, platters, and fruit bowls, as well as pitchers, jars, jugs, pots, wine jugs, milk pails, flowerpots, washtubs, pans, chamber pots, and a whole selection of toys, all of which are glazed and decorated. In addition to these, there are other articles, such as "cántaros" which are not glazed. The flower and leaf motifs of the decoration are at times very stylized. There are many abstract geometrical themes: waves, curves, dots, which frequently are accompanied by vegetable themes.

Formerly in **Tamames de la Sierra** the objects were not normally decorated. Its introduction is recent, as was explained to us by Francisco García Marín, 80 years old. "Before, only plain vessels were made", he tells us, "and I began to decorate them with roses." His children have continued and the decoration has gradually become more profuse. He proudly explains to us that he was presented a certificate of honor by the Union Delegation. Aside from this workshop, where his son also works, only four others are still open; this obviously implies a notable decline since 1953 when the number of potteries had reached twentythree, and imparted an air of medieval guilds to Humilladero Street where they were located. In any event, the remainder have not yet introduced the innovations of Martín and consequently their works are kept more

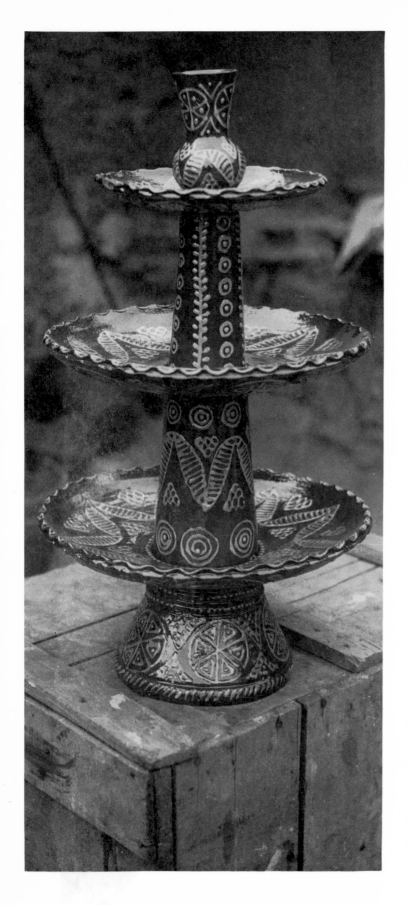

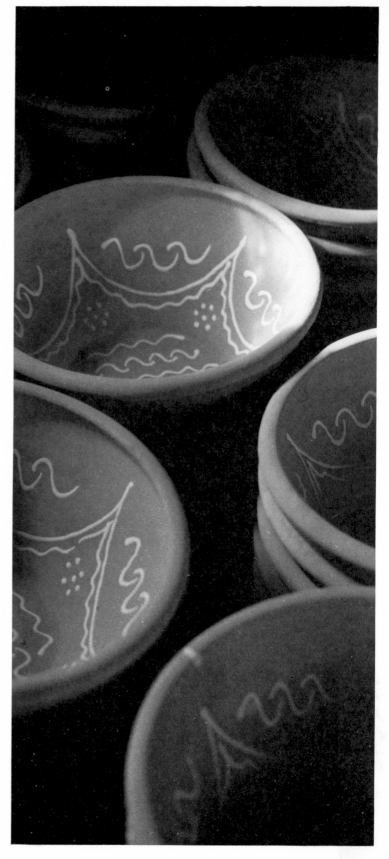

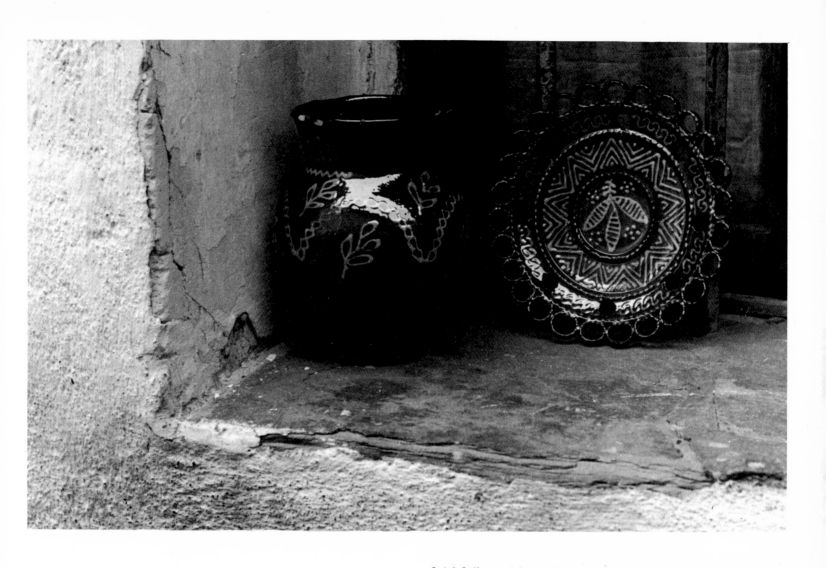

68. Fruit bowl, *Alba de Tormes*
 Unfired and unglazed plates, *Alba de Tormes*
69. Pot and plate, *Alba de Tormes*

faithfully within the bounds of tradition. The most characteristic items in Tamames are the pots, together with the casseroles and kettles, which are sent to the surrounding area, including to other pottery centers which do not dedicate as much attention to these articles. They also make washtubs, dishpans, chocolate pots, piggy banks (known as "borchetas") and water troughs for chickens. Many of these items are made on a small scale as part of the toy selection. There are objects which formerly were only made on order, but which are now reviving, though naturally not always in a desired way, due to the tourists and the current fashion: the "trick jar", with holes, has a beautiful shape and its charm lies in the fact that the drinker must try not to spill the liquid; a good many small "cántaros", vases, and decorative bottles are also made. Aside from the sales of these vessels in the surrounding areas, a few things are sold to travelers; to take advantage of this fact, García Martín has set up a stand by the highway. This event encourages baroque forms of a few of the most popular objects which are becoming more and more richly adorned.

Cespedosa de Tormes must have about 1500 families. In the last few years many people have emigrated to Madrid, Bilbao, and Barcelona and abroad, first to Switzerland and Holand and also later to Germany and Great Britain. The town ears its living through agriculture, which constitutes an important part of the time of almost all the potters. Since the professor Cortés Vázquez visited these towns —where they remember him very pleasantly— the production of vessels in Cespedosa has decreased by sixty or seventy percent. The ones who work most wholeheartedly with the clay are the brothers Florentino and Juan Francisco Hernández Guerrero; the former is the potter distinguished by the professor by dedicating the book to him. There are five other "cantareros" (potters or makers of "cántaros"), as they are called here, who devote a few months each year to the clay and the rest to farm work. The types of objects made here are approximately the same as in other places: "cántaros" (primarily the "half cántaro"), cantarillas, jugs, water jugs with spouts, chestnut roasters (called calboteros here), piggy banks or "buchetas", and the toy selection.

The potteries in **Cantalapiedra** are grouped in the Arrabal district of the town. Around 1950 there were forty-six of them, providing work for more than a hundred families (the town at that time had about two thousand three hundred inhabitants). That number has now dropped to six with six potters. This is one of the most rapid and notable descents that we have recorded. As it is a poor town (the crops do not provide much) the potters can not even count on the land for security. They go where they can earn a day's pay, because "this —potery making— does not provide us with enough to eat." This is the situation of the town which the author Cortés Vázquez was able to call the "most pottery producing town" in the province.

The clay employed in Cantalapiedra is not of as good quality as in the other places, but they have combated this difficulty by lowering the prices. By this method, they have succeeded in selling its "botijos", jugs (the one with a capacity of nine "cántaros" is known as "cuartelera"), dishpans, barrels for carrying water to the country, wine jugs (to carry wine to the fields), pots (the smallest of which is known as the "papero"), kettles (called "orzas"), chestnut roasters, milk pails (for milking sheep) and all of the coarse ware. These vessels reach it own province and

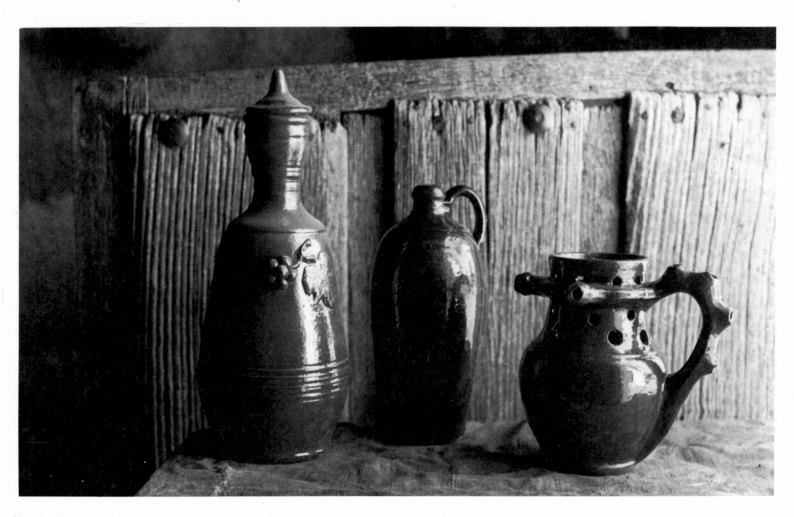

those of Zamora, Avila, Segovia, and part of Valladolid; the "cántaros" and jugs are the most popular items.

Peralejos de Abajo is also a town of jugs, "cántaros", and pots. It earns its living primarily from the wheat, barley, and rye and from livestock "which is what sustains the town". It is a small town, only a few more than six hundred inhabitants. Cristino del Alamo, one of the three potters who are still working at present, has known of twenty-two potteries here, and Cortés Vázquez cites "more than fifteen". We see other familiar objects: the water barrel, "botijos", and other new ones such as the amphora.

The clay, in the region of Salamanca, is also worked in **Ciudad Rodrigo**, **El Bodón**, and **Vitigudino**. In Ciudad Rodrigo, very close to Portugal, they fire a few vessels especially for their neighboring country such as the "Portuguese pots", and the deep boxes, known as "caixas fondas" in Portuguese (which are washtubs without handles).

We were also able to see in Zamora two of the most surprising ceramics in Spain. In both Moveros and Pereruela the vessels are formed on a lathe, or wheel as it is called here, worked by hand. This is a very primitive procedure that consists in a small revolving table; the wheel is not used to rapidly raise and lower the clay, as in the case of the pedal wheel, but as an aid to the potters in such a way as to approach the system by which the clay is "moved by arm." Although the foot lathe is very old, it has still not succeeded in being introduced here. It is interesting that this coincides with the fact that in both places the clay is worked by women. Perhaps the maintaining of the hand lathe, which is at present an authentic rarity in pottery making, is due to the conservative character of women who, in such a society, are the ones who carry on these activities.

We went first to **Moveros**; we had just entered the town when we found María Mosquera as she later proved to be, on her knees ("doing penitence" as they call it) in the midst of shaping the clay on her potter's wheel. We gradually got to know the other women near their respective lathes: Aurora and Esperanza Martín Fernández (sisters), Isabel Nieto Cordero, Paulina Pérez, Dorotea Nieto; and three whom we were unable to visit: Martina, another Dorotea, and Carmen. Being women, they do not always know the surnames of all of them, because they refer to each other by the first name. It surprises us that (and there must be an explanation) apparently in contradiction to the feminine nature, they are less explicit, in spite of their reputation, than the men potters; and when they talk, it is merely in answer to our questions. Maybe they are more intimidated than the men. In any event, at the end they are always animated. They all seem to be congenial and insist that we visit all of them and not forget to note down any name. (None of this frequent among the men.) All of the kilns are communal —which is

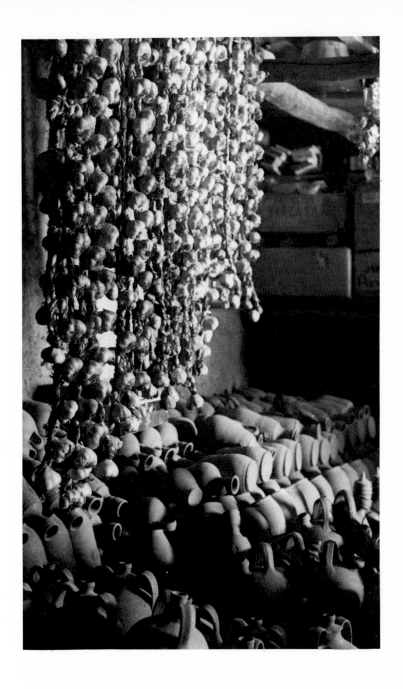

70. Bottle for the table, heater, and "trick jar",
Tamames de la Sierra
71. Various vessels in the warehouse, *Tamames de la Sierra*

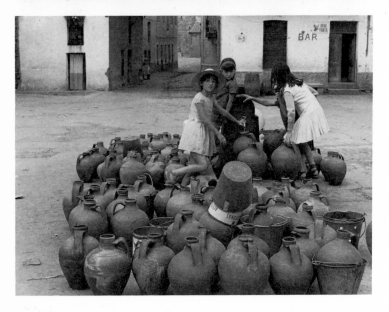

72. Vessels in kiln and potter, *Cespedosa de Tormes*
Typical cántaro, *Cespedosa de Tormes*
Cántaros on the fountain of the Plaza Mayor of
Cespedosa de Tormes
Cantarilla, *Tamames de la Sierra*
73. Filagree barrel, *Alba de Tormes*

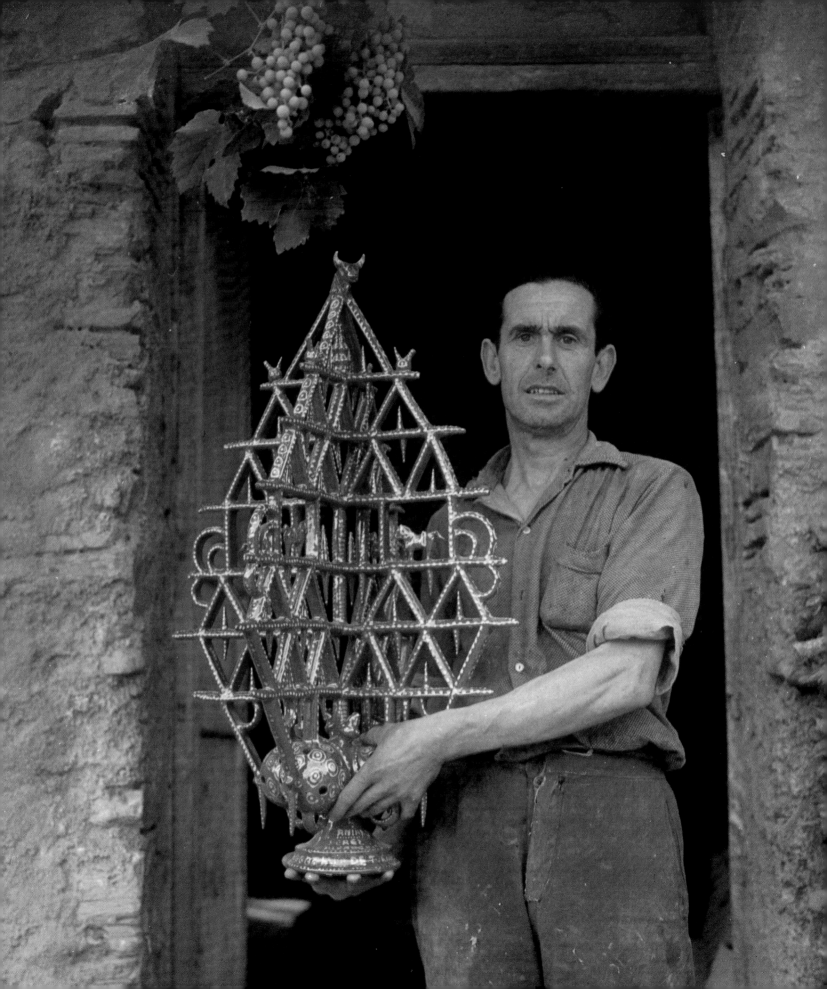

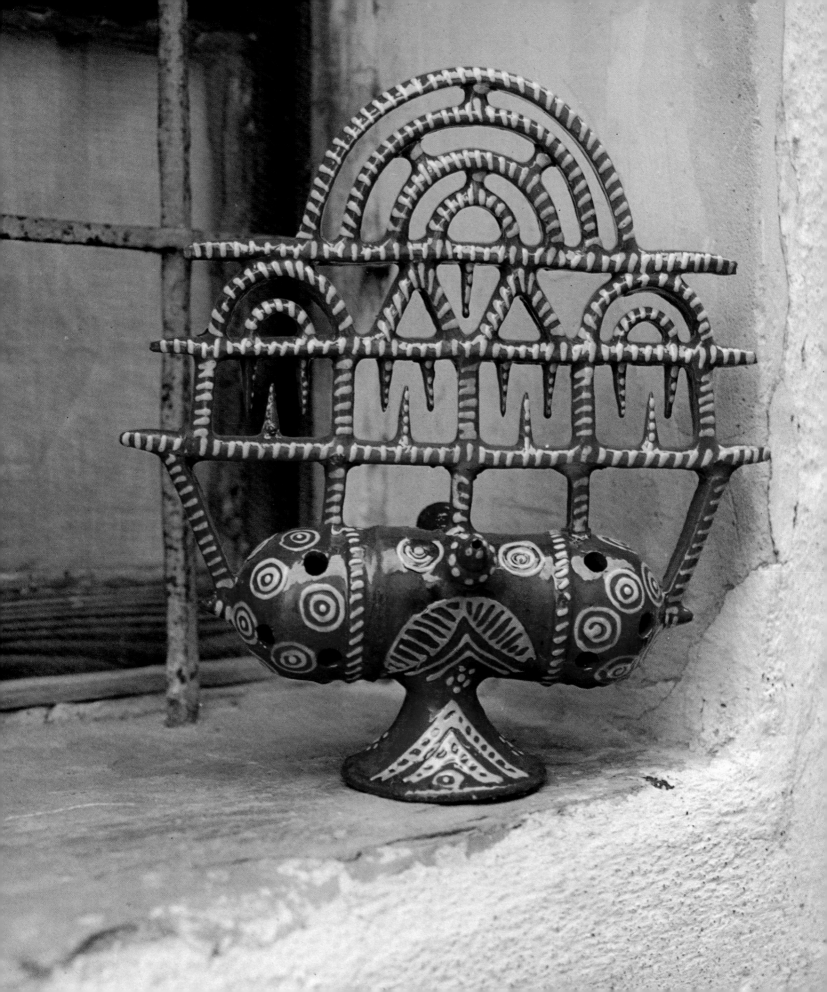

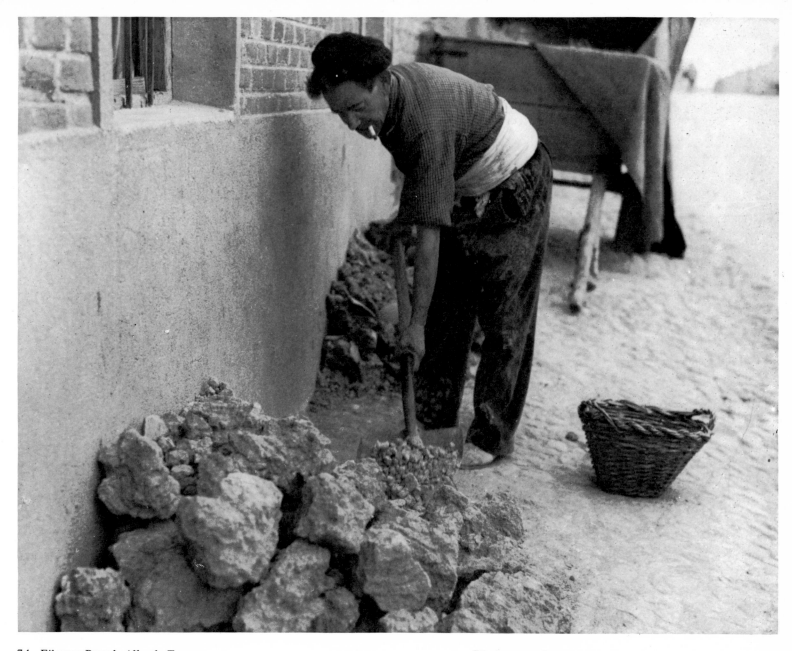

74. Filagree Barrel, *Alba de Tormes*

75. Lumps of clay at the door of the pottery, *Cantalapiedra*

also a symptom of tradition and feminine unity and, as another contradiction, some of them use plastic containers. Here, naturally, the tradition is passed from mother to daughter. They have been taught by their mothers, and in turn, have planted the problem of succession with their daughters. The pottery work is irregular because in summer they must thresh grain and perform other tasks, and in winter there is no one who works with clay. Aside from making the objects, they must also carry them themselves with horses and wagons, helped by their husbands, to their destinations. This is the old pottery making in all of its purity, without any contamination of modern times. It is not just, that they must then have difficulties in selling the objects. It is true what one of the women tells us: "We are poor because there are so many of us; it is a job for the lower clases, a worthless trade". Her words ring with savory forgotten accents.

We were familiar with the vessels from Moveros, and from Pereruela, too, which Augusto Panyella bought for the Ethnological Museum of Barcelona (the women still remember his visit), and we had the opportunity of buying a few articles from both towns at the Country Fair in Madrid. There is not much variety in the objetcs in either of the two places, but they are very beautiful in a restrained way and among the oldest and most elementary ones of the peninsula and the clay has great plasticity. On an average, the

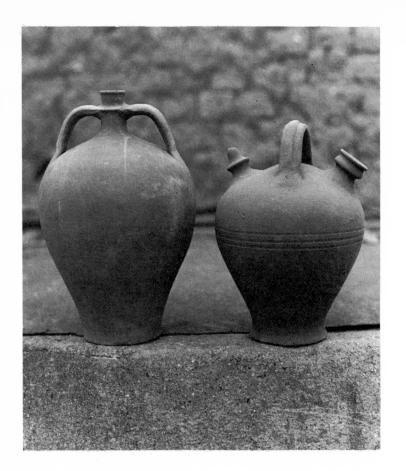

number of "cántaros" made in a day is fifteen. Its price, which unfortunately is to be suspected, is very low ("there is little profit from this; it causes a lot of work and has little utility"), as Isabel Nieto Cordero explains so well.

All of the objects which are produced are water containers. There are two types of "cántaros"; water jugs and "botijos", the "criba" and the "bath". All of these things and more are offered by Moveros, a town of about seventy families, belonging to the municipality of Ceadea.

Pereruela, also in the province of Zamora, about nine miles from the capital, is another similar case, of equal interest. Pereruela is capable of giving us, for example, something which at the present proves to be very suprising: a good size oven for baking bread —three feet in diameter and two and a half feet high— which must naturally be made by hand. The professor Luis L. Cortés Vázquez has published a study of the ceramics in Pereruela in which he examines the town with the same throughness, love for this noble art, and exactitude that we were familiar with in his book on the Salamanca pottery production. According to what he says, his book is the fruit of a trip made in June 1954. He begins his work with a few general notes in which he cites historical references to the ceramics in this town. We cannot fail to include here the reference made to the pamphlet "Historia de Zamora en cantares" (1898) by Joaquín de Barco, in

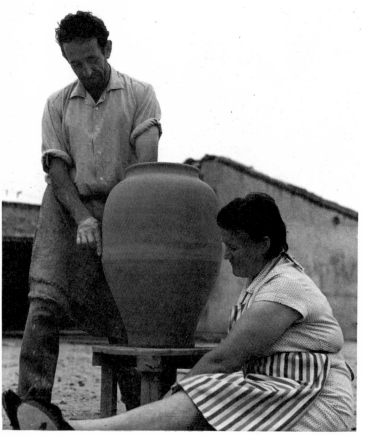

76. Country water barrel and botijo, *Cantalapiedra*
Polishing a tinaja, *Cantalapiedra*

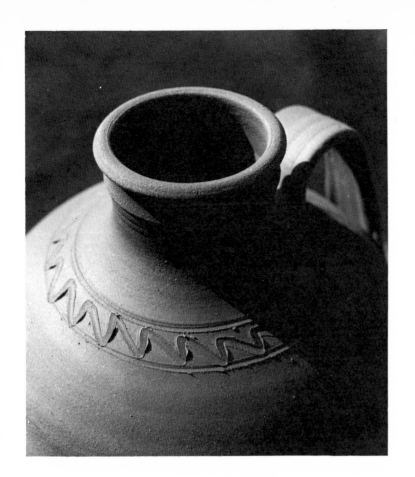

77. Decoration of the cántaros, *Peralejos de Abajo*
 Unloading clay, *Peralejos de Abajo*
78. Polishing the water barrel on the hand lathe, *Moveros*
79. Working the hand lathe, *Moveros*

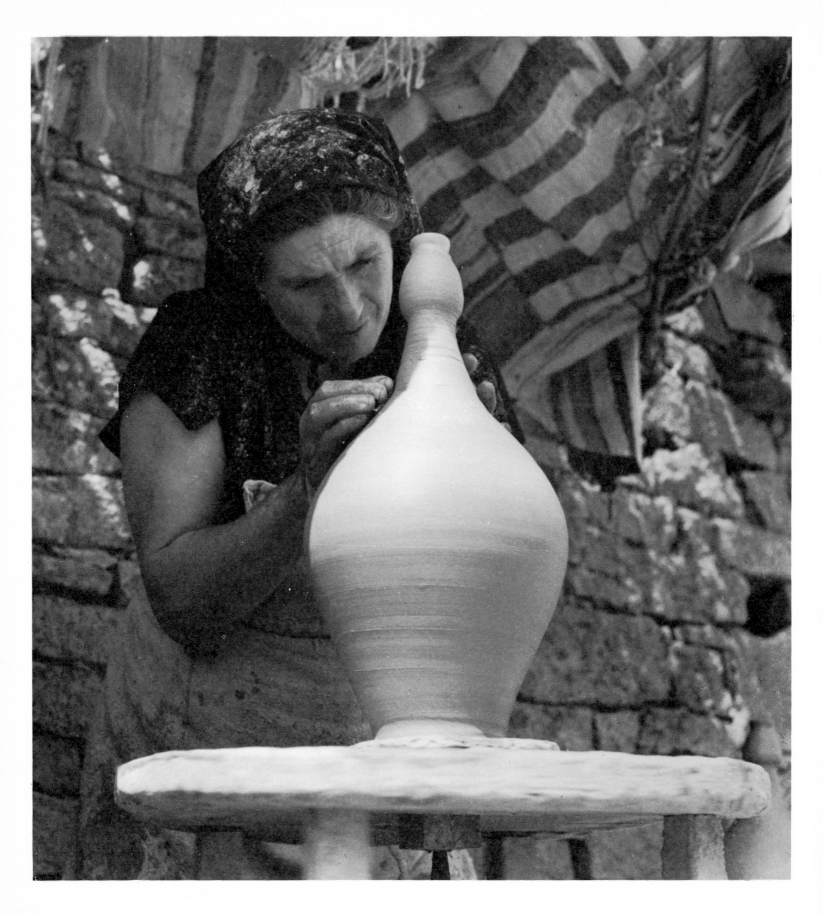

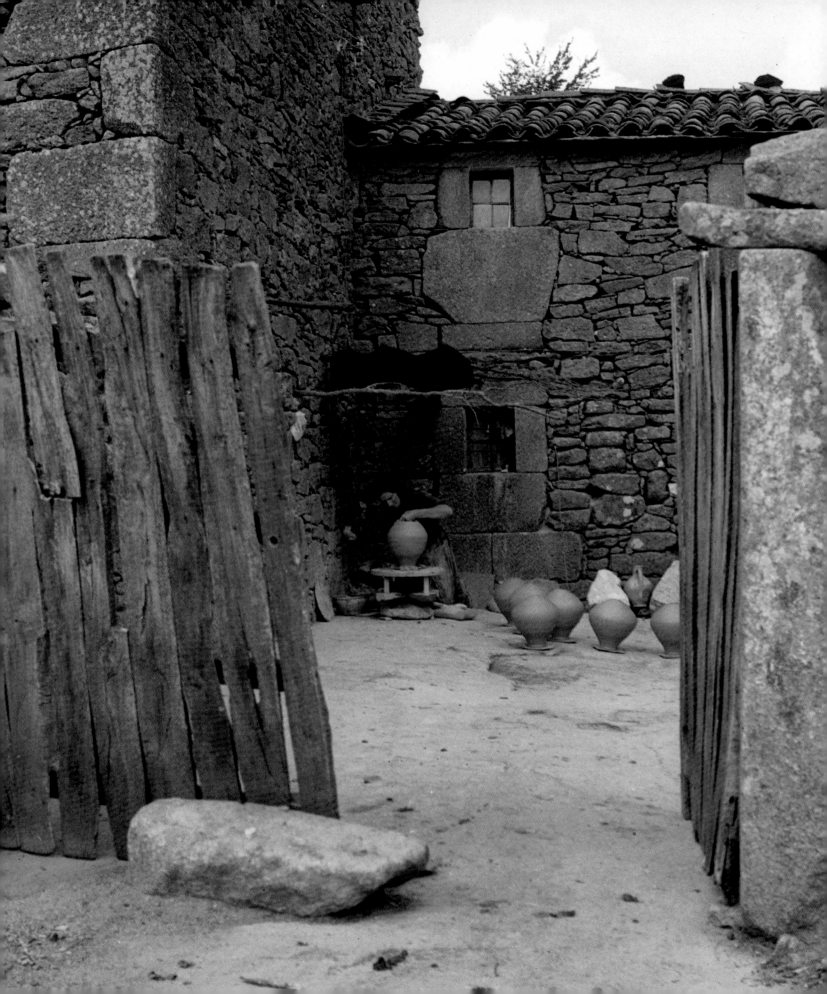

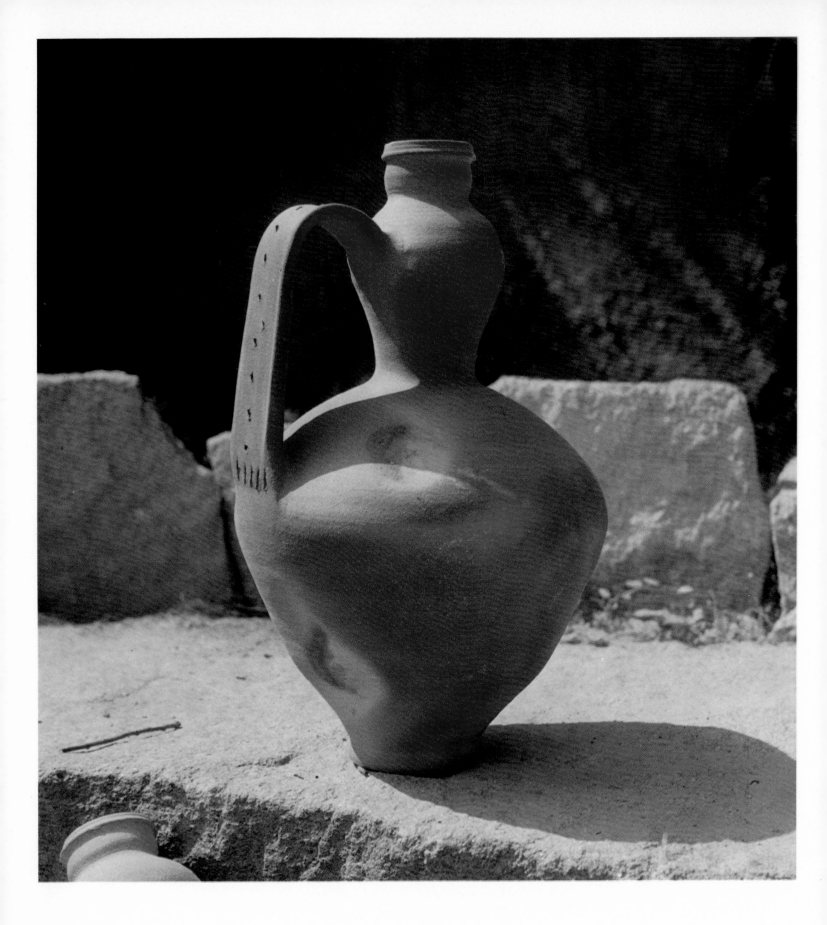

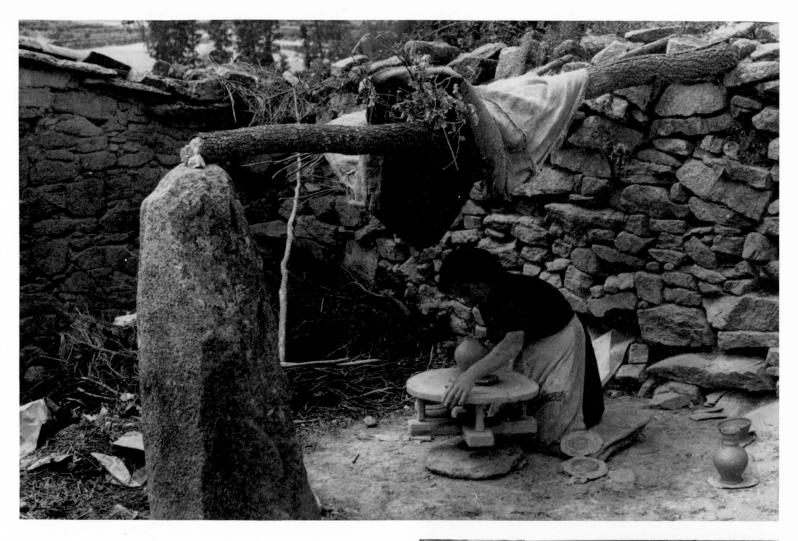

80. Cántaro, *Moveros*
81. Working the hand lathe, *Moveros*
 Hand lathe, *Moveros*

which, refering to the Salamanca industries, he says: "The state from Losacio/ from Sanabria the wood/ the stone from Sobradillo/ and the clay from Pereruela". There is no lack of allusion to this type of pottery making of which it is said "that the most primitive procedures are used". (Felipe Olmedo y Rodríguez: "La provincia de Zamora. Guía histórica y estadística de la misma"). And this was already written in 1905.

It is not difficult to imagine the impression made on the curious visitor by these primitive works, realized in the "height of twentieth century"; there is a coarse, barbaric, and untouched beauty in this baked clay.

The basis of the pottery production in Pereruela is the crockery that is to be used over a fire, especially the casserole, of which the elongated ones are called "roasting casseroles". The "barreñón" (normally a washtub) is here a type of pot for meals intended to feed many people. Other important objects made here: the ovens, already mentioned, the pots, crucibles (at one time made for the National Mint,

but today bought by the silvesmiths in Salamanca, Ciudad Rodrigo, and Seville), chestnut roasters, and jugs. They make small plates for bars, and 'jarritos" or "maceteros", which are vases decorated with flowers made with the same clay. The women ("cacharreras" or crockery makers) are the ones who form the articles on the wheel, or make them directly by hand, as in the case of the oven, helped by their daughters. The husbands take care of extracting the clay, as well as firing the objects, and the sales. Many of these "cacharreras", as they told us, sell the unbaked objects. At the moment of our visit (August 1968) there were many who sold the articles in that manner: Avelina Olea, Rosalía Domínguez, Felisa González and Divina González (sisters), and Ascensión Rodríguez. On the other hand, the following carried out the full process: Angeles Redondo Martín, Alejandría Pastor, Olegaria Merino, Iluminada Pérez and Jovita Tamames.

As can be seen in the study by Cortés Vázquez, the reason that some of the women fire the articles is due to the

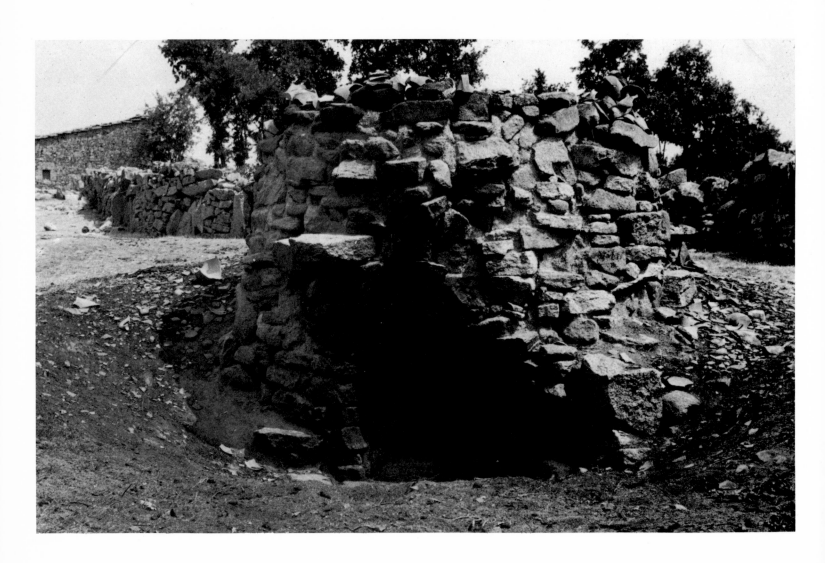

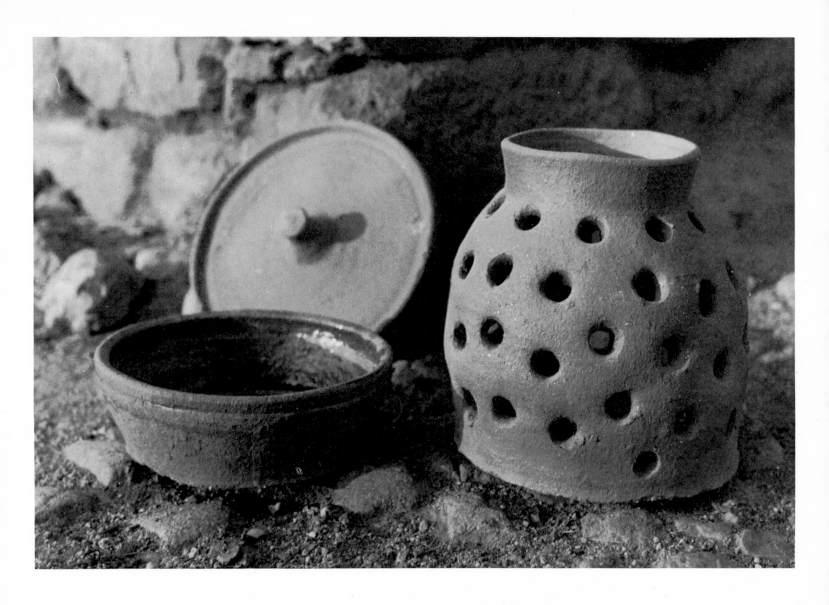

82. Communal kiln, *Moveros*
83. Casserole with lid, and chesnut roaster, *Pereruela*

fact that they are unmarried or widows and do not waver from what they consider to be their sole function, that of working the unbaked clay. The husbands, in charge of selling the objects, normally turn them over to resellers. The items remain in Zamora. These women must alternate the pottery work with that in the fields because of the necessity of caring for the land and the harshness of the climate in winter; but also, as they explain, because the craft is a poor one; "not enough for a car" one on the women in Moveros humorously told us on seeing ours. They are content for the moment, with "doing the fair", as they say when they have been able to sell everything taken to a certain place.

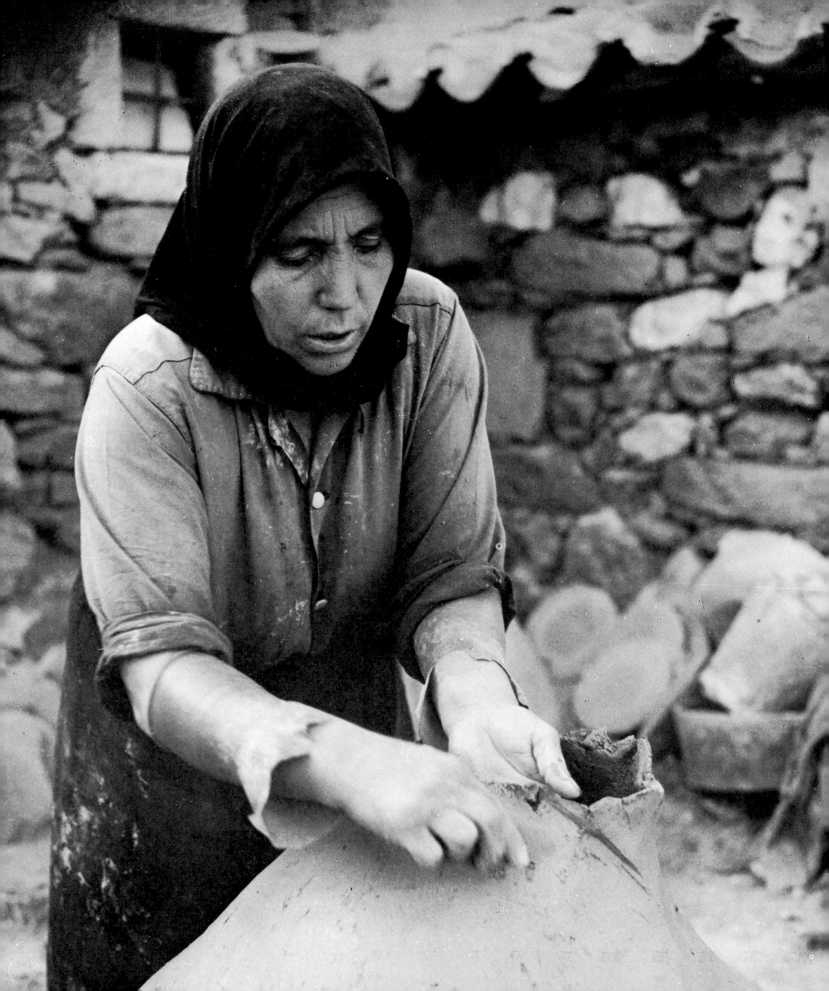

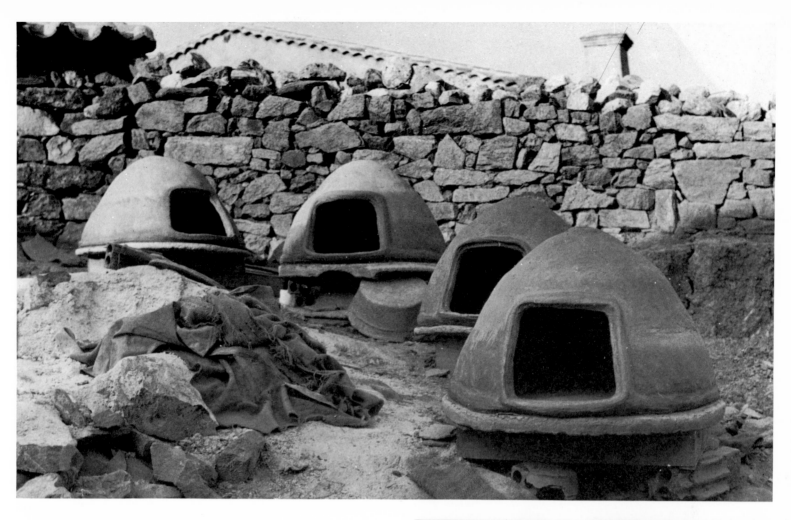

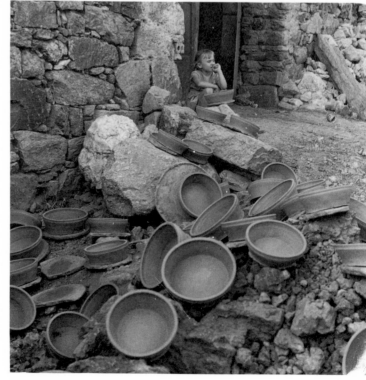

84. Closing a kiln, *Pereruela*
85. Ovens for baking bread molded by hand, *Pereruela*
 Unfired casserole drying in the sun, *Pereruela*

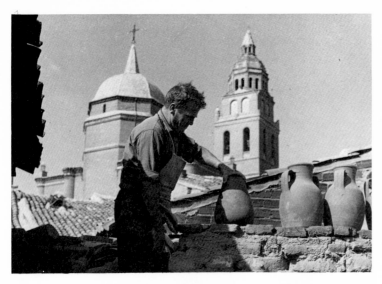

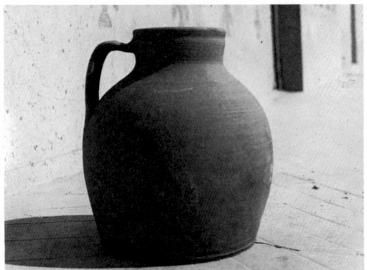

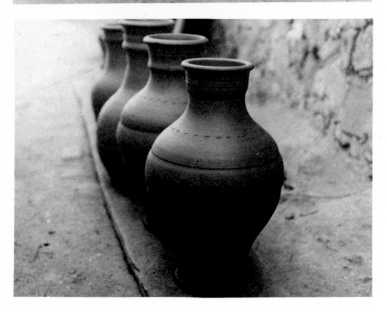

86. Objects drying in the sun, *Alaejos*
Cántara, *Alaejos*
Cántaras still unfired and without handles, *Alaejos*
Wine pitcher, *Arrabal del Portillo*
87. A patio belonging to one of the potteries. The stakes
nailed in the walls are used to support the boards on
which are placed objects to dry, *Arrabal del Portillo*

The hand wheel is used in another pottery center in the province of Zamora, **Carbellino,** where it is also worked by women in the production of "cántaros", washtubs, and jugs. Beside the profusion of pottery in Salamanca and the rare quality of that of Zamora, Valladolid offers very little. We can reduce its accomplishments to three pottery centers: Alaejos, Arrabal del Portillo and Peñafiel.

Alaejos produces: flowerpots, "botijos", "cántaros", small jars, pots, baths; a few pipes which some use, painted, as umbrella stands, which have just recently begun to be made; and other objects made on order, such as the one which the mother of Modesto Frutos Baraja, the extremely cordial potter, suspects is to be a toilet: "You sit there", she explains, "and that's it: there is the business". Aside from Modesto, there is another potter (formerly there were five complete families); the two also devote themselves to farming: "Now that it's good weather, we work with this", he tells us, "later we work in the forests and we spend the whole winter there. We also devote ourselves to gathering vetch; rooting up potatoes: whatever work appears..." The conditions under which they must work the clay are not, therefore, the most favorable, and the sales are not any better: "You move from one place to another in order to sell; a few days in one town, a few more in another." They still carry the articles in wagons or by donkey...

In **Arrabal del Portillo** the pottery production is quite a different matter. At present there are twenty-three poteries, which is still an important number, of the forty which could be counted only ten years ago. Four or five of these devote themselves completely to "commercial craftsmanship" with which we are familiar from having often seen samples of it in so many places. More than any other type of object, one finds here the green vessels, for gardening or decorative purposes, inspired by the town of Quart. It is almost incredible that so many objects in such bad taste can become so widespread; as always we must defend the potter who makes what he can sell. The rest of the artisans devote themselves to coarse ware: "botijos", "cántaros", wine pitchers, washtubs, pots, kettles, roasting casseroles. The small brown jug, partially painted yellow, bears the inscription "Remembrance from Segovia".

Peñafiel has one pottery, with a very small production; the potter can only devote to ceramics the time left free from his main job. The production consists primarily of glazed articles, such as plates, washtubs, and jars, as well as flowerpots. In the town of **Astudillo,** province of Palencia, one potter continues to work: Eulogio Moreno Castrillo, who makes ceramics of the old tradition. These consist of vessels for water, as well as for cooking: "cántaros" (quite

88. Kiln, *Arrabal del Portillo*
89. Valentín Peñín de Blas, potter, *Jiménez de Jamuz*
90. Adding the "juaguete" to the crockery vessels, *Jiménez de Jamuz*
91. Cántaro, *Jiménez de Jamuz*

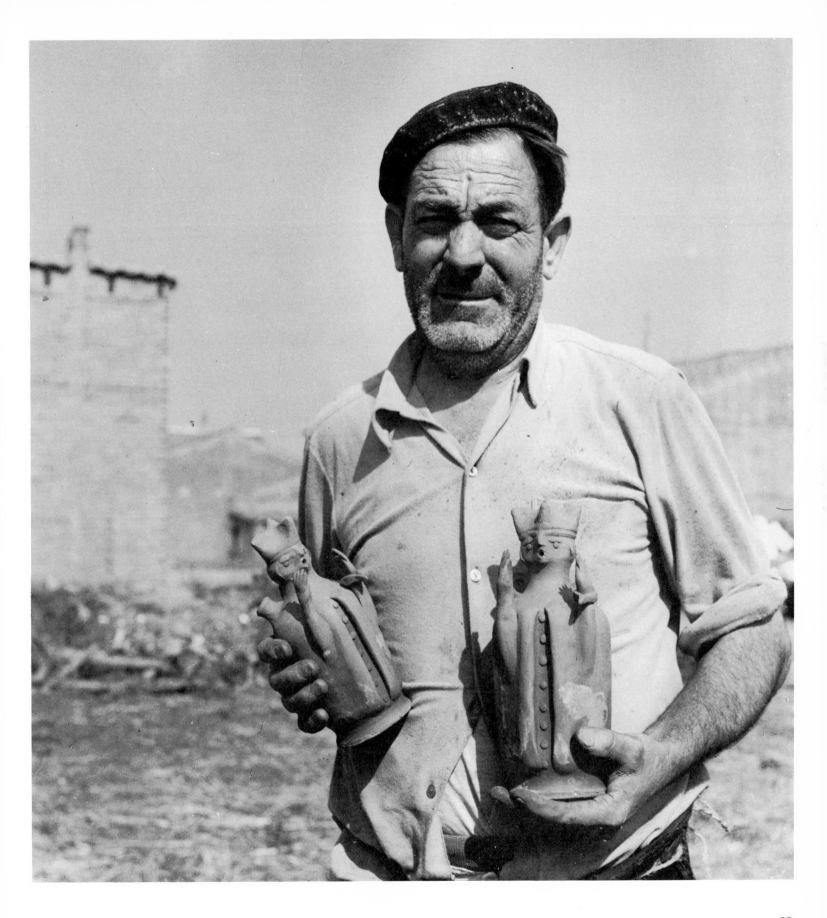

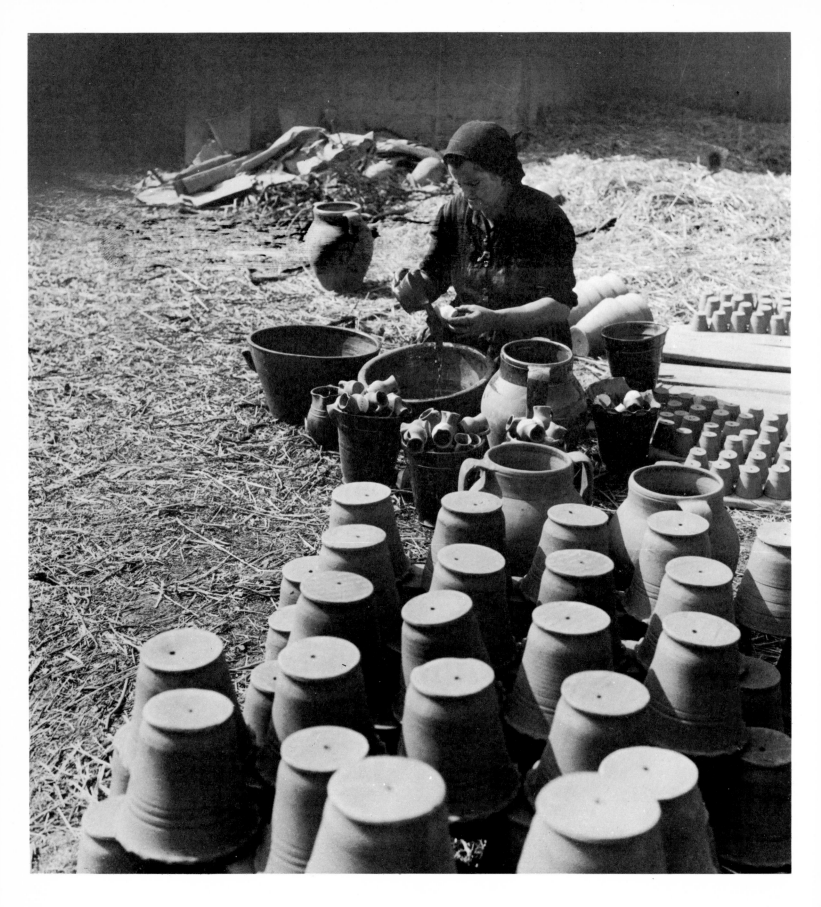

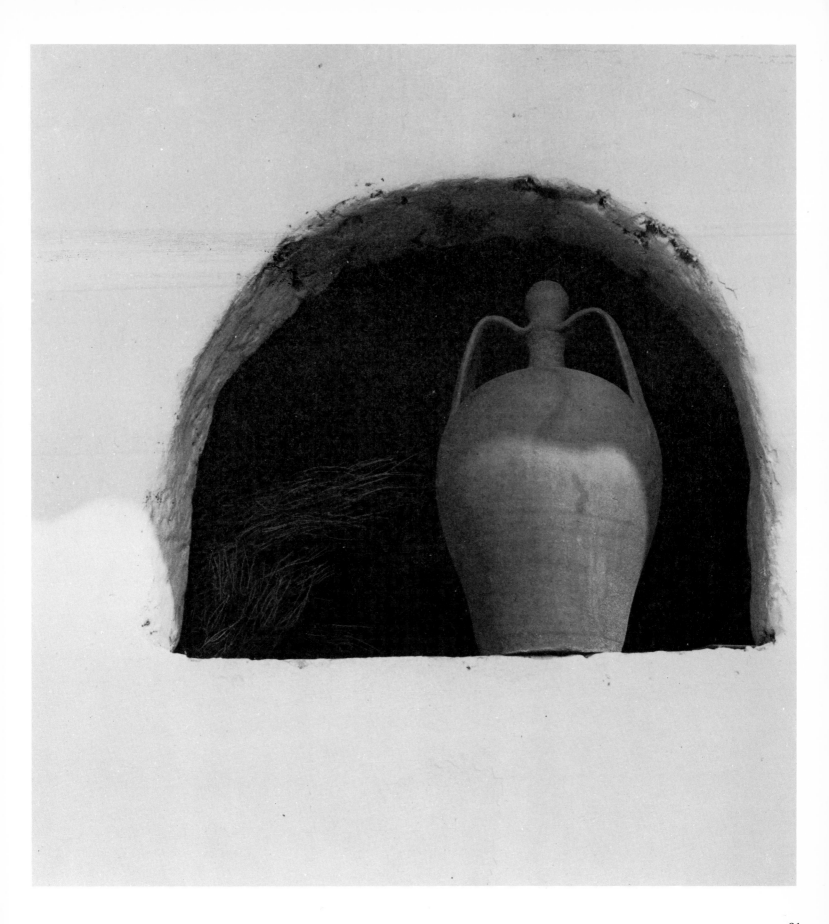

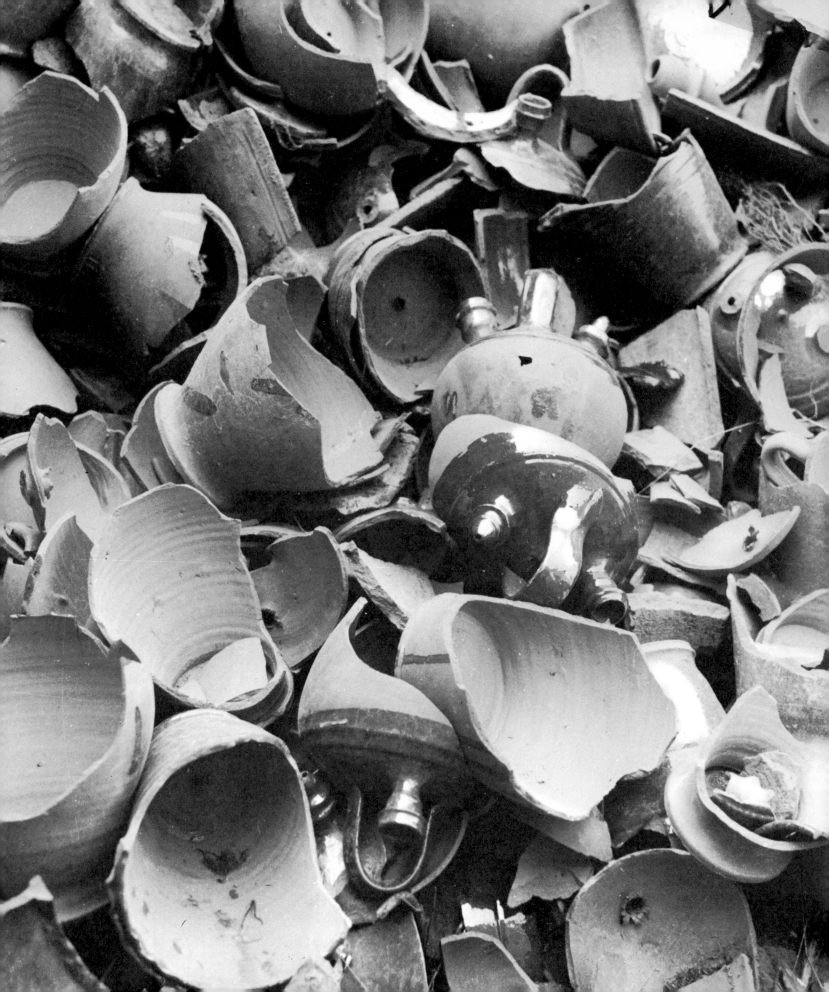

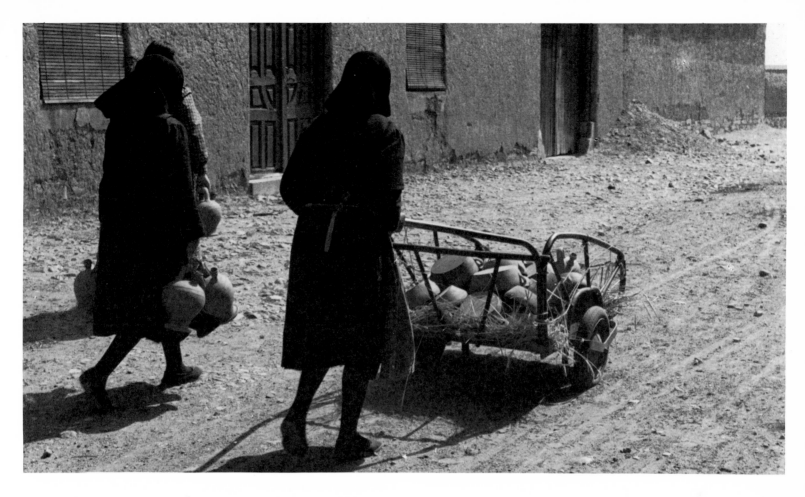

big-bellied), "botijos", jars, casseroles, and also soup tureens.

We move now to **Jiménez de Jamuz** in the province of León. The vessels in this town, must have been well known in this area. The comment made by one of the two potters we visited in the town, when Catalá Roca broke, with previous permission, a "bad" botijo is perhaps expressive: "Jiménez has been heard", as Valentín Peñín de Blas expressed it. There must be many "botijos" and Jiménez must often be heard in the squares by the fountains. Even now, when there is a dearth of ceramics, there are still twenty potters here, though much better were the hundred odd of a few years ago. Still in production are the "botijos", and "cántaros", cups, pots, "chamorrillos", "barrels" (which here are like casseroles), flowerpots, plates, washtubs, and lids. They

are made, as Vicente Sanjuán, the other potter we visited, explains: "The same as always. We live as if in the twelfth century. We haven't changed at all." One or another of them "invents" an occasional object (fortunately, nothing that is similar to the false craftsmanship for tourists): Valentín made some charming figures of priests. He told us that in the town a few of the potters specialize in certain objects, although "some make everything". There is much work done with toys (of which there are nineteen different types) and coffee services. Formerly for Mardi Gras, ceramic trumpets, made by the town's potters were used; "but they caused such an uproar, that the Guardia Civil finally had to prohibit them". About two years ago, some time after our trip to the area, we received the news of the death of Valentín Peñín de Blas.

extremadura

Extremadura offers itself to us today as a hidden treasure. Off the normally frequented tourist routes, it, while preserving the vestiges of history incomparably better than other regions, is safe for now from the barbaric swells of the tourist crowds. She lives in a certain self-absorption, though it is at the expense of maintaining certain feudal structures which prevent many of the people of the region from reaching a humane level of living. It is unfortunate that what is preserved today is due to social and economic anachronisms, although they be capable of providing us with such rare gems as these. In spite of that, we hope that when one day the regional anatomy changes, these will continue to exist, though with the necessary precautions.

To begin with, let us mention that in **Salvatierra de los Barros** there are at present sixty potteries with several workers in each. This is by far the largest number in Spain. One could say that the entire town earns its living from pottery: some extract the clay, others carry firewood, others shape the pottery with a lathe and bake it, and still others roam the countryside with their donkeys in order to sell the pottery. In general, the sales are made to wholesalers who come to pick up the goods in trucks. One can find the earthenware from Salvatierra in almost all of Spain, including the Canary Islands. In many places, the sales are made by means of the donkeys which go about the streets and squares of the towns, as can be seen in Madrid and Barcelona.

The clay in this area, such as that from Salvatierra which is extracted from the surrounding land, is a reddish color and of very good quality. We inspect several potteries accompanied by Alejandro González Nogales, the first potter to whom we directed ourselves. He explains to us the manner in which the pottery is made and the distinguishing characteristics of the town. All the workers use a lathe, although a few are run by an electric motor; as an interesting detail, we might add that these motors are made by one of the townspeople.

The thing most attracts our attention is the manner in which the pottery is decorated with curve-lined motives There is a woman doing this job; she is using a smooth stone from Guadiana which she continually dampens with her tongue. When the desing is made, she wipes it with a dry finger to make it shine. Apparently, wetting the stone in a plate of water, as we suggested, does not work. The water does not have in this case, the virtues of saliva. (How many pints will she use by the end of the year?) Catalá is taking pictures of her, a rather difficult procedure, according to him, because of the speed in which the stone is put to the tongue. The woman is flattered and surprised that pictures are being taken of her (we have found places, as is possible in this case, too, where the people had never had their pictures taken).

The Salvatierra work is very well known; one would not

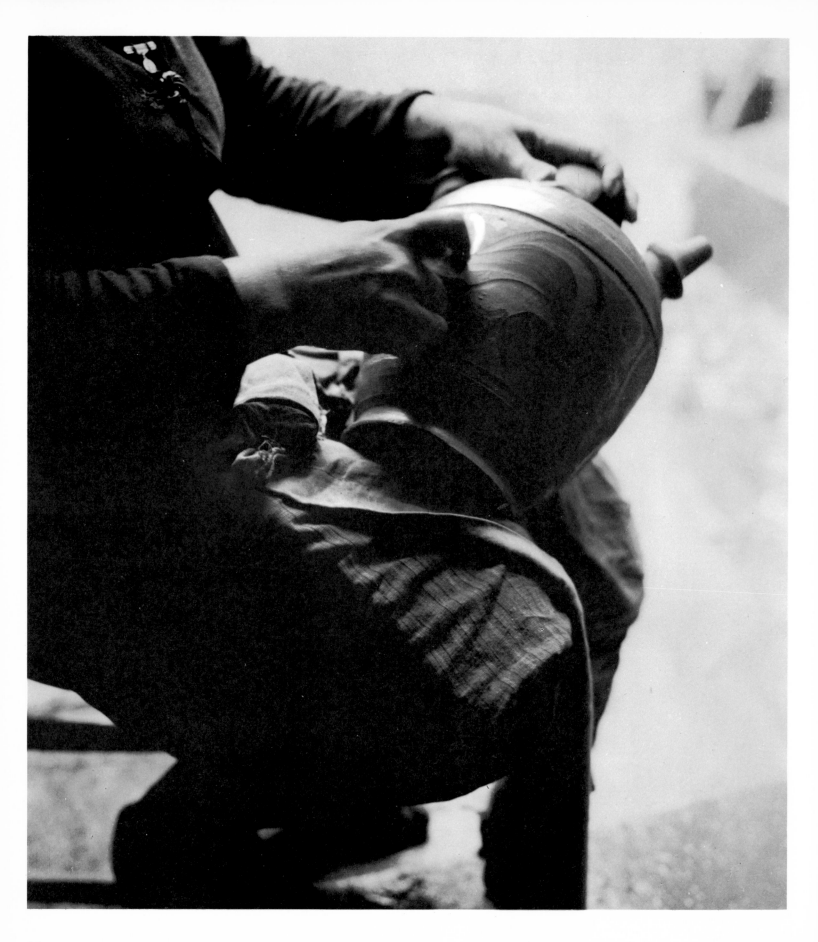

suspect, on seeing the pottery in the saddlebags of the donkeys or in the hands of the man showing them to passers-by, what lies behind them. The object which is most accesible to the public is the "botijo". Its various names deserve to be mentioned: "Pistolo" (the smallest), "mico", "colegial", "chingue chico", "chingue grande", and (the biggest) "embeleco". Very few of the following are made: the bottle (which may be "de cincho", "de maza" or other types), the jar (also in various types), the "jarrón moruno", the "tinaja" (the largest of which are begun on the lathe and finished by hand), and the flowerpot. The ones which are not decorated are: the "cántaro", (which may be "gordo", "chico", or "cantarilla"), the toaster (for chestnuts), the country water jug (flat on one side in order to hang in the wagóns or to be carried in the saddlebags), and the "mari-cona", a type of big-bellied bottle which is narrow at the top. There are very few braziers made, under which are placed live coals and on top of which are put kettles to be kept hot. In addition to these, there is also work dedicated to making toys.

These are the types of objects, all unglazed, that are made in great quantity in the town and are characteristic of it. Some of the people, such as Juan Guisado Bermejo, devote themselves to glazed things, objects like the "botijo", large plates, pots, pastry dishes, and chocolate pots, which are decorated with white clay, that, because of the red in the rest of the clay, turns yellow.

In other places in the province of Badajoz, the clay is

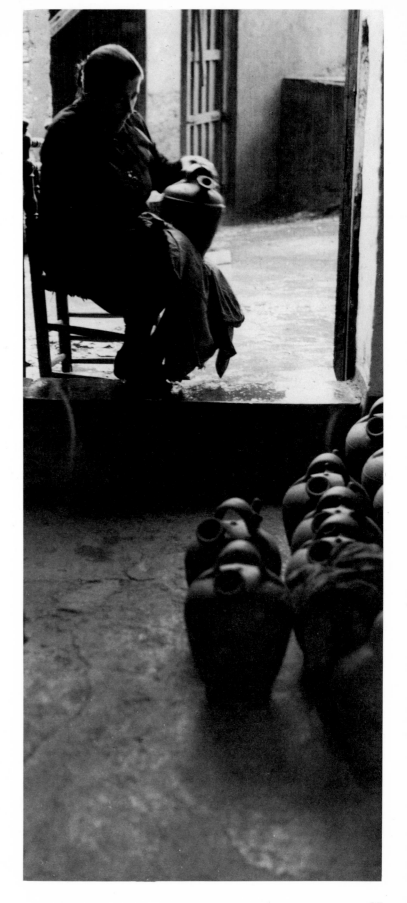

96-97. Decorating the objects. For this a smooth stone from Guadiana, which must constantly be dampened with the tongue, is used, *Salvatierra de los Barros*

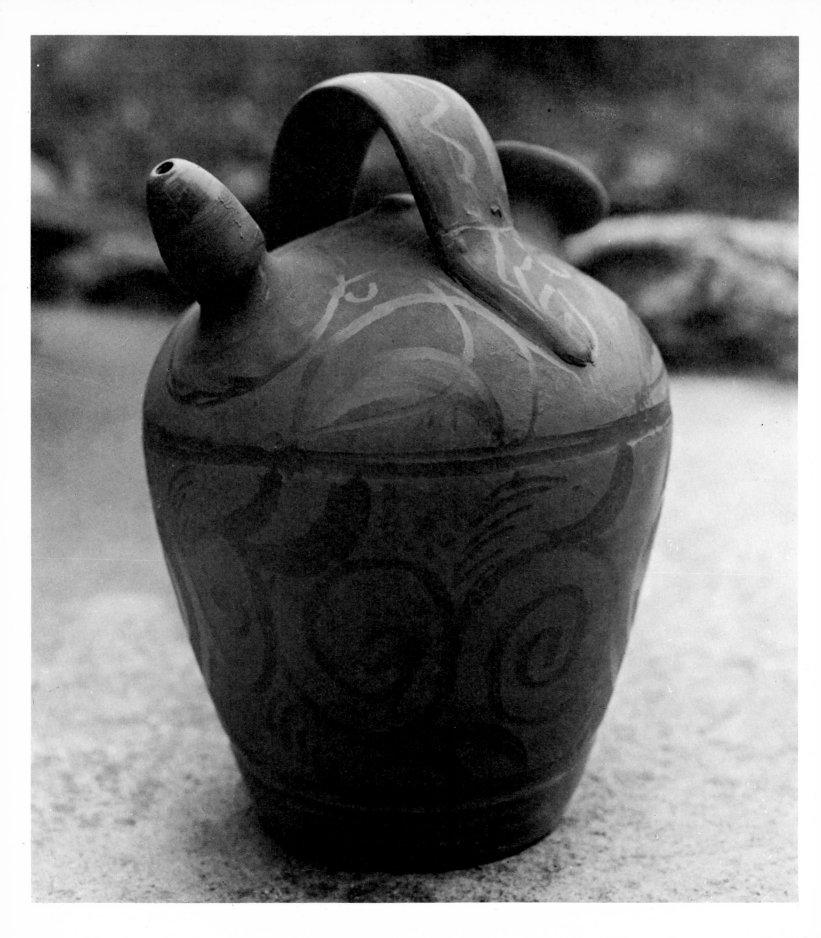

worked in much the same way as in Salvatierra. Examples of these are the "cántaros", "botijos", "botijos" in the form of a rooster, and the "tostador" (or toaster, pronounced "tostaor" by the townspeople) from **Fregenal de la Sierra** (two centers) and all the production from the one workshop in **Jerez de los Caballeros.** In **Segura de León** they used to make, until three years or so ago, "cántaros", flowerpots, pans, and chocolate pots that were glazed with lead. There are also currently two potteries in **Mérida** which maintain the local tradition of "botijos", "cántaros", and casseroles.

Olivenza, which was a Portuguese city until 1801, has had until recently only one pottery, in which worked Antonio Miranda, himself of Portuguese origin. "Here," he told us, "are made the same things as in Salvatierra but with different workmanship." This is only partially true, for a number of the objects and colors were very distinct. The unglazed objetcs consisted of: the "botijo", "cántaro", hen feed trough, rabbit breeder, "barraña" (for gazpacho, the cold Andalusian tomato soup), and the flowerpot. Among the glazed objects were: croks [called "asadas" (roasted) because of the "asas" (handles)], chamber pots (which in spite of their large size were called by the diminutive form or by the Portuguese name "penicos"), washtubs, "conos" (very large earthen jugs), "tinajas", jars, plates, and casseroles.

Around Cáceres there are still many pottery centers. **Torrejoncillo** is known for its "tinajas" while **Arroyo de la Luz** offers a considerable production. Benigno Pajares Talavera, 63 years old, the one who devotes himself most

98. Botijo, *Salvatierra de los Barros*
99. Firewood in a street, *Salvatierra de los Barros*
100. Jar, "maricona" and jarrón moruno, *Salvatierra de los Barros*
101. Botijo and plate, *Salvatierra de los Barros*

wholeheartedly to the craft, accompanies us. Of the
twenty-six potteries that he has been familiar with here,
there are only six today. In one of the workshops the paste
is being macerated with a stick, the same one with which
they grind; some, they tell us, use a grinder moved by
animal.

We devote ourselves to seeing the various types of
crockery; a woman pleasantly explains them to us while her
husband continues to make the handles. The "cántaro" is
made in only one size with a capacity of three or three and
a half gallons; it may have one or two handles. The "can-
tarilla", or little cántaro, generally has one handle and is
available in four sizes varying from a half to three gallons:

102. Pot, chocolate pot, and pastry dish,
Salvatierra de los Barros
103. Cock botijos (unfired), *Fregenal de la Sierra*

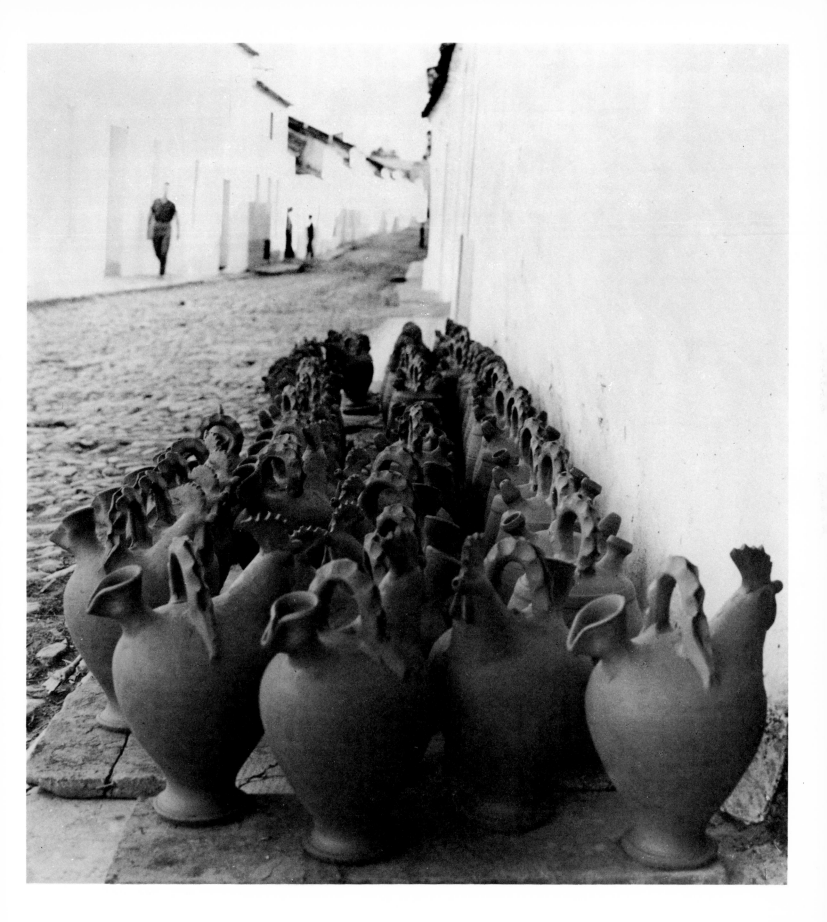

"cuatreña" (the smallest), "jarriera", "de espanto", and "cantarilla grande" (or big "cantarilla", the largest, after which comes the "cántaro"). There is also the "botijo" which is called in this region the "pimporro". The pots, from large to small, are known respectively as: "Puchera" (five and three quarters gal.), "puchero crecío", "de espanto", "puchero jarriero", "puchero mestizo", and "puchero cuarteño". "Redonda", or "round", is the name given to the large jug, because of its shape; it has no handle, but it does have a "rollo" [or "galanura" (adornement), as we were told]. There are three types of water jugs which are used to carry the water to the countryside; the smallest are flat on one side so that they may be hung ("Some have a bigger belly than others."). Finally we come to the portable brazier with holes, to be used with the earthen pots; the toys, and the crèche figures. These are not normally glazed, though a few of the flowerpots and figurines are glossed. Nor is it frequent that they be decorated, although there are some who, with a reed or sharp point add a border, flowers ("some very pretty bouquets of flowers", they explain to us), or letters. These are the things that are produced in this vicinity and people come from the surrounding area to collect them. They come from Malpartida, Eliseda, Plasencia... "It is a very old craft", Benigno tells us, "and an improverished one, but it is not properly appreciated. It is a craft that is very wretched; the young people are not interested in it for that reason: because it is very wretched."

Recent research by Rüdiger Vossen, in collaboration with Natacha Seseña, has allowed us to become familiar with other pottery centers in the region of Extremadura. Natacha Seseña describes these in an article published recently in *Triunfo* magazine (November 10th 1973). In general they give testimony to the decrease in ceramic output, no matter how much Salvatierra continues as the primary production center in Spain. One of the potters from Salvatierra is now working in **Guijo de Granadilla**. In **Plasencia** there remain only two potters, of the six that formerly worked here; of these two, one produces very little. A similar decline can be observed in the case of **Ceclavín**; only two potters remain to bear witness of its former ceramic fame. This is also the case of **Trujillo**, where there are now only two potters, of the twenty who worked here recently. **Montehermoso** has six potters; their production is based primarily on "cántaros", "botijos", and toy items. There are various ceramic centers whose production consists exclusively of unglazed vessels: **Ahigal, Torre de Don Miguel** and **Zarza la Mayor**, each with one potter. The decorative pottery made in **Casatejada** is unusual, of a folkbaroque style: the dark, glazed "whimsical" dragons and crocodiles. Quite a different speciality is that of the "tinajas" produced, as we have seen in Torrejoncillo. We must also refer to **Arroyomolinos de Montánchez**, where the ceramics factory belonging to the Jiménez brothers produces primarily cylindrical "cones". The size of these vary from ten to two-hundred "arrobas", though upon occasion they make, on request, ones of up to three-hundred "arrobas". Natacha Seseña describes, in her above-mentioned article, another pottery center that ceased to function in the 1940's: **Burguillos del Cerro**, where large "tinajas" and "cones" were made.

105. Plate, pitcher, and "penico", *Olivenza*
106-107. Types of articles produced:

1. Redonda (round)	8. Flowerpot
2. Water barrel	9. Little cántaro for four
3. Cántaro	10. Pot
4. Portable brazier	11. Wine bottle with long spout
5. Little water barrel	12. Little "fright" cántaro
6. Child's water barrel	13. Handle cántaro
7. Child's little cántaro	*Arroyo de la Luz*

108. Typical form of carrying water, *Arroyo de la Luz*
109. On the way to the fountain, *Arroyo de la Luz*

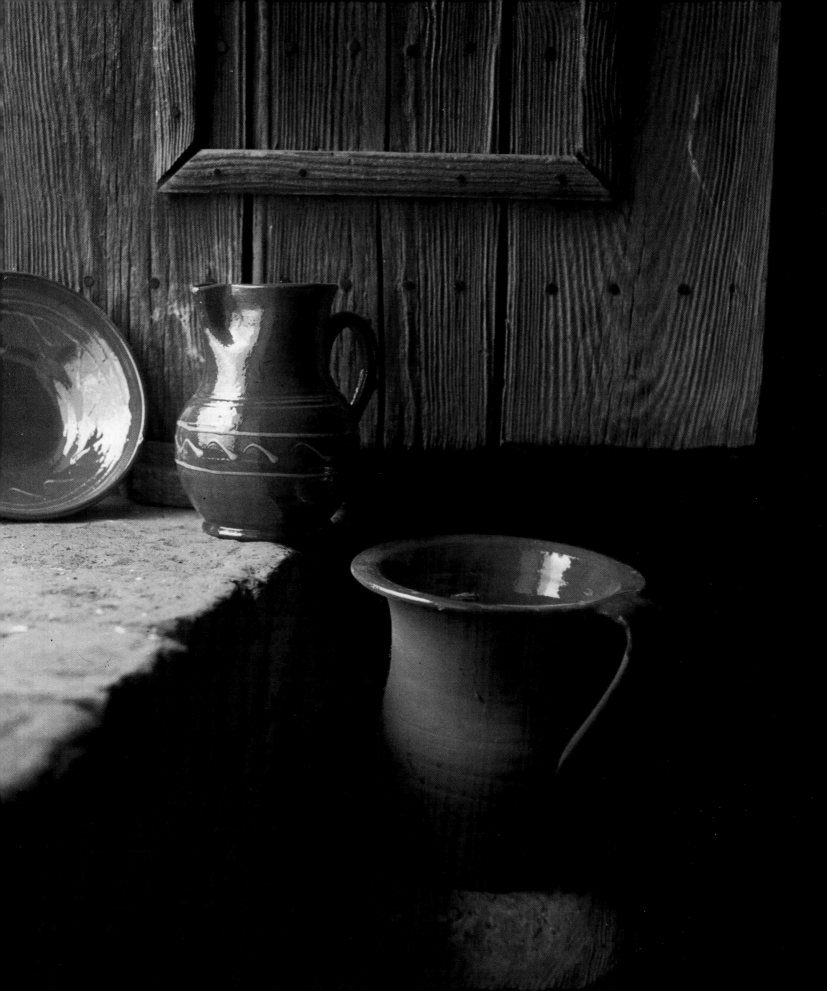

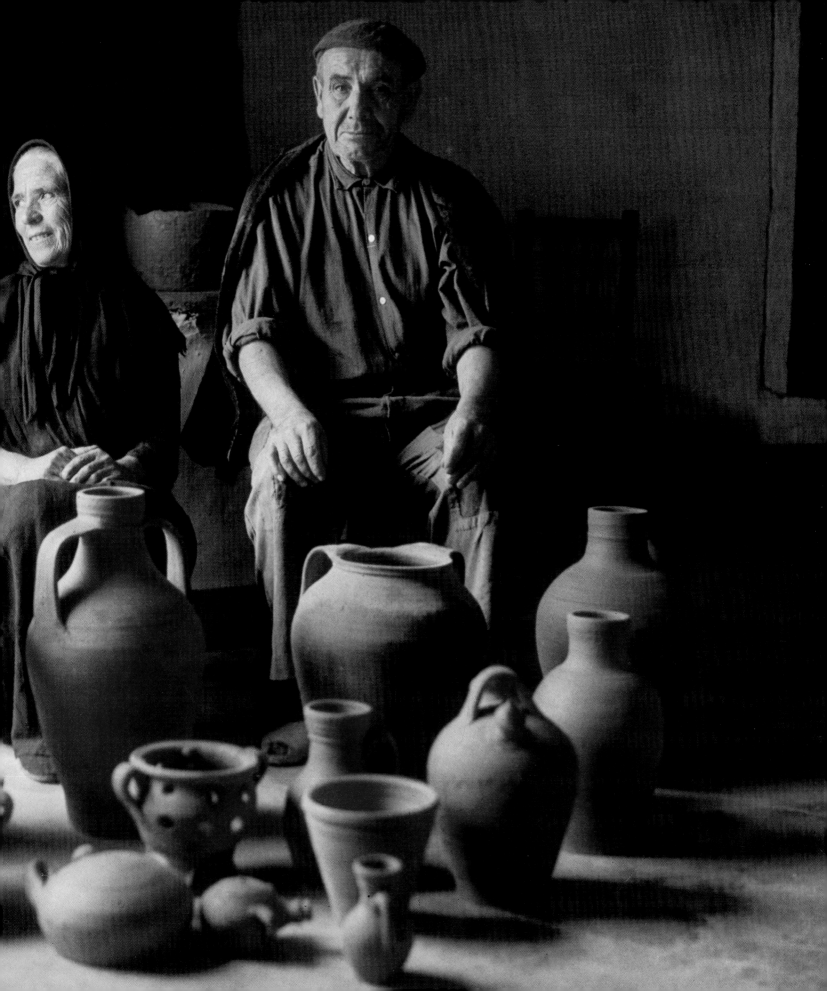

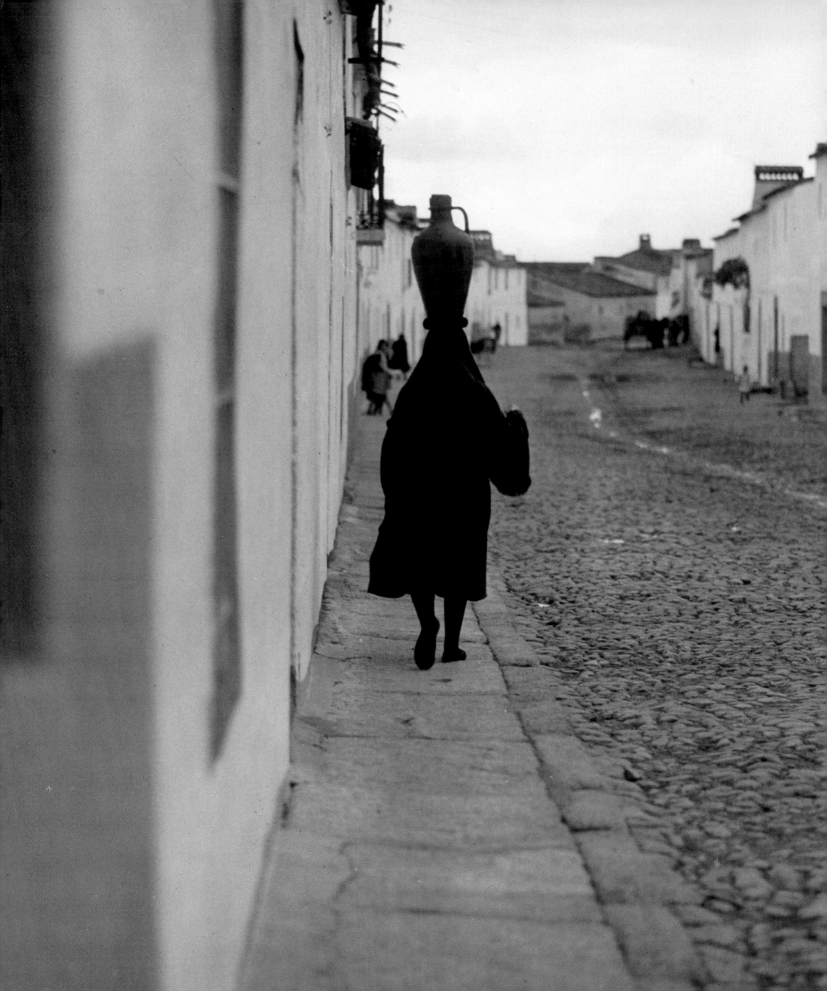

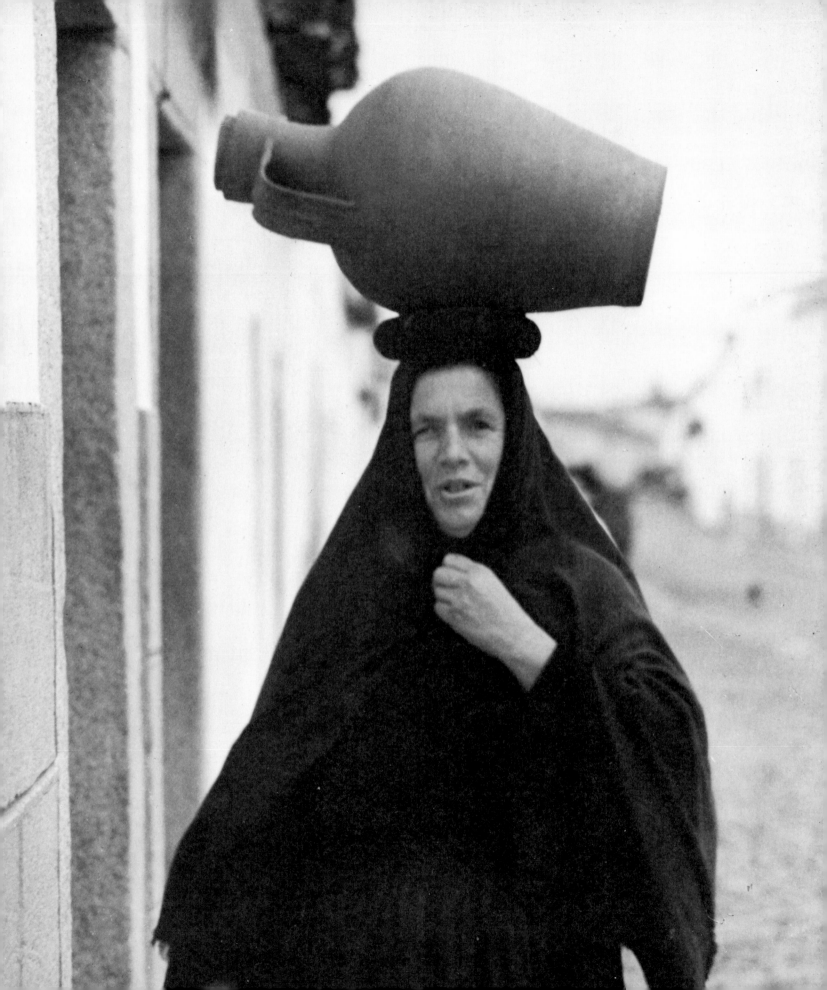

castila

In this chapter we will be dealing with ceramics in the two Castiles. In New Castile there still can be found pottery centers as important as Talavera and Puente del Arzobispo, and in reference to ceramics strictly for popular use, others such as Mota del Cuervo, Colmenar, and Priego. In Old Castile, on the other hand, there is very little that we were able to gather on pottery making, to the point of being insufficient to form a chapter.

La Mancha, for example, maintains with relative vitality towns such as La Mota del Cuervo, Consuegra, and Colmenar, all three especializing in some type of pottery making: the first supplies the dry towns in this area with "cántaros"; Consuegra provides the kitchen vessels and one of the most rustic table services; and Colmenar furnished until a short while ago, the jugs for storing wine in the wine cellars — with wine jars, used now as ornaments in "typical" hotels and restaurants. Towns near Madrid of old tradition in glazed ceramics are again filling orders, primarily from the "Court" or in order to sell to travelers. In other regions of Castile, the situation is more obscure. It may be asserted without any doubt, that here, as in all of Spain, the most industrialized areas have lost their former wealth in this field, although a few pottery centers have known how to adapt themselves successfully to the demands for certain objects, which still exist in these more developed regions.

The mere name of **Talavera de la Reina** evokes the image of its rich ceramics. In spite of the general state of prostration through which this art is passing, we can still admire today magnificent objects in the old tradition, inspired by the Renaissance, which have just come from the workshops. Fortunately, this is one of the best studied ceramics and it is not necessary that our references to it be as extensive (in proportion to other places) as it deserves.

The present period of Talavera glazed ceramics originates at the beginning of the century. In part, it is a reflection of the interest awaken at that time by the objects from its best previous epoch. Its new style is adapted to the preferences of those years in which the consequences of the Art Nouveau claimed for it decoration, variegated forms,

flowery ornamentacion, and the development of the curved line. In 1908 the Nuestra Señora del Prado Factory is founded which brings together primarily the efforts of two artists interested in restoring the Talavera ceramics: Juan Ruiz de Luna and Enrique Guijo. Together they offer to a public composed of the upper class and those aspiring to be part of it, excellent copies of the sumptuous and brillint "Italianized" objects of earlier times. The technique which they succeeded in attaining, also in imitation of the Italian, was likewise auspicious, as can be seen by the success achieved by the traditional glaze, of lead and tin. This makes Ruiz de Luna and Guijo deserving of a just recognition of their extraordinary work.

The activivy of this factory determined the orientation of the remaining ceramists in Talavera. It stayed open until 1961, when the workmen decided to unite and form the La Purísima cooperative, which still continues to operate. In addition, there are four other small factories devoted to glazed ceramics, and four to coarse ware: "cántaros", "botijos", and casseroles. La Menora (one of first four), although founded in 1963, deserves to be distinguished because of its successful objects, of great quality, as well as its skill —as pointed out by Natacha Seseña— in having revived the forgotten series of blue, orange, and manganese color, originated in the sixteenth century. El Carmen, the former Niveiro Factory, which now works in the form of a cooperative also deserves to be pointed out.

In Talavera there are five colors of the traditional ceramics which are habitually used: blue, green, orange, yellow, and black. Aside from the polychrome articles, copied directly from Talavera's best period, there have been introduced other new ones, which often correspond to new necessities, and for which traditional forms are adapted: vessels for "sangría" (a wine punch), small "cántaros", big-bellied jars, coffee services, beer sets, umbrella stands, etc. It is not necessary to add that all of this production is very successful and that the objects are sold throughout all of Spain and exported abroad.

In **Puente del Arzobispo** we also find great activity. The

"refined" objects are made in nine factories, while there are six "canterías" (makers of "cántaros") who devote themselves to coarse ware: "botijos" (with a large mouth and spout), "cántaros", washtubs, and flowerpots. Of the first nine companies, seven belong to the members of the Cal family who were already known for their excellent workmanship at the end of the last century; four are brothers, and three, cousins of theirs. It was precisely Pedro de la Cal, one of the brothers, who most contributed to the present renovation by reintroducing the traditional decoration which had, for the most part, been lost.

The green color and the themes related to the countryside and to the hunt (very typical of which are the rabbit and little bird) characterize the ceramics of Puente. The green is accompanied by yellow, orange, and blue, and upon occasion, chestnut; in a very few objects, blue is the predominant color. The production is varied; and together with themes from a more cultured tradition [such as the "cola de gallo" (cock's tail), taken in the eighteenh century from the town of Alcora] and certain pure Renaissance motifs, we find some very simple ones. Since before the incorporation of the old themes, another ordinary plate,

decorated with circular motifs in the center, from which four plumes extend toward the outer border, was being made. Recently, due primarily to Pedro de la Cal, new types of articles have been sets, dishes, and ashtrays; in addition to others, such as the charming little bell with the figure of a woman in a full skirt.

In the region of Toledo there are three more pottery centers: Consuegra and Ocaña, with five potteries each, and Cuerva with one; until three or four years ago, work was also done in **Escalona.** In **Ocaña** the ordinary "botijo", the "cántaro" with a small mouth (both unglazed and of white clay), and flowerpots are made. The upper part of the "cántaros" are very simply decorated. **Cuerva** has one pottery, that belonging to Mariano Gómez, who continues with the traditional vessels, all of which are glazed: kettles, casseroles, pots, saucepans, washtubs, "botijos", and large pots for decorating kitchen ledges. They also make at present amphoras, vases, coffee and beer sets, etc., all oriented particularly toward the tourist.

Consuegra has much more variety and interest. They also make "botijos" (in various types), pots and casseroles, and other objects for the kitchen; all of wich, including the "botijo", are glazed. The flowerpots, and formerly the large pitchers, are unglazed. The earth which is used is red; the vessels are decorated with a white clay that turns slightly yellow. The designs are very simple: wavy lines or zigzags, making elementary geometric forms; dots, interlinking arches with a dot below each arch, crosses with dots between the arms, and in general straight and curved lines, with the open spaces filled with dots.

We visit the five existing potteries: those of the two brothers Baltasar and Gregorio Moreno Aparicio, who have known of thirteen in former times, in which forty-eight potters worked; in all, one hundred families were able to

112. Two handle crok: blue on a white background, *Talavera de la Reina*
113. Decorating the object, *Puente del Arzobispo*

live from the clay. In the fairs in La Mancha we have had the opportunity of seeing in previous years, objects which aroused emotion by their simple beauty. But even the ceramics in Consuegra, so widespread in all this area, is in inmediate danger of being spoiled. Already many objects are being made for purely decorative purposes, which in itself, of course, is not bad; although it is bad that they neglect the quality of the work and begin to decorate the articles, upon occasion, with white plastic paint, producing an effect that is very hard to describe. All this cannot be blamed on these wonderful people, who feel flattered by the interest noted in some of the city people, but rather on those who, instead of orienting them as they should, disorient them. It is necesary to avoid this danger as soon as possible; for, aside from the sporadic appearances of the visitors mentioned who at present buy only on small scale, the demand for objects for authentically popular consumption is decreasing at an alarming rate. It is for this reason that the production is being oriented inadvertedly toward ornamentacion. This is not, we repeat, necessarily bad (for the moment it is

inevitable), since the people in the cities are not inclined to use these objects on their tables; but the lack of orientation and the taste of the buyers, have an influence on the ceramics and may determine a possible final decadence.

We were familiar with the famous jugs from **Colmenar de Oreja** from having seen them in the large wine cellars of La Mancha. It was surprising that at the present time, when technical avances are being made with such fantastic speed, the "tinaja" was still being produced. It was our belief that on visiting Colmenar and Villarrobledo, both dedicated to the same industry, we would not find anything except its traces. We had read and article by José Gómez Figueroa in the Madrid newspaper "ABC" (february 4, 1966) in which the state of this activity was reported. "In Colmenar de Oreja", it said, "is made a 'tinaja' of 500 arrobas (approximately 1.500 gallons) which will be the last of this class that is made in the world." The proceeding was a direct quotation from the potter who was going to make the jug. In order to make "tinajas" of this capacity, about four

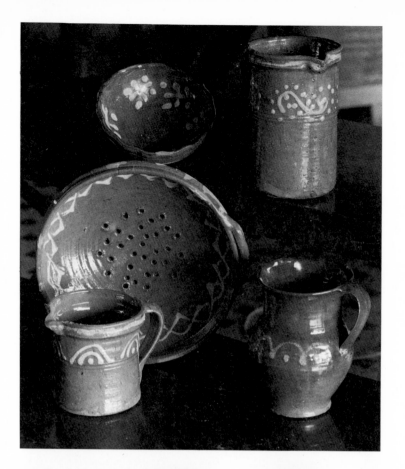

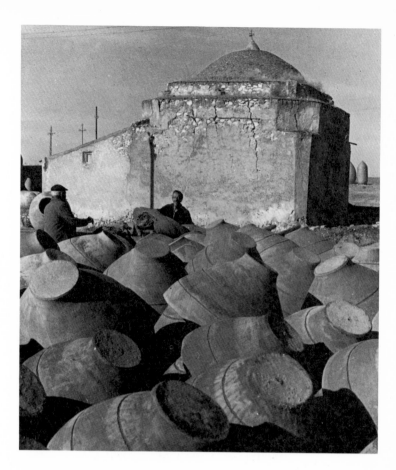

114. The office of the potter Pedro de la Cal,
Puente del Arzobispo
Brocken crockery pieces used to make a wall, *Consuegra*
115. Various examples of the pottery in *Consuegra*
Flowerpots, *Colmenar de Oreja*

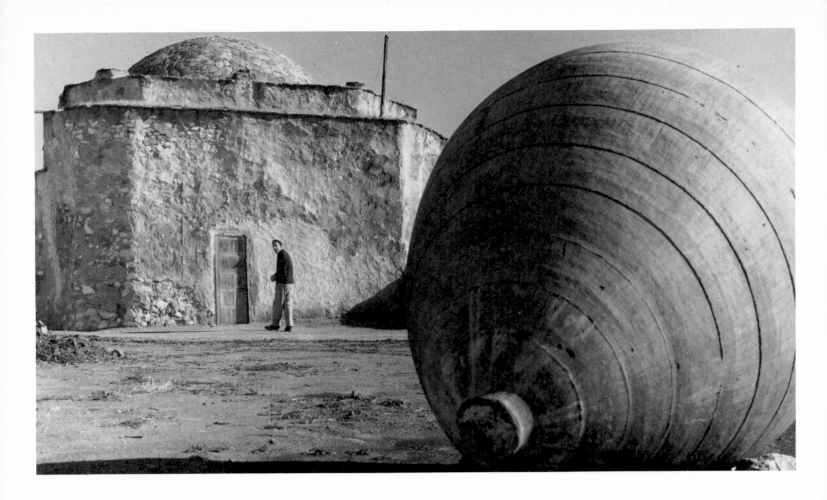

thousand and forty pounds of clay are needed and the height of the finished vessel is almost five yards. Formerly, we were informed during the visit we made to Colmenar, "tinajas" were made with a capacity of as much as 1800 or 2000 gallons approx. Now they normally devote themselves to jugs of fifty gallons or less: 150, 120, 90, 75, 60, 45, 30, 24, 18, 12, and 3 or 6 gallons. All of these sizes have been, and are still made by hand. They are made by segments ("aros") beginning with the bottom pieces; they are then transferred to the kiln by a group of men. In each bake tnere may be as many as a hundred and twenty jugs of forty arrobas each.

This "tinaja" industry had, not many years ago, a flourishing period. According to what we were told, there were thirty workshops; of these only two remain and one already produces very little. There is now a definitive decline in this work, due to the preference for cement tanks in the wine cellars. On the outskirts of Colmenar, in the open country, one can see "tinajas" in various sizes, ready to be shipped. Generally they are placed at the entrance to a restaurant, hotel, or shop as a local color attraction. They also make in Colmenar very large flowerpots, between 2 and 3 feet high which are normally used in public gardens; their sales are vey good.

116. Kiln for the tinajas, one of which is already fired, *Colmenar de Oreja*
117. Tinajas, *Colmenar de Oreja*
118. Scalloped plate, *Talavera de la Reina*
119. Soup tureen, plate and pot, *Puente del Arzobispo*

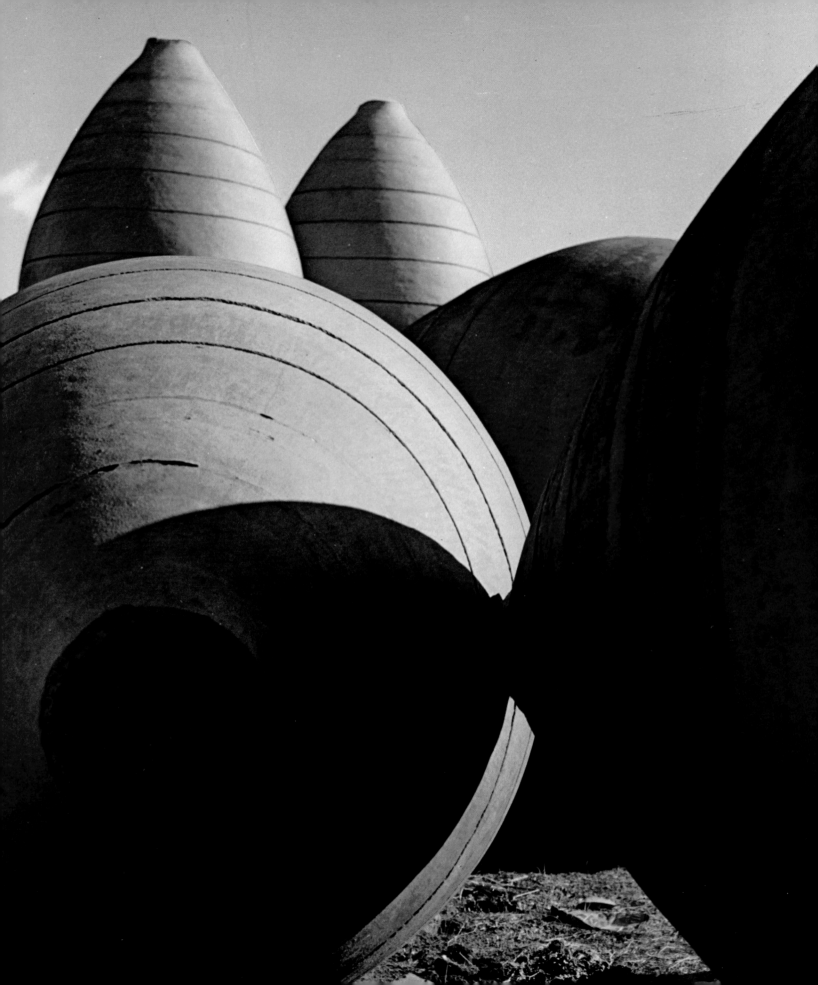

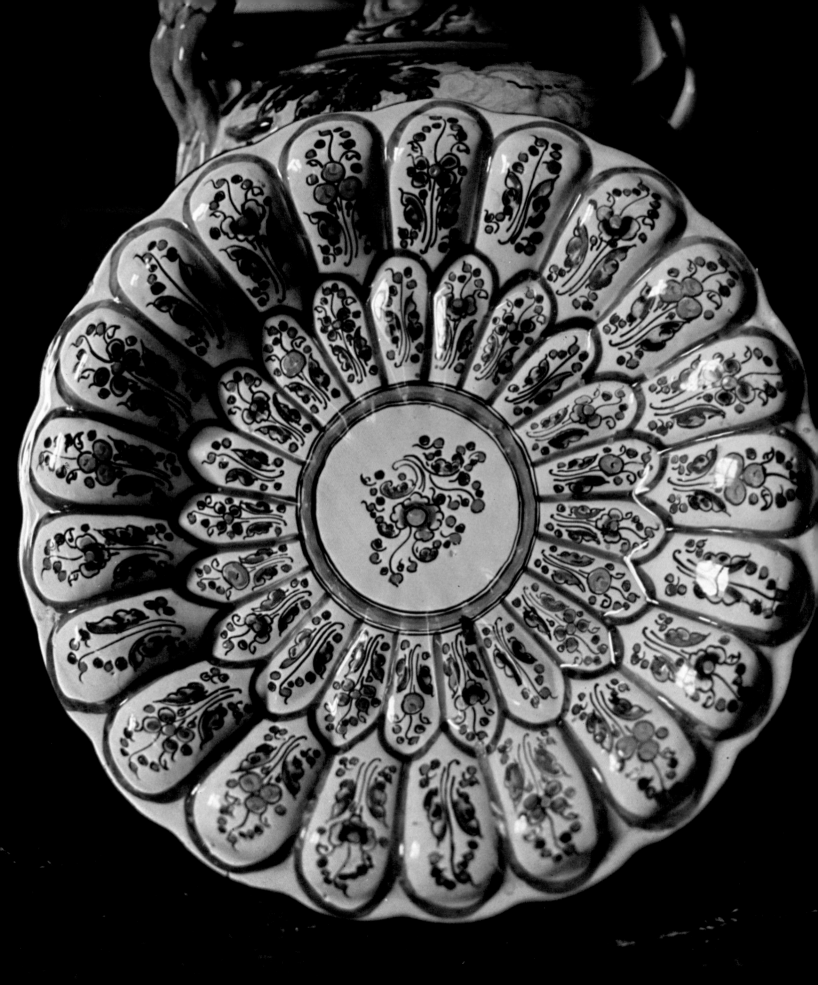

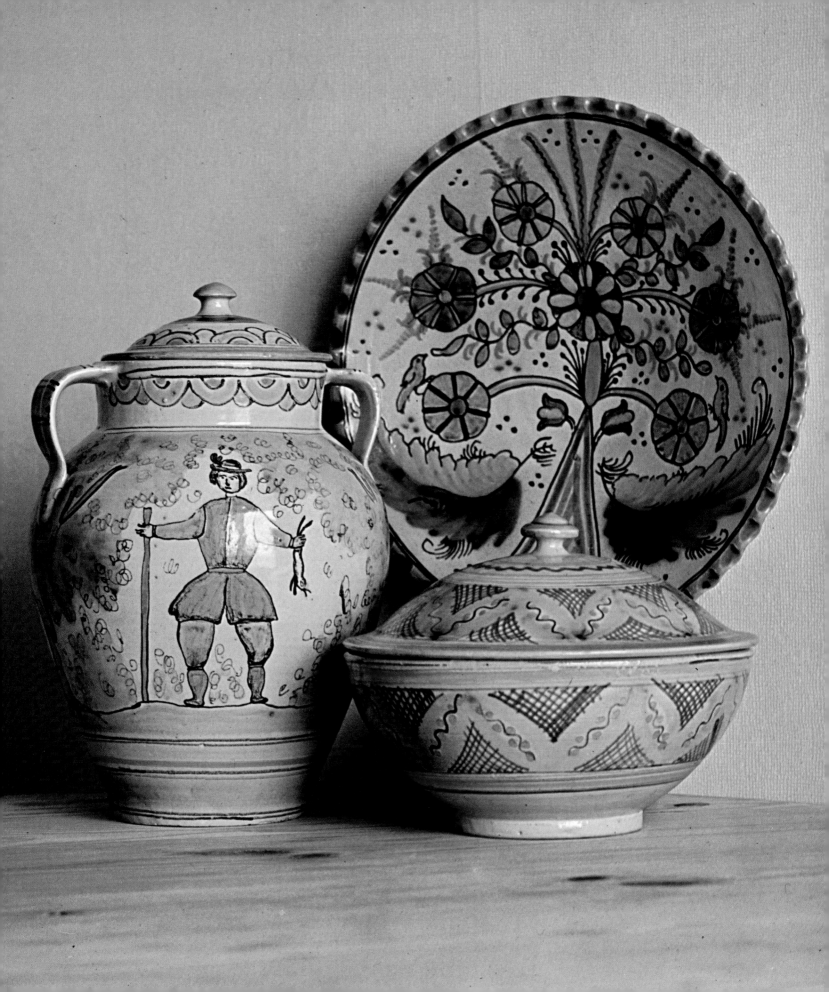

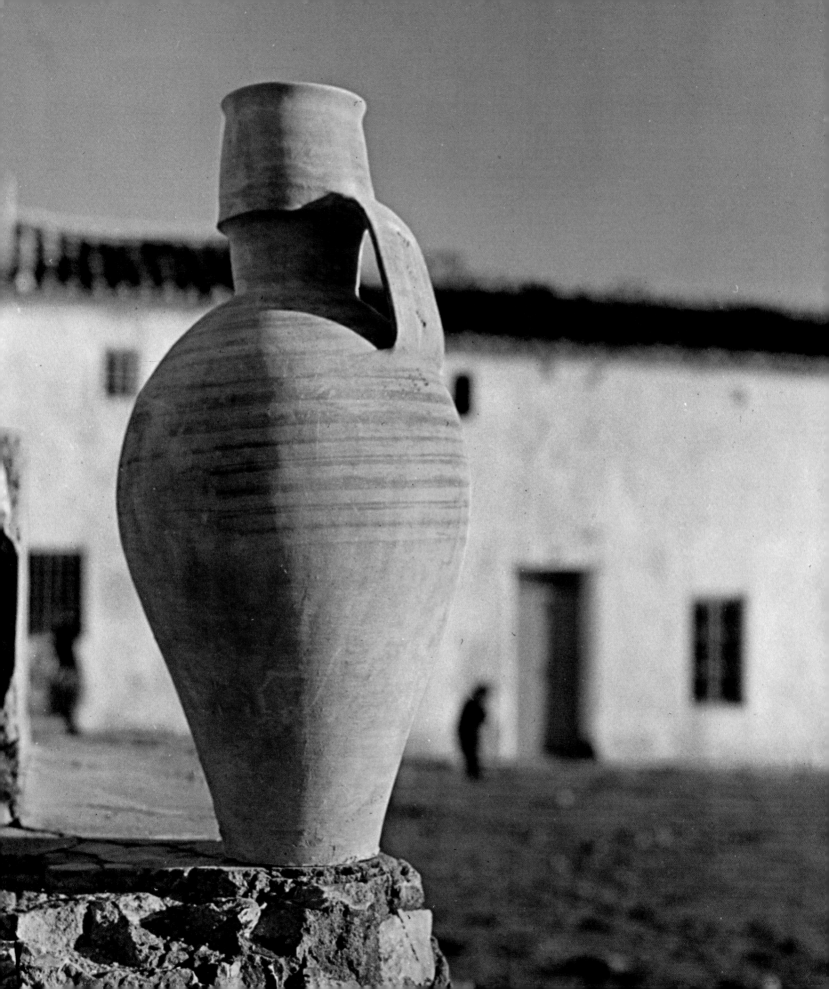

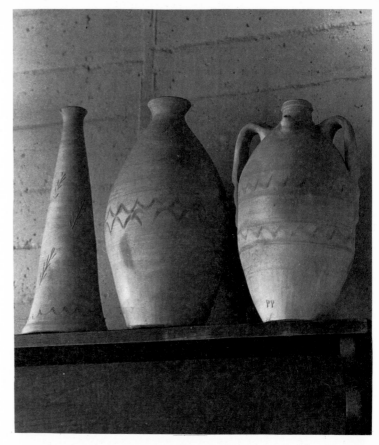

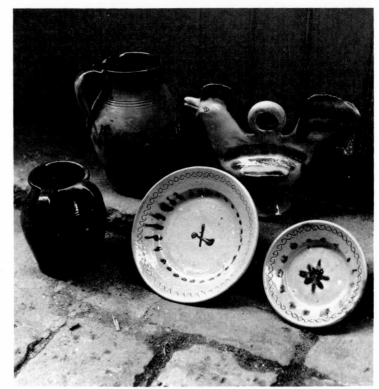

120. Cántaro, *Mota del Cuervo*
121. Toy strainer, *Mota del Cuervo*
"Caracola", cántaro for a water trough and botija, *Villafranca de los Caballeros*
Puchero de dos asas, olla, botijo de gallo y platos, *Castellar de Santiago*

The scene in the Casas Quemadas Street and the nearby area, with all the kilns lit at the same time, seems somewhat Dantesque. In its other aspects, the sight of Colmenar would not evoke the least bit of interest; but a certain excitement is aroused at the moment when hundreds of wagons from many different places assemble to load the "tinajas", with groups of men gathered for the laborious task of putting them in the wagons (the larger ones occupying a whole wagon), and finally the long lines of returning wagons filling the roads throughout La Mancha, at times taking as long as six days to reach their destination. But all of this now belongs to history. Today the wine is stored everywhere in cement tanks rather than pottery ones.

In New Castile there still remain, fortunately, various areas of pottery production. It is surprising that in the city of **Madrid** itself, there is a pottery. It is in the Puente de Vallecas area, and from it come kettles, pots, and casseroles, as well as "cántaros" and flowerpots, the last two of which are unglazed. Near Madrid, in **Navalcarnero,** there remains only one pottery, devoted primarily to the production of delightful and charming Biblical figures. **Santa Cruz de Mudela,** at the southern boundary of la Mancha, had formerly had 12 or 14 potters; the last one abandoned the

craft some two years ago. The articles that used to be made the last potter consisted of: plates, casseroles, pots, crocks, glazed washtubs of red clay, as well as flowerpots. Before going on to the famous and important pottery centers of La Mancha, we wish to mention that of **Castellar de Santiago** (popularly known as "Santiago of the Kettles") in the province of Ciudad Real, where only one pottery remains. Their most characteristic articles are the "trick botijo" and the two-handled kettle, although other glazed cooking utensils are made, such as pots casseroles, as well as coffee and articles that are paint after being fired.

The crockery from **Villafranca de los Caballeros** is practically unknown outside La Mancha. And it is a shame. The production is not large; at present, only Gregorio Peño is still working. The most characteristic objects are: the magnificent "botija" (a type of "cántaro" with a drinking spout), the water trough whose tank is a "botijo", without a handle and with beautiful lines; the "caracola" and the charming cricket box. Piggy banks and flowerpots are also made. The "caracola" is a horn used by the groups of harvestmen; now that farmwork is generally mechanized, however, very few are made. In a previous trip through this region in 1962, we were still able to see some, though even

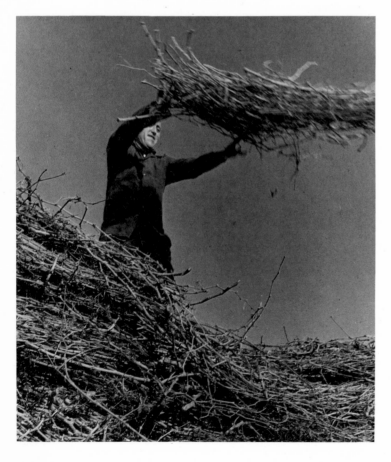

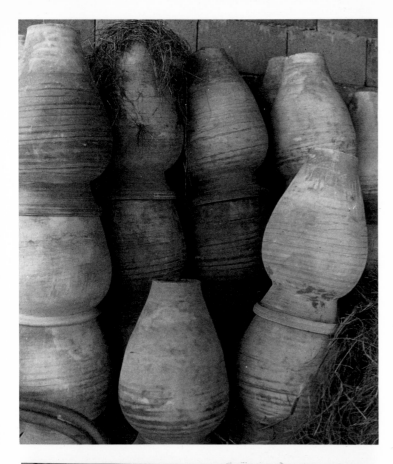

then there were just a few being produced; on that occasion, we made the acquaintance of Gregorio's father, Pedro, at present retired because of his age. All of these items are made with a reddish clay, which when fired turns a pinkish white. They are decorated with straight line, zigzag, or wavy incisions resembling those from La Mota. On the whole, these objects offer characteristics distinct from those of similar function that we have seen in other places; their shapes and decoration, imparting an antique flavor, are very distinctive.

Mota del Cuervo is one of the places most renowned for its pottery. This is suggested by the saying known throughout La Mancha: "From one hour to the next there are cántaros in La Mota." All of these dry lands have been, and are supplied primarily by these "cántaros". We had seen them at the fountains where the women go to fill them with water, in the houses supported by wood stands, and in the booths set up at the fairs by the people from La Mota. Its image was so clear that it never occurred to us that it could now be obscured or clouded. In spit of that, this is the sensation we experienced on our last visit to La Mota. The same women who where working the clay, confirmed this for us. The demand for "cántaros" is declining, first of all because running water is being installed throughout the area, and also because of the widespread use of plastic containers. Contrary to what has happened in other cases in which women also performed this task, here they were very willing to inform us fully about pottery making in La Mota, including details about everything, and even to the point of several talking at the same time. We ask for Victorina Chinchilla, whom we had seen with her "cántaros", in the fair grounds, and who is almost an institution here, and are informed that she is in Barcelona living with a son. Soledad Rodríguez Manjavacas accompanies us to the kilns and

122. Kiln, *Mota del Cuervo*
123. Tinajas, *Mota del Cuervo*
Bull, Pedro Mercedes, *Cuenca*
125. Cántaros unfired and the kiln in the background, *Priego*

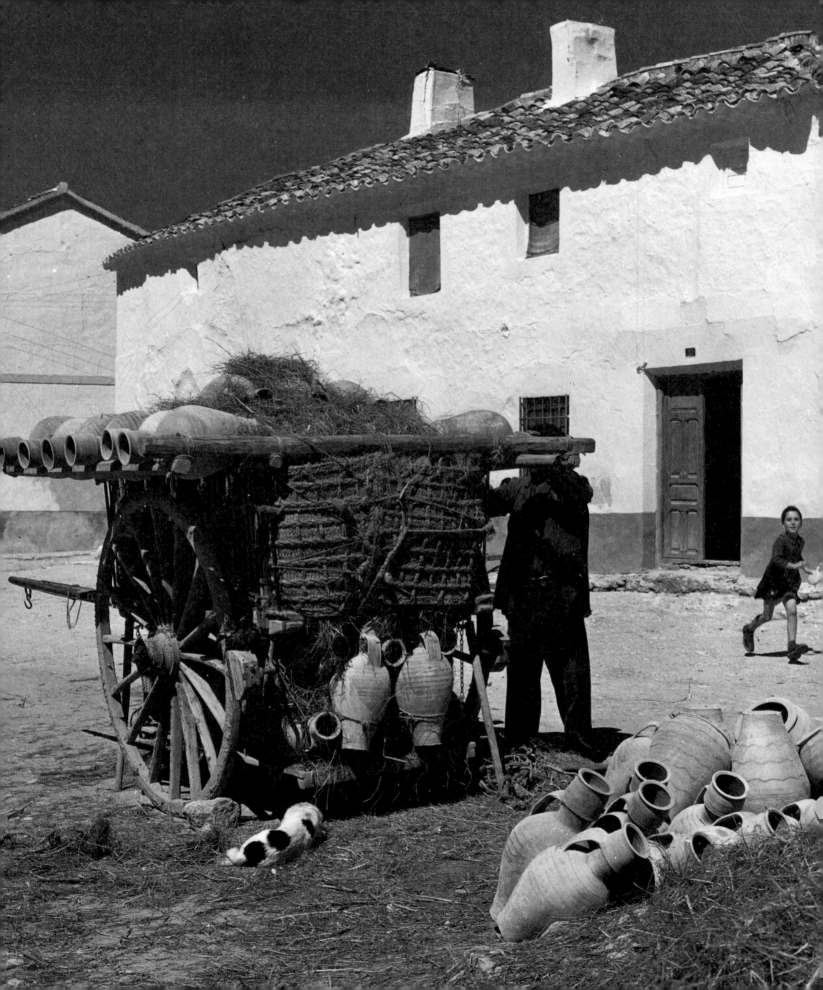

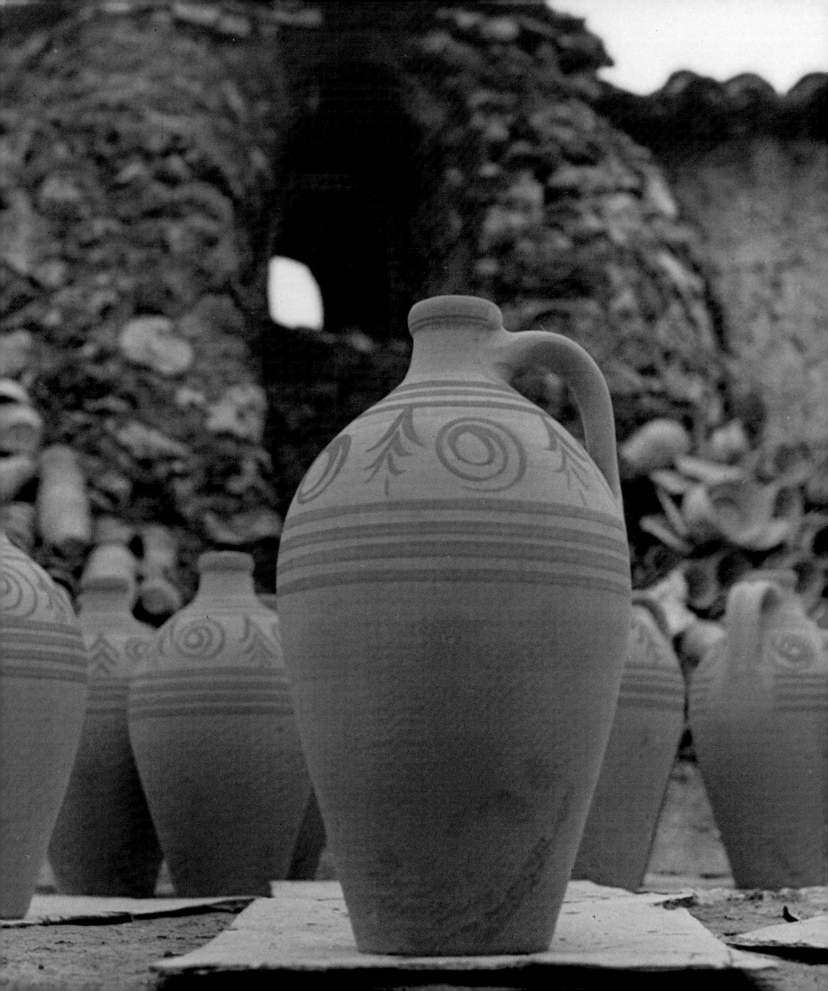

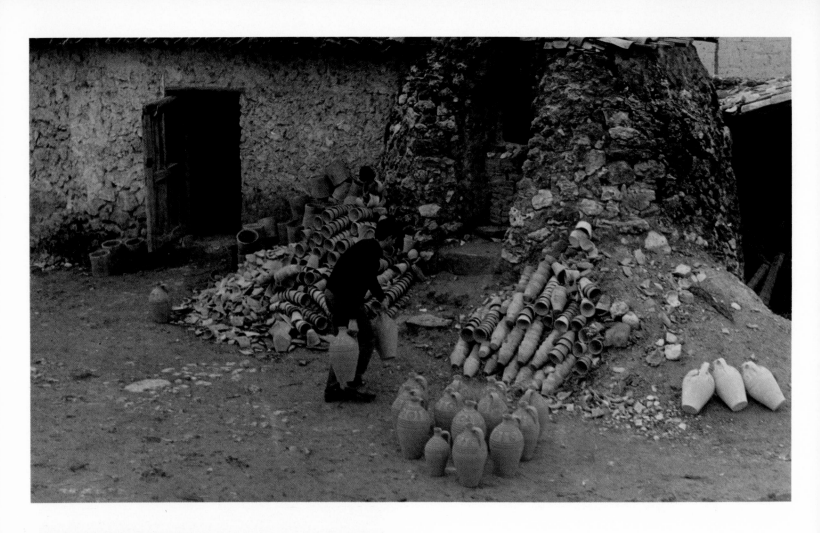

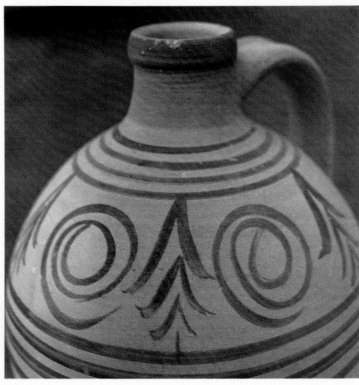

shows us the objects. Things are obviously declining. "In the last five years", Soledad tells us, "much has been lost. Formerly every year between September and Easter, five or six wagons a day left for the region of Albacete alone, and another couple of wagons for Madrid, and for the Ciudad Real area, five or six more." Of the five kilns that were here, only two remain.

Here we see the "cántaro" with its ashen white color, its wide handle and its high neck; it is a rotund object with a capacity of 2½ gallons. There is also the "little cántaro" for 1¼ gallon (half the normal size) and the little jar" (which is also a "litle cántaro") for one quart or a half; the latter is a toy item. The "tinajas" or jugs are measured by the number of "cántaros" they hold; there are jugs of 8, 6, 4, 3, 2, and 1 "cántaro" (the last being a toy). There is also the "copa" ("goblet") in which are put flowers to be placed in entrance halls; flowerpots, and "barquillos". The latter, which is rarely made now, was a plate, "which was not for sale; it was used for the children or to feed the cat", and it had four spouts or little canals for drinking. These types of crockery were always unglazed.

In **Cuenca** there is at present one ceramist, trained by one of the potters from the same town who became very renowned: Pedro Mercedes, whose "Iberian" bull is very well known in all of Spain. In spite of the undeniable interest that his work arouses, we will not refer particularly to it because, although it originates in the traditional forms, its intention is to produce a consciously artistic creation which separates it from the traditional ceramics.

There are five potteries in this town dedicated to the traditional items, some of which have felt the influence of Mercedes. They normally make: the bull, the spice box (with 4 or 6 compartments), jars, camping "botijos", canteens (which formerly were used primarily by the hunters and shepherds), "botijos" (few of which are made now), containers for storing olive-oil, and vessels for serving wine.

It would seem that in a town such as **Priego,** half hidden because of its geographical setting, this art would be maintained more vigorously; but here they were careful to set us straight. In any event, there are still five potters working. We spent the evening talking with Mariano Magán, one of them, and some of his friends in a bar (it was Saturday, and they were enjoying some spareribs, enhanced by the local wine and pleasant talk, to all of which they invited us). Mariano explains to us that he – and he is still a young man – has known of at least forty-two potters here. The production is only sold within the region. He has two children, but, "as we said yesterday", he adds, "if things don't improve..." The "cántaro" from Priego, although of the familiar shape, has its own distinctive decoration which is indeed pretty:a few simple spirals, with some strokes between the rings, that encircle the vessel. There are

"cántaros" in five sizes, from 3½ gallons to two quarts. The "botijos" may be one of two types; both are available in four sizes, from 1½ gallons to a quart. Aside from the ordinary "botijo", there is one which is glazed and decorated with flowers, bearing the inscription "Remembrance from Priego". There can also be seen crocks for storing pork sausage, the inside of which is glazed; washtubs (used during the slaughter of the pigs and for washing dishers where there is no running water), pots to be used over a fire, and flowerpots. In autum 1973 the painter Julián Grau Santos resided in Priego; the artist has long been interested in folk articles and has decorated, with great respect for their original spirit, some of the vessels made by Aurelio and Mariano Magán.

These objects, combining the purest of ceramics with artistic design, have displayed great beauty; they were shown in an Exposition in Barcelona in February 1974.

There is very little that can be said concerning the ceramics in Old Castile. In spite of that, there exists even today an important pottery nucleus in **Navarrete** (Logroño). There are twelve potteries which give work to more that fifty men. The principal object produced is the flowerpot, although the technique employed is no longer "craftsmanship". Around Aragón, we had already been told: "It is the only part of Spain that is going to flood us with production, and we will have to export. A German man went to Navarrete and took them a special kiln and with it they make carloads of articles every day."

If we had visited Avila a few years ago with the intentions that now guide us, we would have been able to find a number of things. Two potters, for example, who worked until recently in **Cebreros,** have now changed jobs and today dedicate themselves to farming; they had made "cántaros", "botijos" and casseroles. On the other hand, one can still see in **Piedrahita** similar vessels being formed on the potter's wheel. In **Tiñosillos** are still produced the "cántaros" and flowerpots which together constitute the basis of the production. There remains one potter, Celedonio Muñoz Mínguez, in **Tajueco** (Soria), fromwhose kiln continue to appear a variety of articles: "cántaros", "trick botijos", and others for holding water such as kettles and pots, and cooking vessels in general.

In the region of Burgos, work is still dobe in the town of **Aranda de Duero.** Mariano Martín León, the potter, continues to make a varied assortment of water and table vessels, as well as cooking containers: "cántaros", jars, vases, flowerpots, "botijos", casseroles, an oval plate for roasts, and one especially designed for roasting lamb. The city of Segovia has one potter, who makes wine jars and vessels in the form of animals. Another potter, Otilio Bautista, had died just three months before we made our trip to the area; he had made, in addition to wine jars, toy items.

andalusia

Andalusia is large and varied, rich in its entirety, rich in nuances. To cross its borders is to enter another world. There are, however, too many legends and trite expressions concerning it, which prevent one from seeing what there is of truth; and even this is more and more threatened. There is nothing more contemptible or ridiculous than something, rich and authentic, being exploited for its appearance, to the point of spoiling it:this is happening, for example, to the song and the dance of this region, which have been converted into exportable commodities, which are only the grotesque shadows of their former selves. Almost every one has aided bringing this about: by the conscious action of the people who take advantage of the situation, and by the naive dedication of the innocent people.

We enter these blissful lands by way of Almería. In this manner, there is not the brusque transition from Despeña-perros, but an almost fluid continuity. We arrive in **Vera,** where we had one of the greatest satisfactions and one of the greatest disappointments of our trips. We went directly to the street with the most indicative name: of the Potteries. Salvador Hernández and his son Bernardino work at number 11. The lot which was about to be fired will be the last that is made. The unbaked objects are in the entrance to their workshop. Later they will dedicate themselves to buying potter pieces in Lorca and other nearby places and to selling them here; yet it is Salvador's pottery that is one of the most beautiful in Spain. His forms, of very old lines, have a very light color. Salvador's wife has known of seven potteries that have existed here; today there remains just this one, and within a few days not even that will be left. These beautiful forms will be lost for lack of acceptance. Who should concern himself, if private initiative does not know how or does not succeed in finding a way of protecting them? Now, the father tells us, "with all these refrigerators, and so much lordliness, nothing can be done". In Vera, consequently, by now they are no longer shaping and firing pottery pieces; and soon perhaps, even the names of the objects will be lost in the memory of the people: "bartolo" (a "cántaro"), the "balloon" jar (with lid); the "buseña" jar; the beatiful pitcher (topped with a type of bizantine dome), the surprisingly distinctive "ordinary" jar, and the glass.

Sorbas is like an eagle's nest. There, in the houses perched on the cliff, we find four potteries. This is merely a maner of speaking, for the work is irregular. "The main reason, is that in summer you can't work, because there's no water." Juan García Lario, with whom we are discussing the pottery problems, will have to go back to working abroad, in spite of the fact that he would like to continue living in Sorbas (with his wife and children) and earning his livehood from pottery making. He (who is just thirty years old) spent three years in Germany and seven in France; years of sending money back to his homecountry. At the moment when we were there, he was making the kettles and casseroles. The kettles are sold by "saltas" (a measure: according to the size, the vessels hold more or less "saltas"). The ceramics was among the most rustic that we had seen, but for that same reason, interesting. The objects are sold to Guadix, and parts of Granada, Almería and Murcia. Aside from the kettles and casseroles, which constitute the basis of his production, some coffee services (very few) and "cántaros" are made.

Níjar has declined a great deal. They make use of the traditional forms, but the decoration and the colors given articles, detract from them. This is the danger which often affects these platters, cups, bowls, mortars, and croks. There was a charming toy object known as "ajuar". The colors generally used are green, purple, yellow and blue. We also see some "cántaros", flowerpots, and piggy banks. More and more is being devoted to the tourist items, making them uniform, in appearance, with the objects from other pottery centers in Spain, afflected by the same disease.

Not many years ago, **Albox** had forty potteries, "in my father's time", as Herminio Hernández, 36 years old, tells us. He continued the craft, but today not more than five potteries, including his own, remain. They are ceasing to

make the washtub and the crock — they do not make more than one or two barches a year; on the other hand, the flowerpot, "botijo", mortar, and "cántaro" are still being sold, "because the little villages around here don't have water." Herminio produces as many as two ot three thousand "cántaros" a year. The items are sold throughout the region, as well as here in Albox, along with crockery brought from Agost. Now they are going to also make the refrigerator "botijo". The present production has a brown background with purple and yellowish decoration or a greenish white color with green designs. The very simple decoration is always made by women.

The pottery making in **Guadix** in the region of Granada, has a distinctive reputation and character. There are two remaining potteries (one with three potters and the other with two) though in past years, the number was four. The lathe here has been lowered into a hole so that the work is done at floor level. Eduardo Giménez Lorente, who was a potter, but has since left the work to others, explains this to us. It is obvious that is not very fond of the craft: he has the pottery, he tells us, because it was the desire of his father, who had been a potter; but for reasons of this own, he left the work and now dedicates himself to brick making. The objects are pretty: "cántaros", of which there are ten types, called "de juguete", "de perra", "de 25", "de 12", "de 9", "de 7", "de 5", "pezeños", "de 4" and "de 3" (the order does not refer to capacity or price, but is meant, at least at present, as a means of identifying them), the "botija" (a type of "cántaro" with a spout), the "pipo" (a "botijo") which may be either "pancilla" (the smallest), or "pipo" "de 6", "de 5", "de 4", "de 3", 2 or 1; croks, washtubs, flowerpots; unusual baroque borders (with small domes

130-131. Various unfired objects, *Vera*
132. Jar and "bartolo" (cántaro), *Vera*
133. Ordinary jar, *Vera*

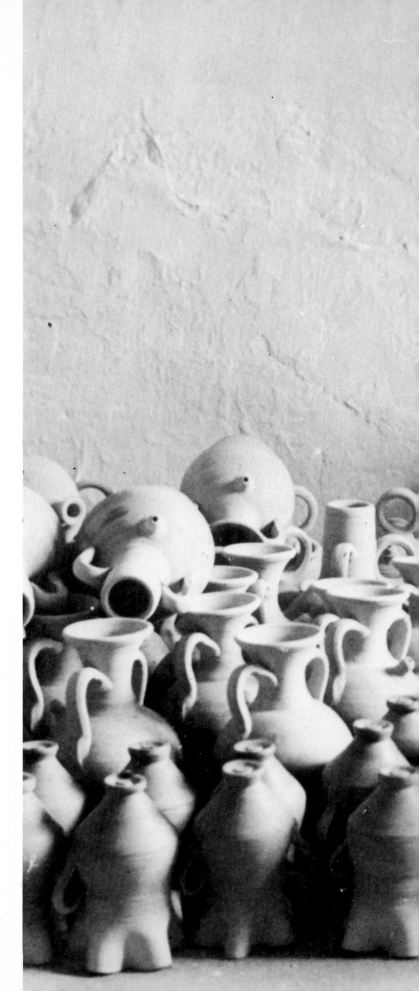

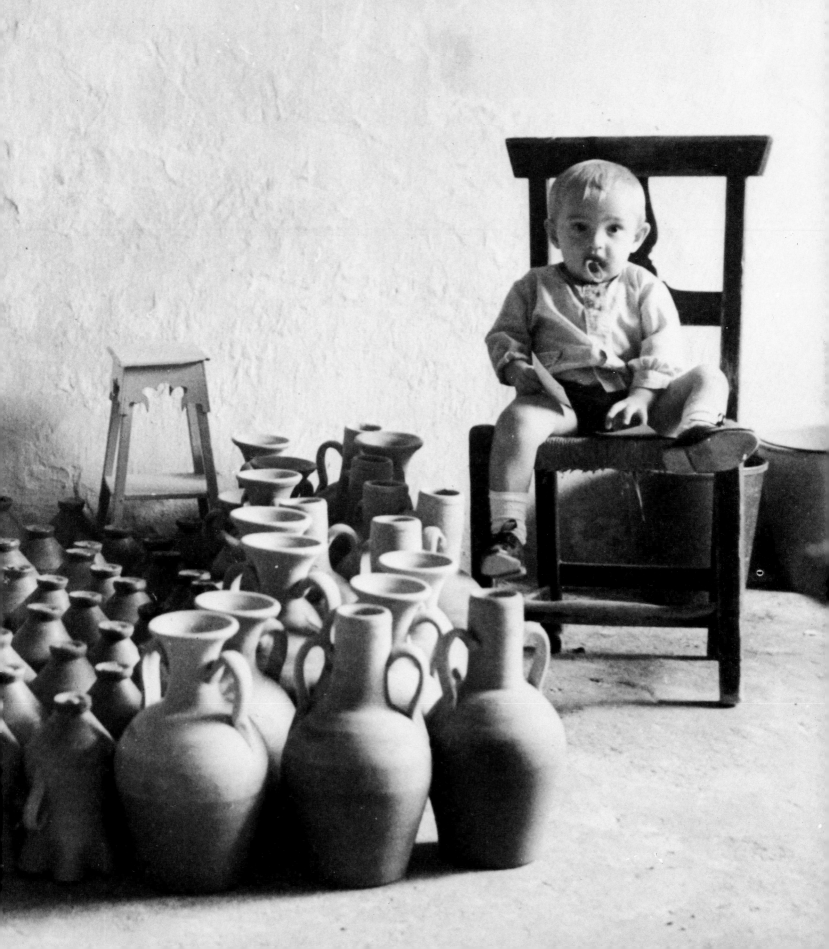

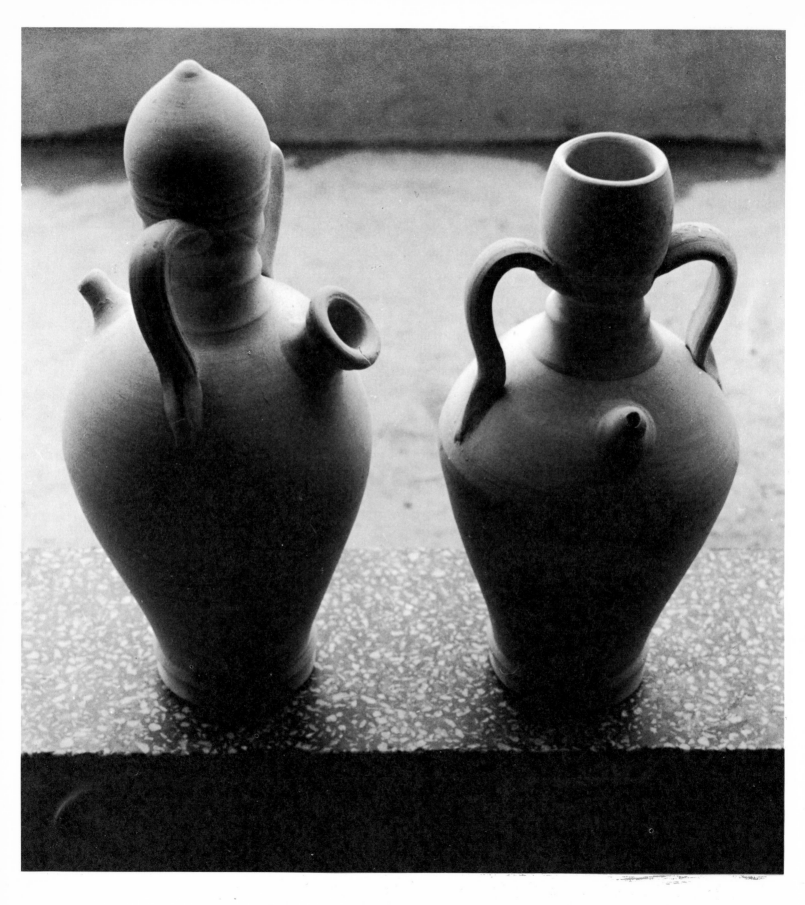

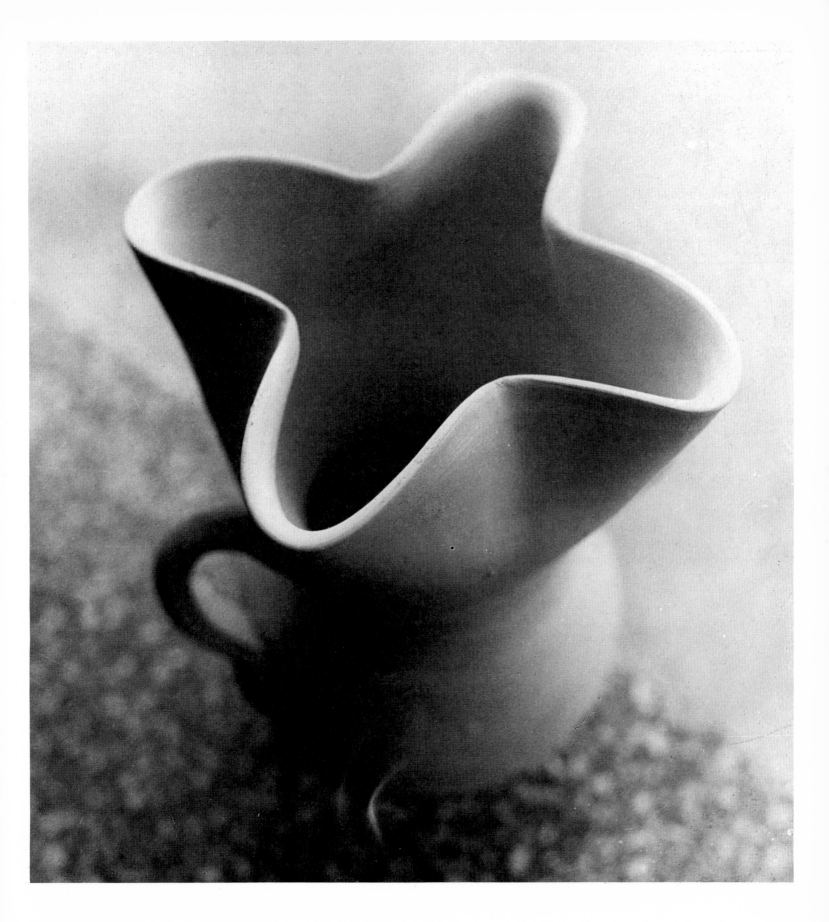

topped with cocks) for terraces; cheese jars; water closets, and "pipos de gallo".

Purullena, also in the province of Granada, has one pottery which would like to make articles, although at present their technique and the shape of their vessels are related to those we have seen in Guadix. Here we also found a large number of shops selling ceramics.

In the sixteenth century there began to develop in **Granada** near the Fajalauza gate, a beautiful glazed ceramics with blue, and at times, green and purple colors. This popular tradition has reached us without having lost virtually any of the charm of its multicolored decoration. There are very few motifs used for this ornamentation: birds, pomegranates, flowers, and branches of trees.

At present, the articles come from two workshops of very different characteristics. The San Isidro Factory, on the Madrid Highway, has organized the work very well, while adapting themselves faithfully to the traditional craftsmanship. In charge of this important company, serving as technical manager, is Agustín Morales Alguacil, who has a degree from the Escuelas Especiales de Cerámica de Madrid and from that of Manises, and is professor at the Escuela de Artes Aplicadas y Oficios Artísticos de Granada.

The abundant production is regularly of excellent quality. The various types of objects maintain the old decoration of blue, green, and purple which is still very beautiful today. At present, there is more tendency to make the objects in green or purple, due to the fact that the wholesalers can sell them more easily than those painted only in blue. The enamel is composed of silica, tin, and lead sulfide; and the colors used, have as a base this same enamel, stained with a small amount of cobalt and manganese oxides, and copper sulfate, which are refined by mixing them with water. Given the good conditions in which to manufacture, and the good distribution which they have obtained, the favorable continuation of this ceramics with its genuine character, seems to be assured.

The variety of types is noteworthy; the most popular forms are: the "cántaro", the demijohn, decorative platters to be hung on the wall, bowls, soup tureens, vinager pitchers; and many other objects used to serve the wine in the little roadside inns.

Today, foot lathes or electric ones are ased according to the article that must be made. The foot lathe is always more pleasant, as they say here, when doing the dedicate work; but nevertheless, the scarcity of labor has resulted in greater electrification of the lathes.

Formerly, the sales covered large areas — Alpujarras de Granada, the provinces of Málaga, Almería, Jaén, Córdoba, and Ciudad Real —; these vessels which previously were used in the farms, villages, and country lodges, are used today as luxurious decorative elements in hotels, elegant inns, and country retreats in may areas of Spain, especially on the coasts which are most visited by the tourists. There is some exportation abroad of the goods; at first the articles went primarily to Great Britain and France, but today there is more demand for them in America and Japan.

The other company, which operates in Fajalauza itself, is called Hijos de M. Morales; and it is the only pottery that remains of the five that they have known of. The foot lathe is used and all the ones that we see are sunk in the floor, in order to work at ground level. Some vessels are also made with molds, bowls, platters, and shallow bowls. Aside from the delicate glazed articles, they also devote themselves to other simpler things.

We have heard, through Rüdiger Vossen, of the existence of two new potteries: Cerámica Albaicín, in the district known by the same name, and Azulejera Granadina, located on the road to Viznar.

We find in **Coín,** not far from Málaga, more examples of baked clay. One pottery remains, that belonging to the widow of Cumbreras, which devotes itself to manufacturing "botijos", flowerpots, and pitchers.

Our interest leads us as far as the lands of Jaén, where there are various noteworthy pottery centers that are well known. We first visit **Ubeda,** one of the most beautiful small cities in Spain. Valencia Street was at one time full of potters; at present, very few are left. In the four years since our previous trip, the pottery making has declined in various senses. We go directly to visit Salvador Góngora. We had

135. Ordinary jar, balloon jar and the "buseña" jar, *Vera*
136. Kneading the clay, *Sorbas*
137. Casseroles and pots, *Sorbas*

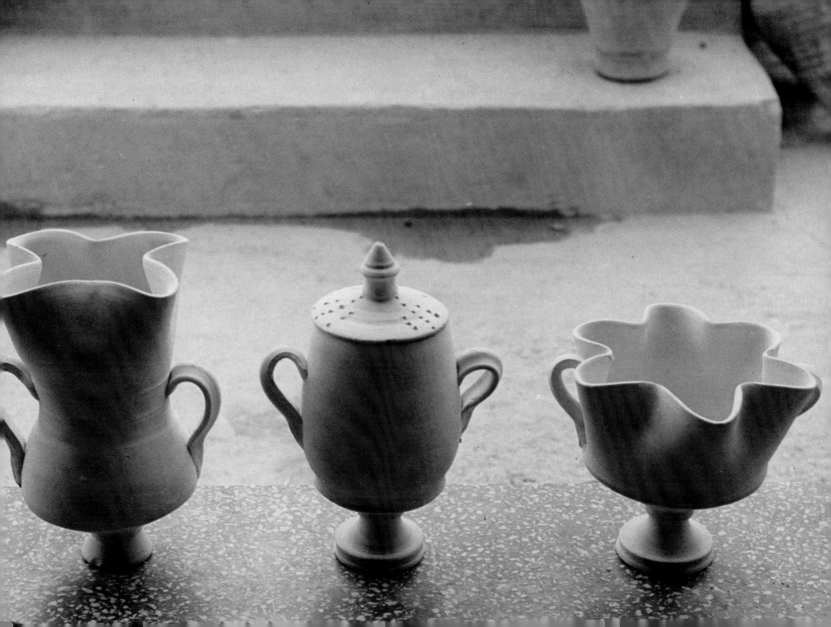

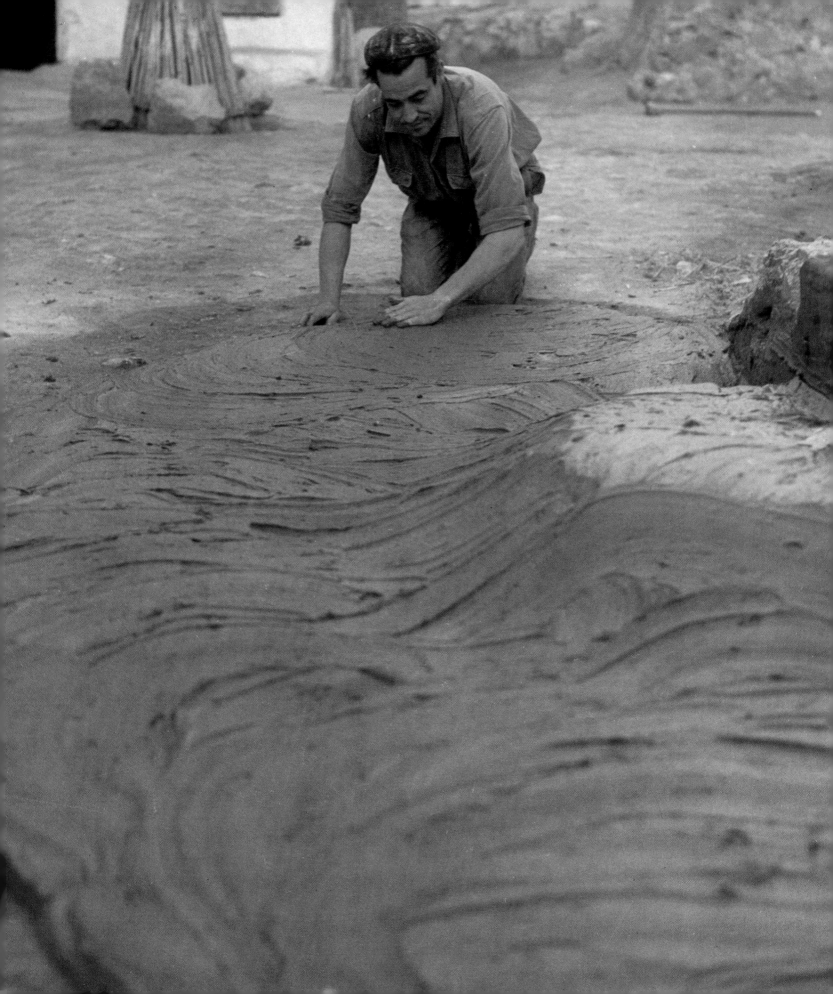

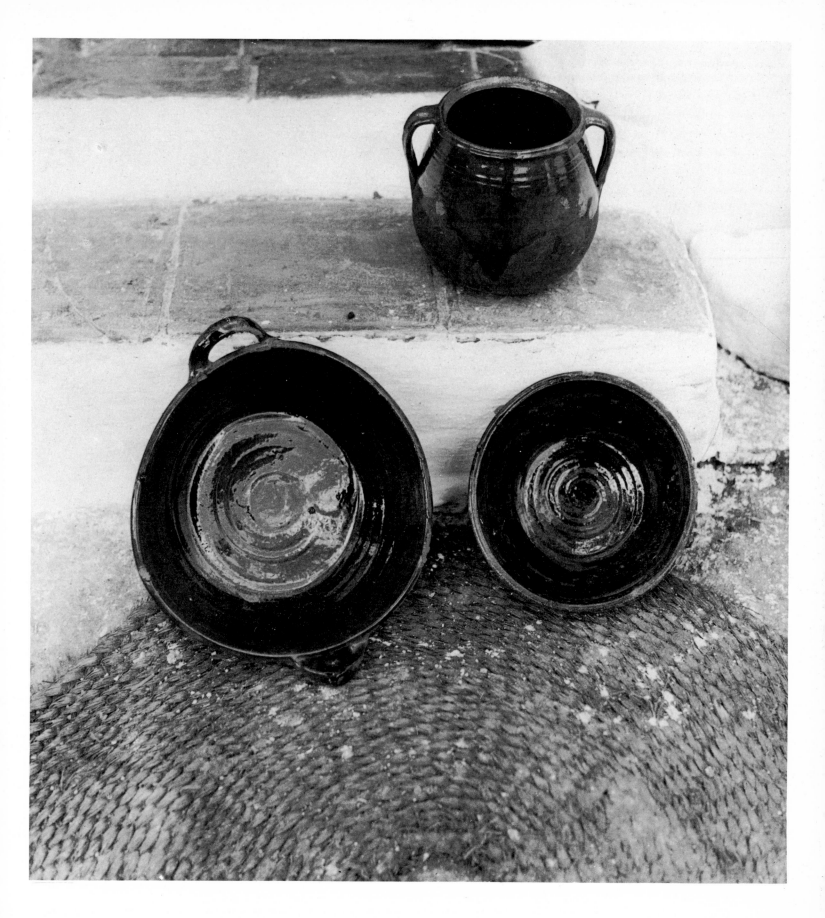

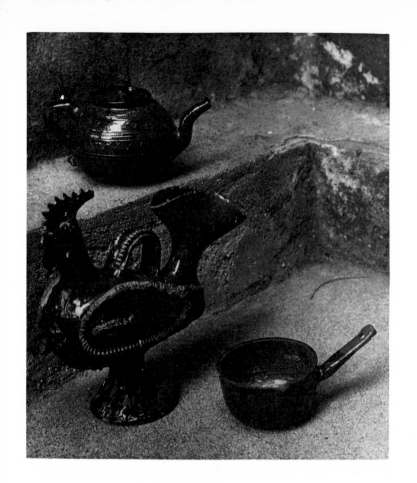

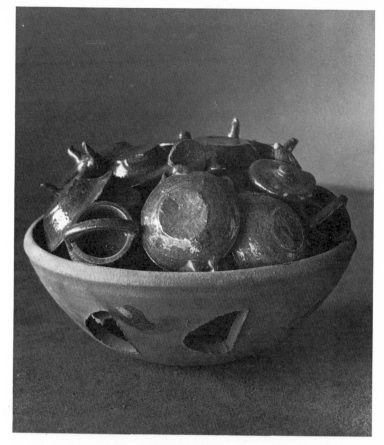

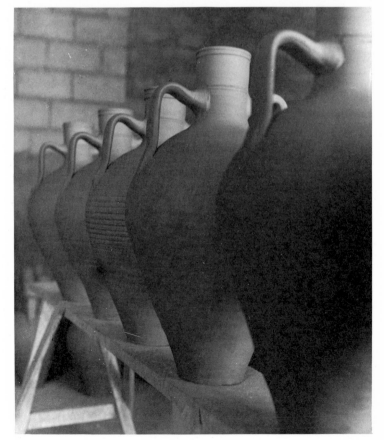

138. Pottery, *Sorbas*
139. Botijos in the form of a cock, milk ladle, and coffee pot, *Sorbas*
 Kitchen utensils (toy items), *Sorbas*
 Cántaros, *Albox*

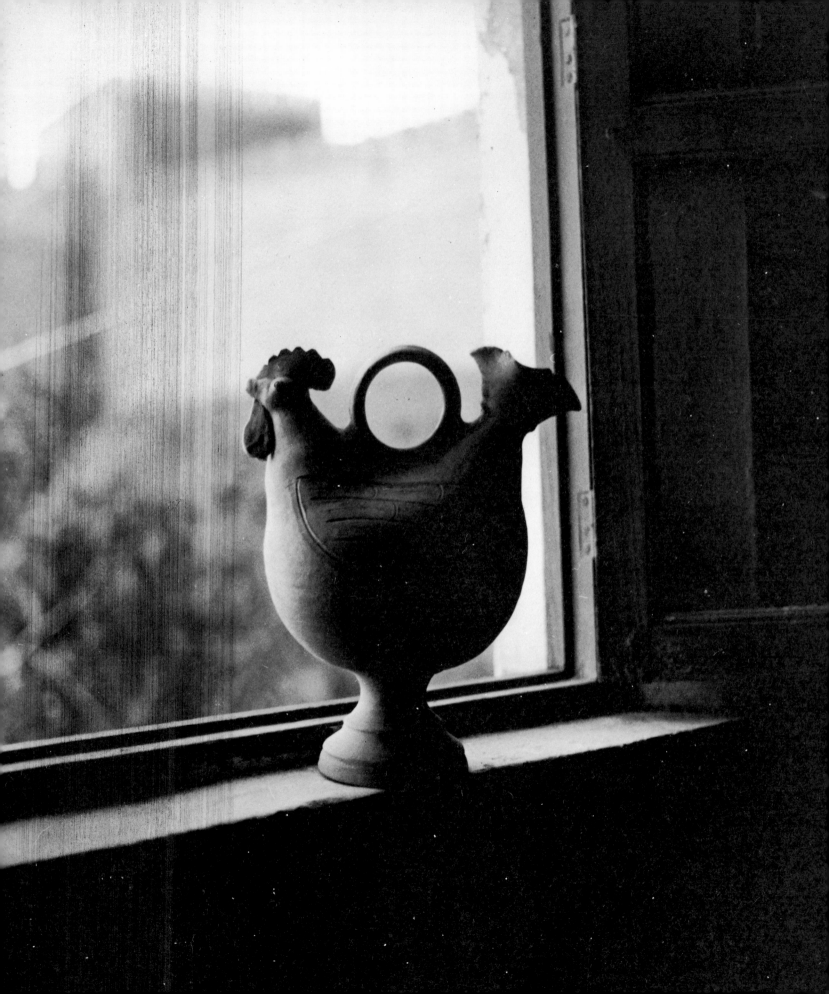

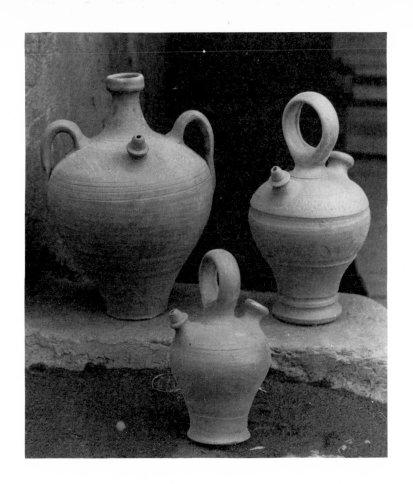

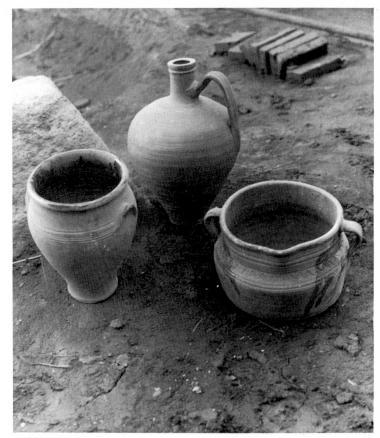

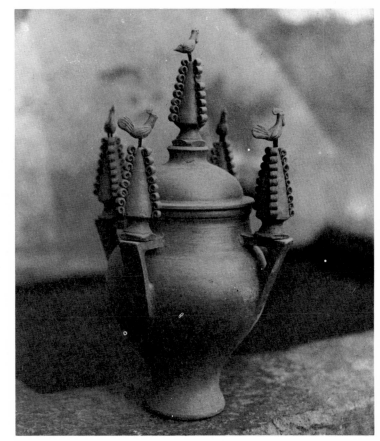

140. Cock pipo (botijo), *Guadix*
141. Botija (the largest) and "pipos" (botijos), *Guadix*
 Crock, cántaro and cheese jar, *Guadix*
 Borders for terraces, *Guadix*

hoped to find in his workshop and store, the wonderful wessels seen on the previous trip. The objects that we were familiar with, of a brown color, very dark at times, and decorated with a light colored clay, were among these which had most attracted our attention; and their beauty was achieved by very simple means. Formerly the decoration

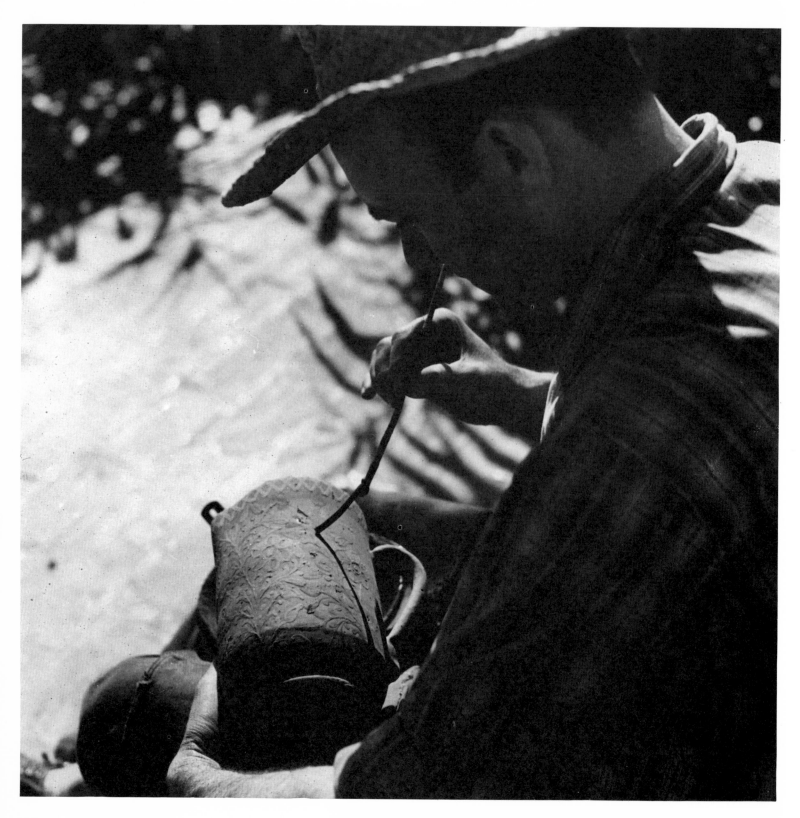

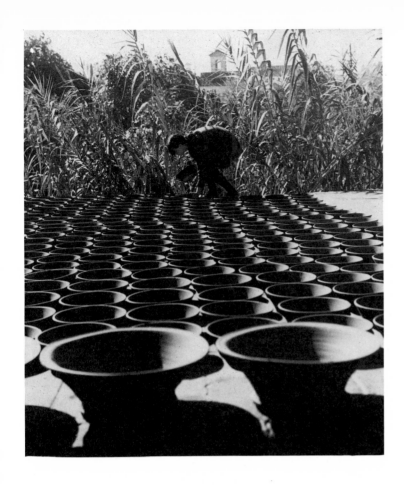

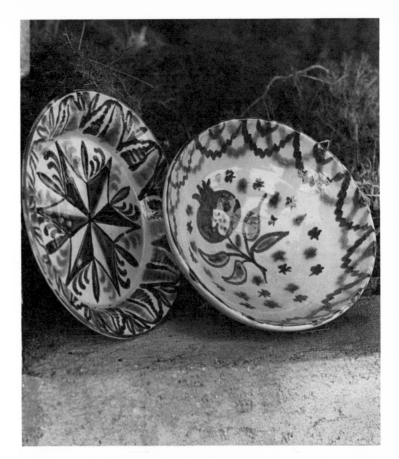

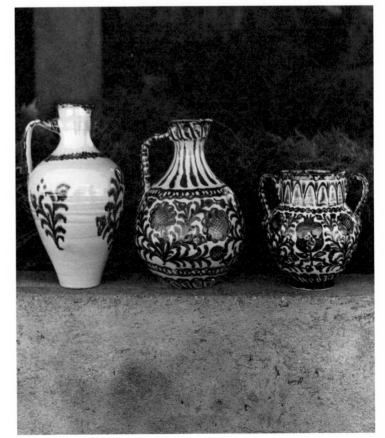

142. Decorating the object, *Granada*
143. Unfired serving bowl put out to dry, *Granada*
 Serving bowl, *Granada*
 Pitchers, and in the center a "turned demijohn", *Granada*
144-145. Decorations, *Granada*
146. Jars, botijo soup tureen, and serving bowl, *Granada*
147. Valencia street where the potteries are, *Ubeda*
148. Various objects, the majority of wich are cántaros and water closets, *Ubeda*
149. Salvador Góngora in his pottery, *Ubeda*

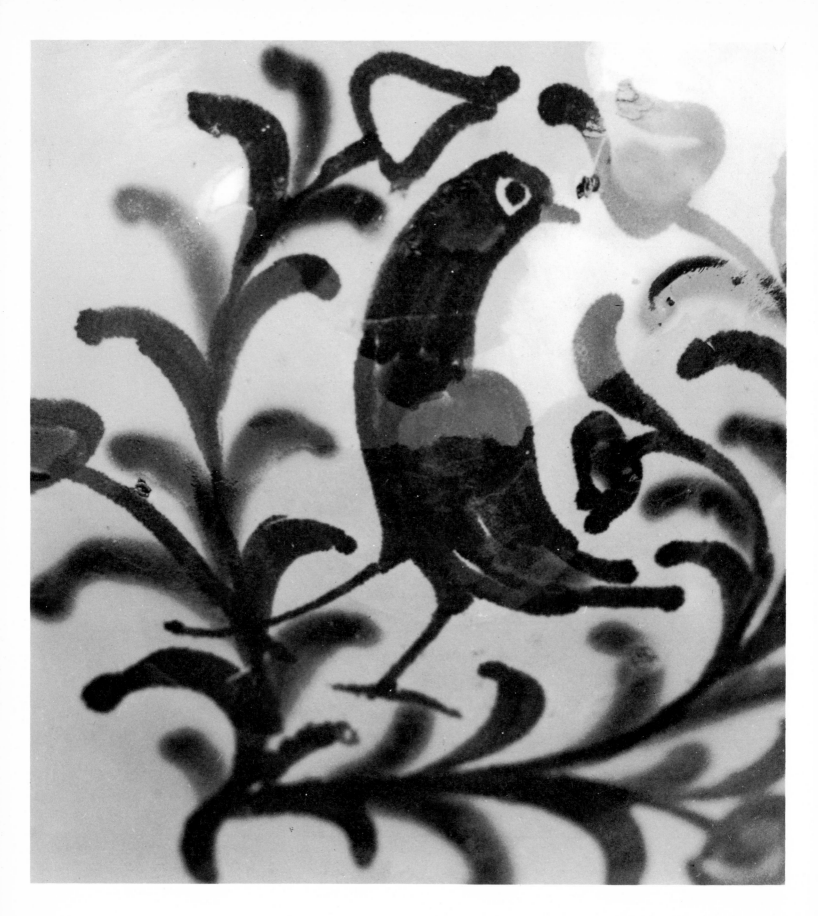

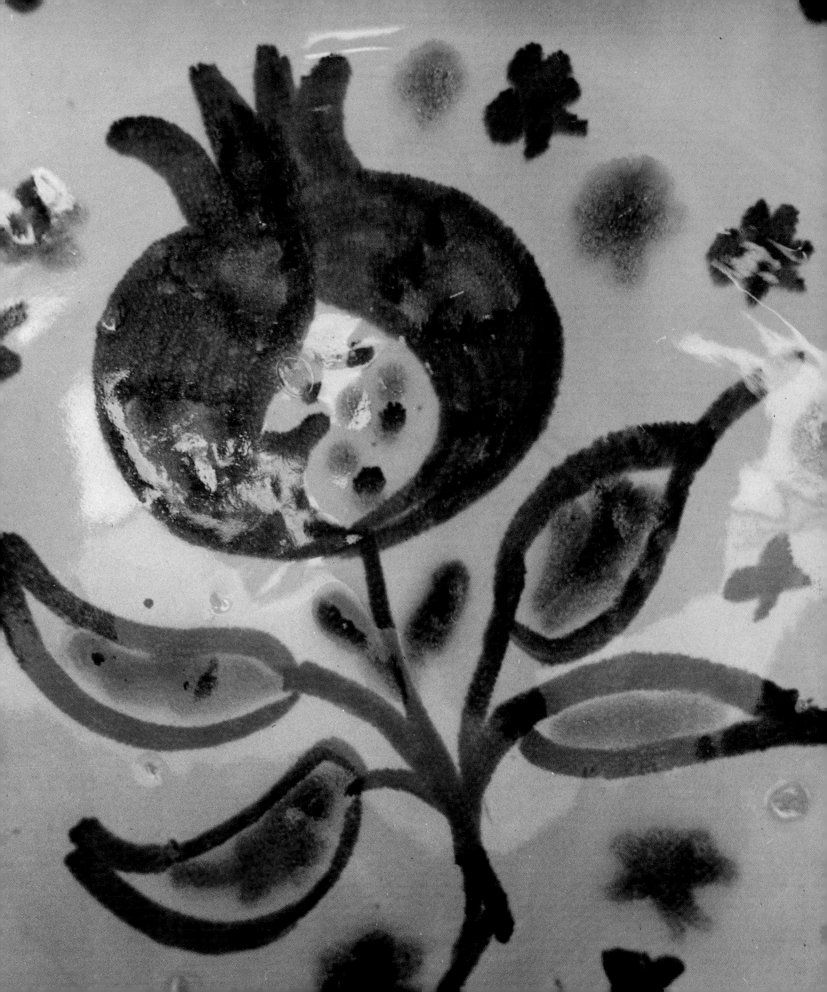

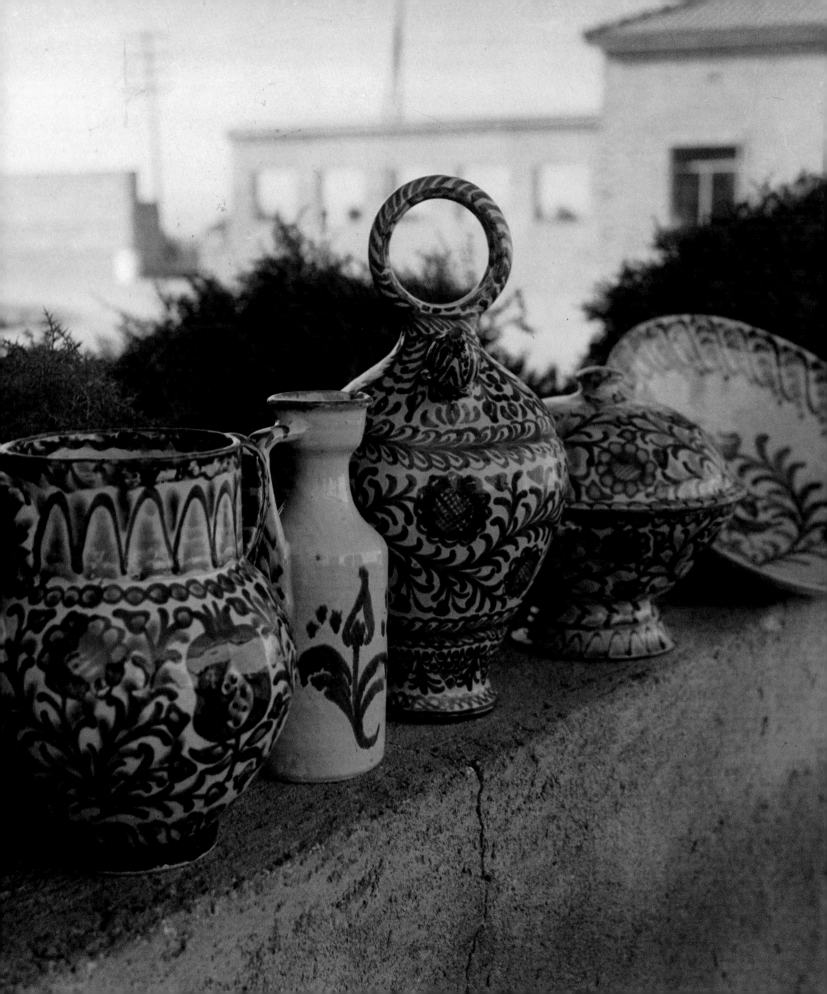

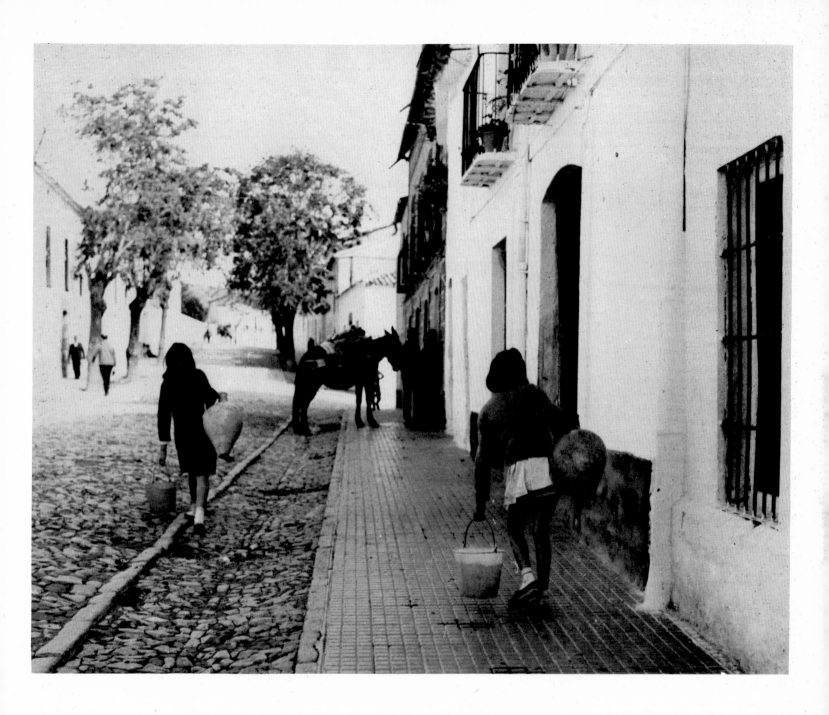

was green; but some seventy or eighty years ago the white clay from El Viso del Marqués, which is used today to decorate the articles, was discovered. The workshop is closed, because Salvador gave up pottery making about three years ago. He opens it for us and shows us the articles that still remain, half forgotten. He stopped working with ceramics primarily because the cave from which he was extracting the clay, collapsed: the others get the earth from another place, but it does not produce the same red. Salvador has known seventeen potteries in Ubeda, of which five continue to work, one belonging to his brother Alfonso.

Salvador accompanies us to another pottery, that of Pablo Martínez Padilla who works with his son Juan. The later maintains the traditional forms, although at the same time, he copies objects seen in books (even Assyrian lion). The ordinary objects are produced: "cántaros", "litle cántaros", and flowerpots, all of which are glazed; pitchers, jars, pots, soup tureens, plates, platters, washtubs, crocks, olive-oil jars, water closets, and flowerpots; in adition to novelties that are already "old", such as the coffe services

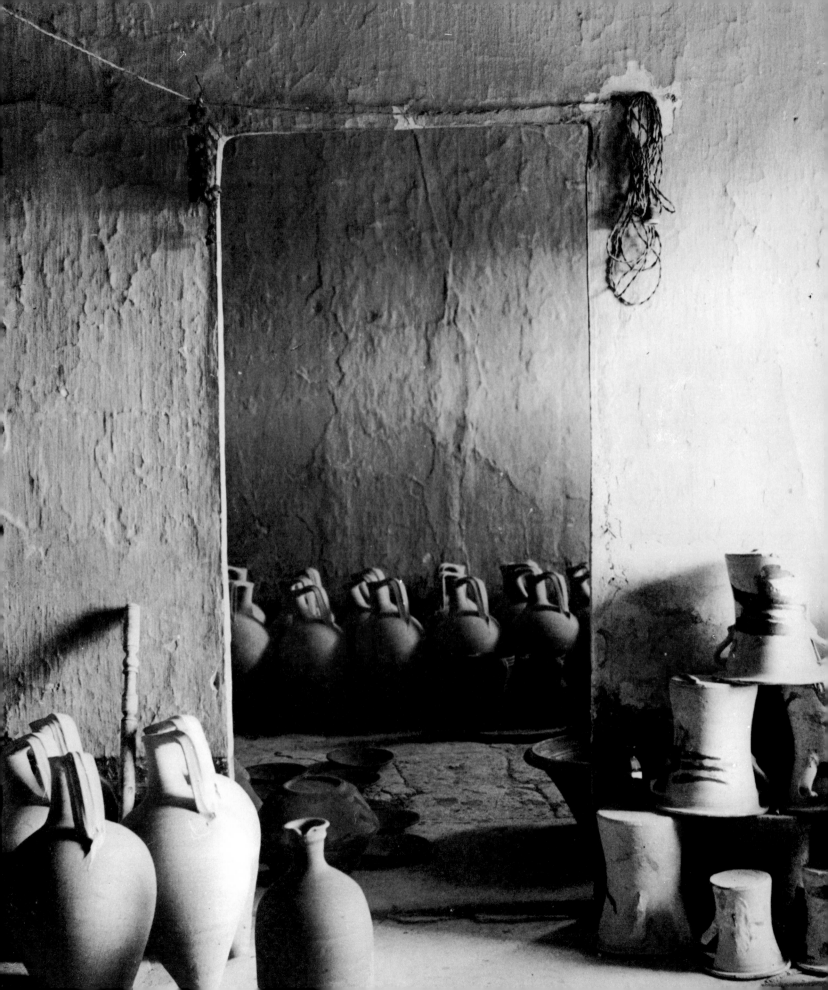

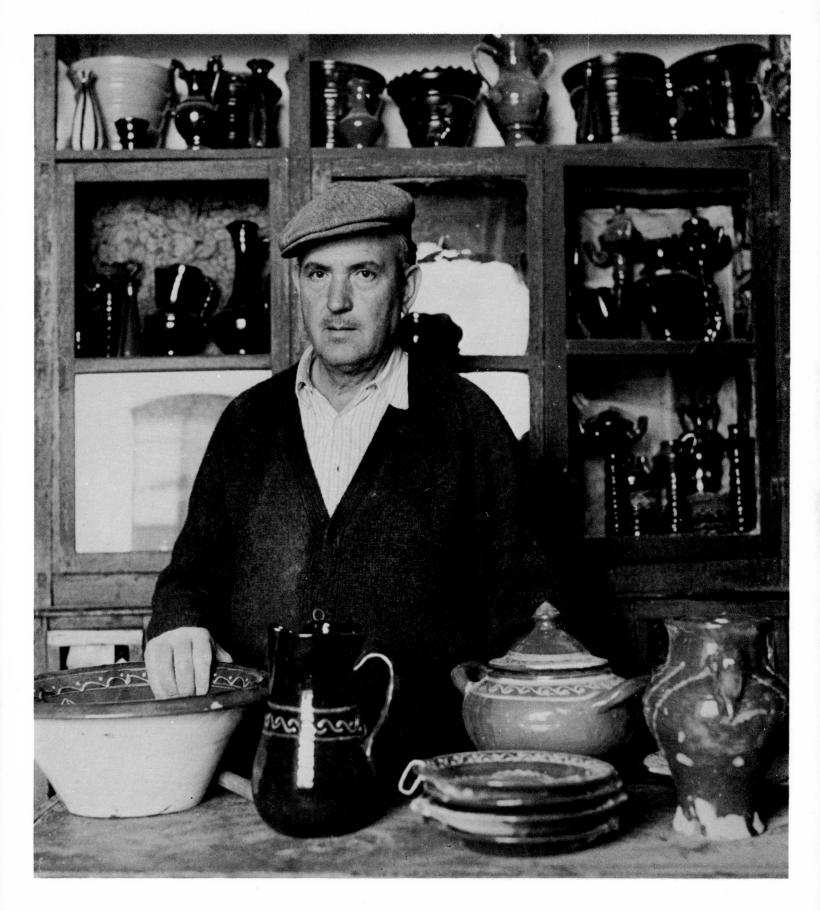

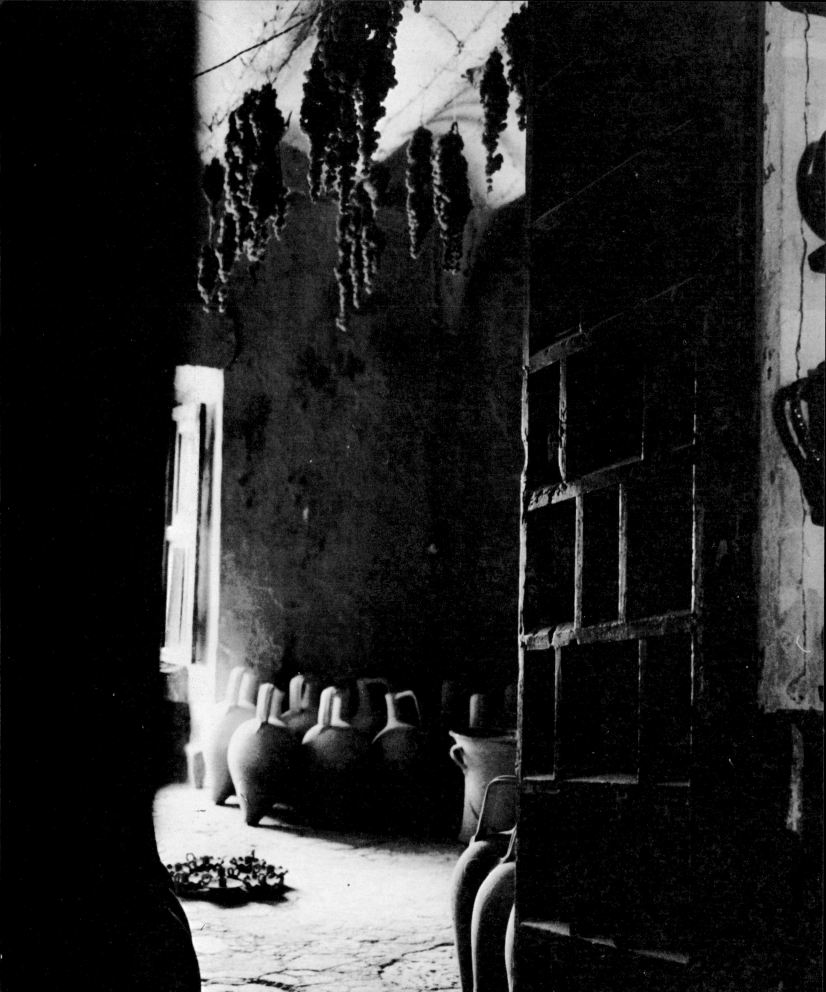

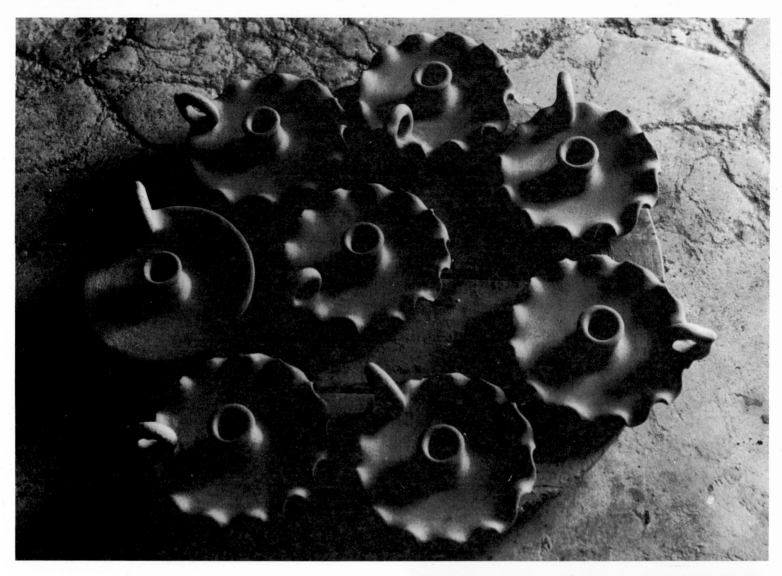

150. Cántaros, *Ubeda*
151. Candlesticks, *Ubeda*
 Sugar bowl, *Ubeda*
152. Plate, *Ubeda*
153. Washtub or dishpan and cock, *Bailén*
155. Jar, *Ubeda*
156. Vents in a kiln covered with pottery articles, *Bailén*
157. Unfired washtub, crocks, and flowerpots put out to dry, *Bailén*

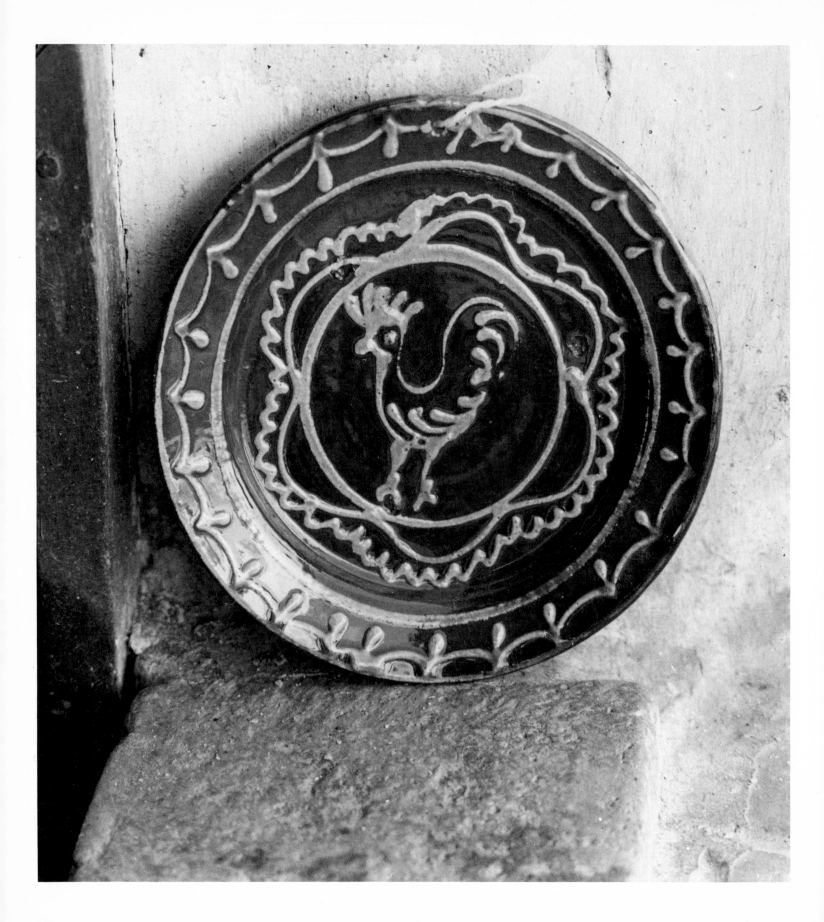

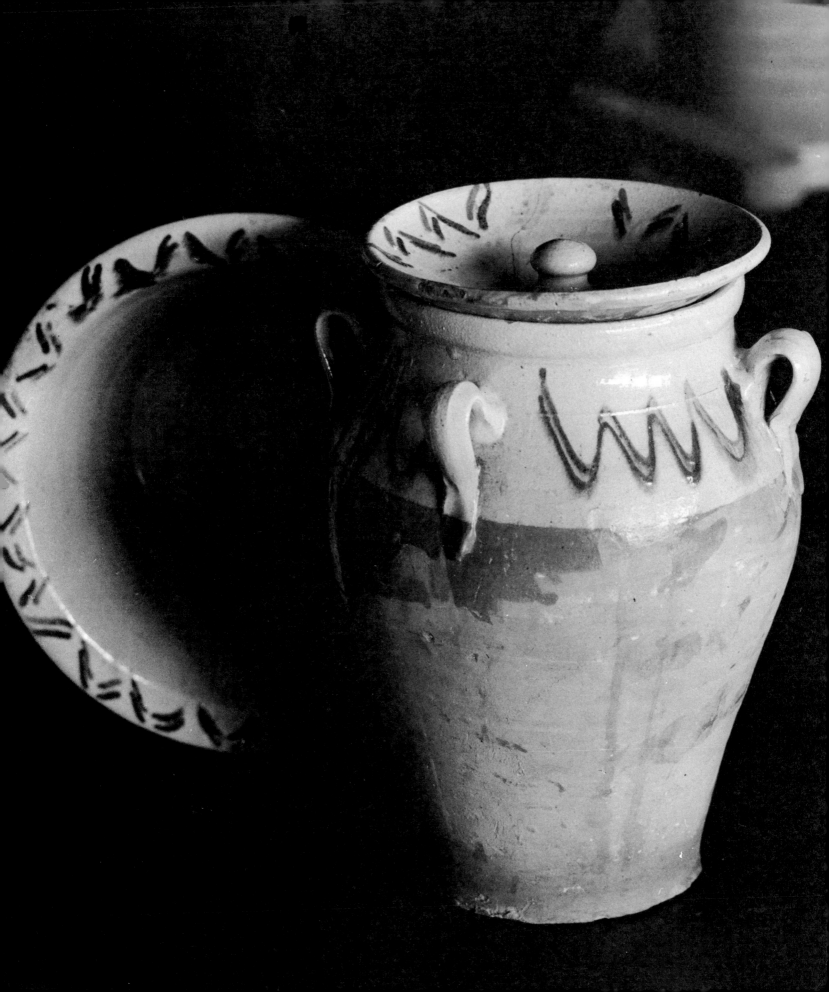

and beer sets. But things are on the point of changing radically. For the moment they continue to sell throughout the province and (especially the articles for domestic use) in La Mancha and Albacete. As an interesting note, we will add that Eugenio D'Ors; while on a visit to Ubeda, made a drawing for the pottery piece he requested, and wrote a poem on it.

Bailén has a large number of potteries: not less than forty one. At the present, they are in the hands of the former workmen, while those who were the owners, now devote themselves to the more lucrative ceramics for construction purposes. One or two of the potteries have thrown themselves wholeheartedly into the "artistic" production. The traditional object most frequently made is the flowerpot; of the six months during the year when the clay can be worked, three are dedicated to this type object. The crock is made with red earth and glazed with copper, turning it even redder; sometimes to this same red clay is added white clay from El Viso and then the glaze, and with the copper sulfate and the manganese, green and purple waters appear. They also glaze the "tinajón" or large jug, the washtub, and the flowerpot; plates and platters (all of which are green or purple, glazed only on the inside). The unglazed "cántaro" is also made. The lathe is generally operated by foot, with the exception of ten or twelve that are electric, one of which belongs to Mateo Durillo Carmona whose pottery we are familiar with. The production in the town is abundant, and easily sold to the wholesalers from Bailén, who ship it to other towns.

The ceramics from **Andújar** of Moorish filiation, sucessfully resists the difficulties of this period of decline. We visit Juan Muñoz Lara's house where his son Juan is now working. There are two other workshops devoted to glazed ceramics, and two potteries that make white "botijos". We have the opportunity of seeing: the jar (which at times bears the inscription "Viva la Virgen de la Cabeza"), the "student jar" (with four spouts), the "grotesque jar" (of one or several parts, made only on order), spice boxes, vinager pitchers, vessels for storing oil, "pito de toro", "pito de picador", "mula de cántaro", candlesticks, olive-oil lamps (with several parts), "pito" (whistle), toothpick holders, and glazed toys. The forms are graceful and the decoration is of quality, although it has lost some of the value of its design and colors in the last few years. The background color is white, and the design, blue with a little yellow and orange; at a later date the use of green and red was introduced. The decoration is done by the men. They work all year, although "in winter with less probabilities of dales." Their production is large and they sell their articles throughout all of Spain.

Some Potters from Andújar have moved to **Arjonilla,** where they make the same type of object that we saw in Andújar.

In another town in the province of Jaen, **Alcalá la Real,** earthenware is also made; here there are two potteries, only one of which is true to tradition, particularly in the production of "botijos".

La Rambla is an important pottery center which we later encounter. The thirty potteries found here are sufficient number to accredit it; and, we might add, none had less than three lathes. The town also has another industry or two, such as a flour mill which the potter, Juan Montaño Salado, assures us, "is the second largest in Europe." They work the clay eight or nine months out of the year, and the rest are dedicated to working in the mill or in the olive groves. The crockery production is, in large part, mechanized: half of the lathes are electric, and in a few potteries the paste is kneaded mechanically, with electric devices. It is sold throughout Andalusia, and at times they have shipped goods to Madrid. The types of objects made are unglazed water vessels: "botijos", "botijas" (à large "botijo" —canteen), pitchers, "bottles" (of very old tradition, few of which are sold today), "botijos de galio" (botijos in the form of a cock), "porrón de piña" (type of jug in the form of a pineapple), and "jarra de cuatro picos" (a jar with four spouts); in addition to the wooden "gazpacho" bowl. The forms are fairly usual, though the decoration of dots, embedded in the clay, and lines give the vessels (particularly the jar) a special touch. The bottle is very svelte and graceful. The color of all these objetcs is white, similar to that of Agost.

The four potters from the town of **Lucena** sell a large part of their production to wholesalers from Barcelona. Their vessels are similar in shape and decoration to those from other places such as Bailén. The articles made in Lucena are: olive crocks, cream-colored washtubs and plates (the latter decorated very simply with an olive branch, or the smaller ones with a border). Together with these, there are other vessels of a green color with no decoration at all, or at most, marked with notches; examples of these are the: "perulas" or big-bellied "cántaros", jars and "botijos", some of which are quite elaborate. All of these, both by reason of their shape and the quality of the green, exemplify a sober beauty.

There are four more pottery centers that we can point out in the province of Córdoba. The one with the largest number of potters, three, is that of **Bujalance,** devoted primarily to the production of "botijos". In nearby **Cañete de las Torres,** now in the process of disappearing, there

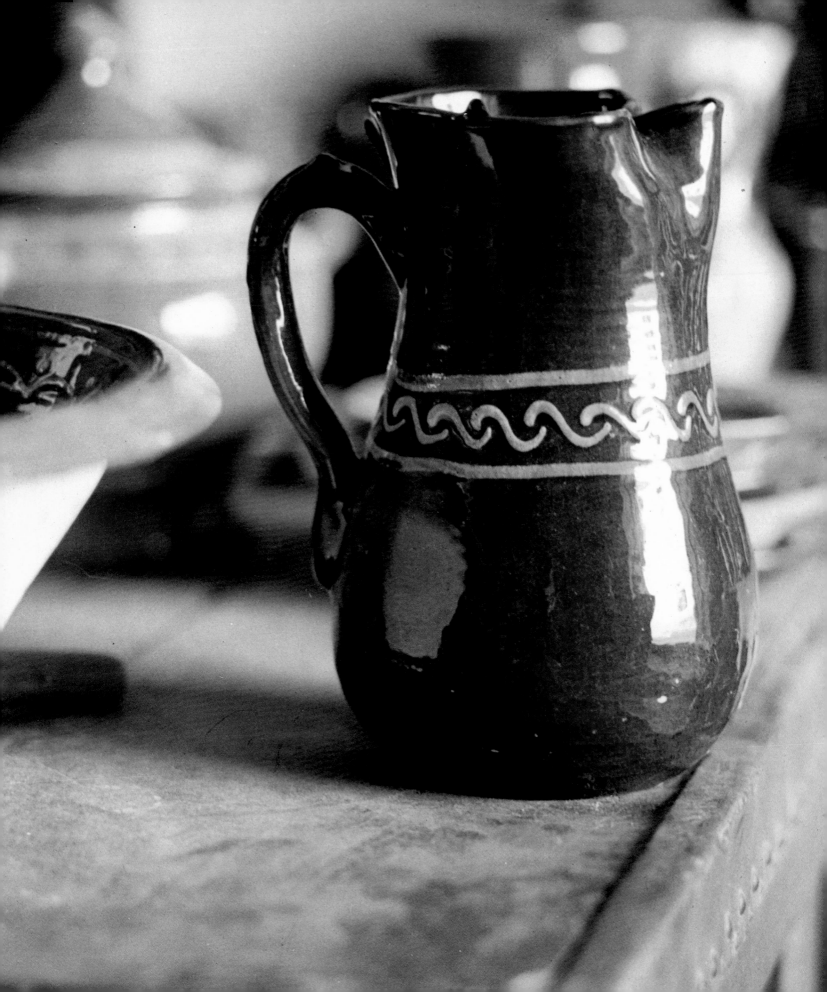

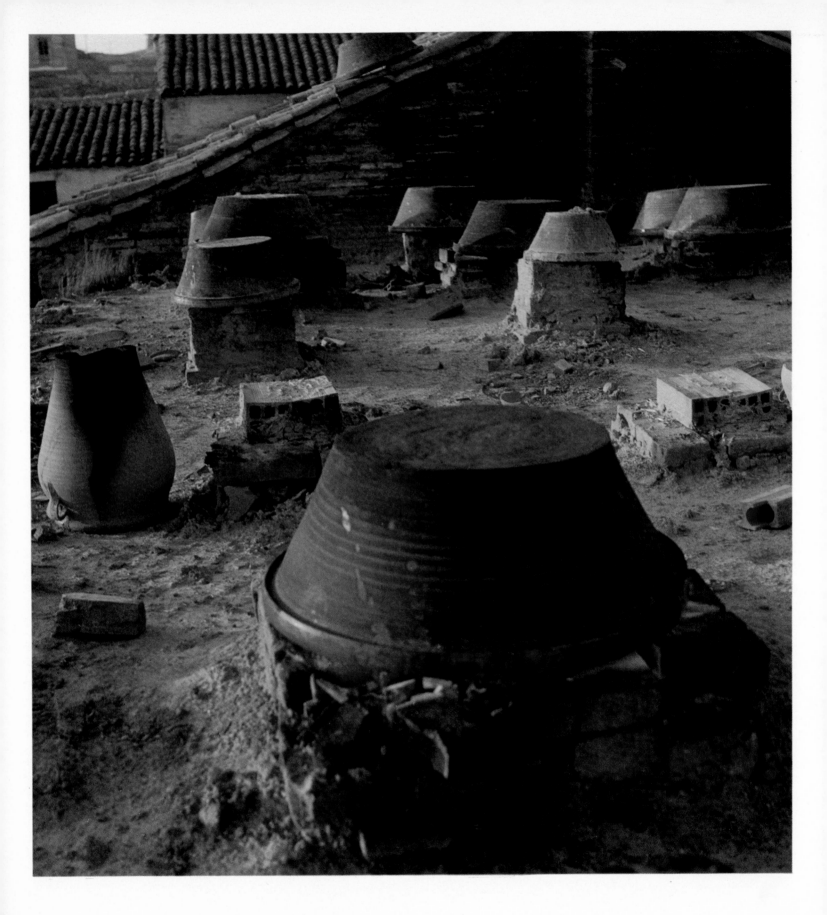

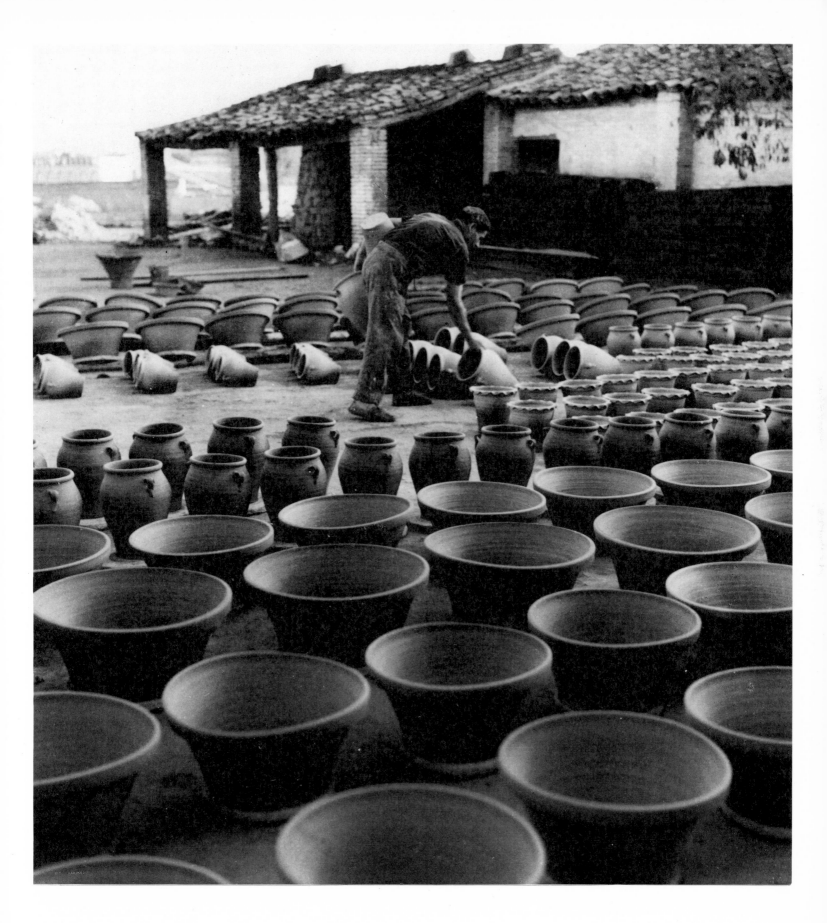

remains one lone potter whose work is also dedicated primarily to making "botijos". And we find still another pottery in the town of **Puente Genil**. Finally there is the pottery center of **Palma del Río**, devoted also to the production of "botijos", as well as troughs and flowerpots. On the way to Seville, already within the province of the same name, we find the town of **Lora del Río**, where "botijos" are also made, as well as washtubs.

Seville, which has more and more the air of a big city, old and modern at the same time, forces us to linger here a while. The ceramics from **Triana** is famous here; the shapes and decoration originated in former times, are copied, and many of them are now regularly reproduced. The glazed ceramics of Triana is today a mere reflection of its past moment of splendor. The distinct influences, made in the sixteenth century by the Florentine and Venetian ceramics on the pottery here, can still be noted. We are assured that in a relatively recent date more than thirty pottery factories have existed here; of these only three remain: Cerámica Santa Ana, that of Mensaque Rodríguez, and Cerámica Montalbán, one of which is on Pottery Street, not far from one of the others. In the first, which is the one we visited most thoroughly, only one foot lathe remains; the lathe operator is named Rafael Muñoz Chávez, who is well acquainted with all the details concerning the clay. According to what we were able to observe, the work is maintained within the bounds of tradition, although there are slight signs of "modernization": for example, he uses a mechanical kneader to prepare the paste. The enamel is prepared here with primitive formulas. All of the production is glazed, with the exception of a few types of flowerpots. The color of the objects is, in general, one of the traditional ones of Triana: blue, green, yellow, orange, black, and white; there are several different greens, blues... The catalogue in the workshop, in color, allows us to see a résumé of what we had found while going through the warehouses: jars, "cántaros", "botijos", plates, candlesticks, flowerpots, pharmacy containers, cáne stands, vases (in an endless variety of types, some of which are modern), beer sets, coffee services, dishes, every type of platter, decorative plaques for buildings (8 in. by 8 in.), borders for flat roofs

158. Bottle, *Andújar*
Whistle, oil vessel and spice box. *Andújar*
159. Loading the kiln with objects, *Bailén*
160. Jars, botijo, and botija, *La Rambla*
161. Various objects of the current production in *Triana*
162. Dishpan and plates, *Cortegana*
163. Oil vessel, *Andújar*
164. The clay ready to be softened, *Cortegana*
165. Urn, vase and cane stand, *Triana*

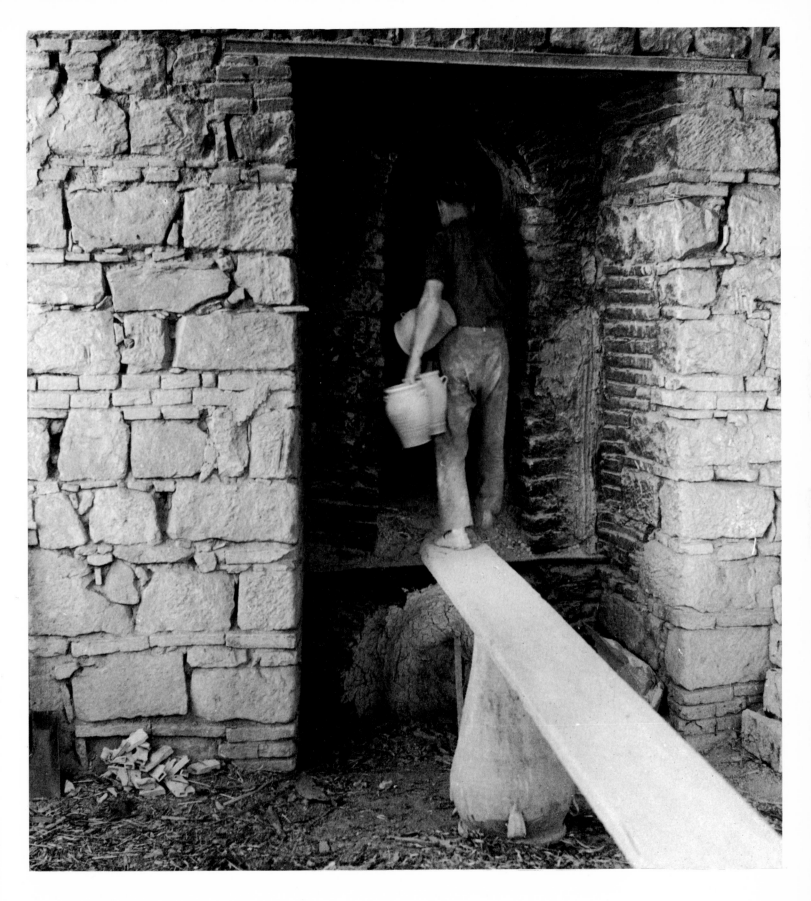

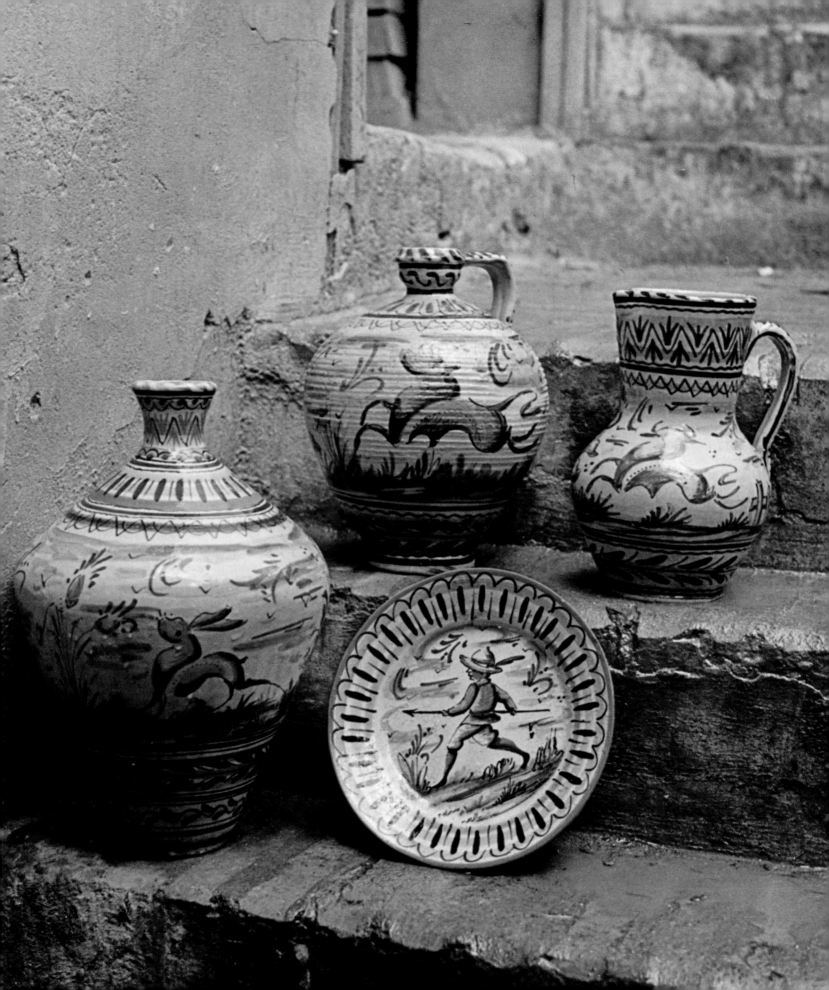

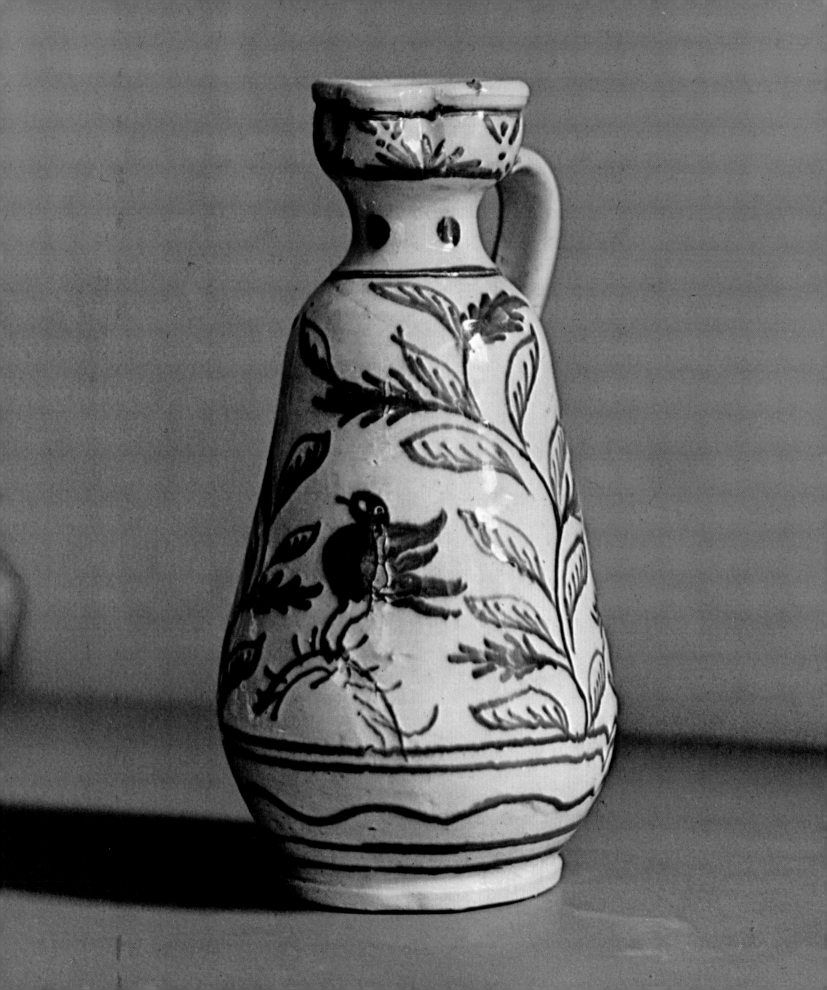

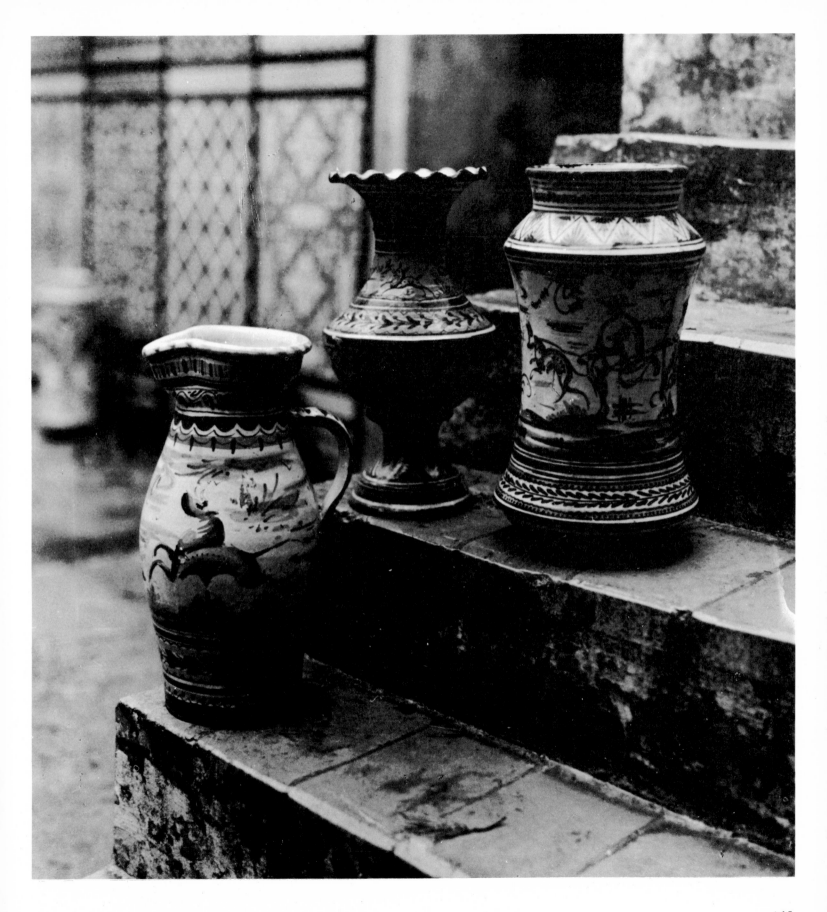

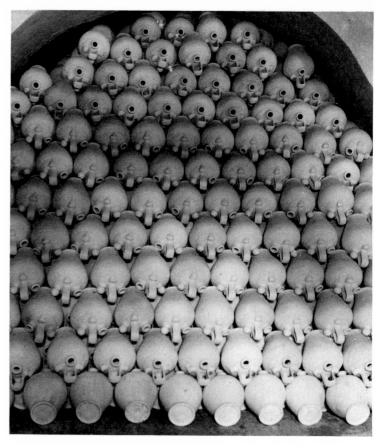

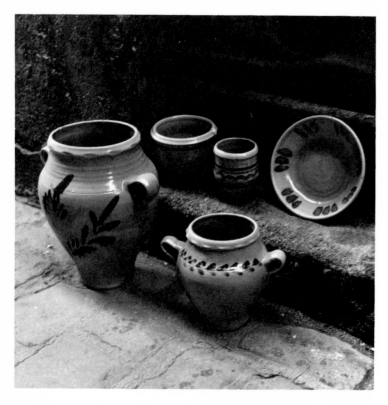

166. A pottery, *La Rambla*
Botijos in the warehouse, *La Rambla*
Crock, mortars and plate, *Lucena*

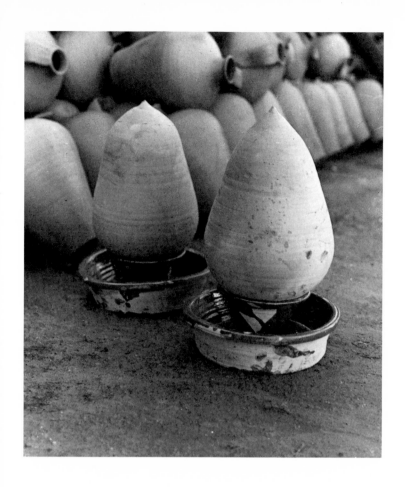

(generally made with the l..the), samples of "cuerda seca", mosaic and raised tiles (they come from the press with the relief made, and the women fill the openings according to the color desired) and unglazed flowerpots. They also sell ojects from other towns, such as La Rambla, Bailén... Their characteristic articles, which are properly appreciated, are shipped, on order, to different countries. (As we are about to leave, a caravan of tourist enter with their guide...)

In neighboring **San Juan de Aznalfarache,** no work has been done for the last twenty years. But there are two other pottery centers to be found in the province of Seville: **Ecija,** with three potteries, and **Lebrija.** The former produces water vessels, primarily "cántaros" and "botijos" and latter unglazed earthenware such as "dornillos" (for gazpacho), flowerpots and mortars.

Here we find, in general, simple ceramics (glazed and unglazed), although that of Cortegana is rather interesting. In **Trigueros** there are seven potteries. José Sánchez Pérez, the owner of one of them, seems optimistic about the possibilities of the pottery industry: the businesss is good and he believes the work will continue. Neither the kneader, lathe, nor kiln is mechanized. From the town come: "cántaros", washtubs, jugs, flowerpots, gazpacho bowls and water troughs in two parts.

The ceramic production of **Beas** is dedicated at present to amphoras and sculptures out of the traditional line. **Aracena** has two potteries: Artesanía Pascual and Cerámica Madre de Dios, the latter with enameled artistic ceramics.

Cortegana has some industry: the processing of cork, curing of hams, production of steelyards, as well as six mechanical workshops and three potteries (of the twenty that existed at the time of Antonio Ramos' father, as the former, a potter here, explains to us). He also tells us that once there was a television report on the ceramics here. The interest is due to the decoration of the object, for the types and shapes are the usual ones: "botijos", "cántaros", "cántaro-botijos", flowerpots, piggy banks, all of which are unglazed; crocks, washtubs, plates, pans, chocolate pots, the interiors of all of which are glazed; and a few decorative vessels completely glazed, such as the amphoras and jars, with which this book is not concerned: There was one potter who dedicated himself to crèche figures, but he had died four years before we made our trip to the area in 1968. The decoration of the glazed objects is made with a spoon, one for each color. The decoration is varied; by using a few elements of alternating colors (various shades of green and white, which have been yellowed by the red in the clay) they succeed at times in giving the article a surprisingly modern flavor (in the complimentary sense of the word) with an abstract decoration, in which the color is innocently used to improve the optical value.

167. Water trough in two parts, *Trigueros*
168. Polishing the objects, *Cortegana*
169. Pitcher, two handled pot, cántaro-botijo, and crock, *Cortegana*

167

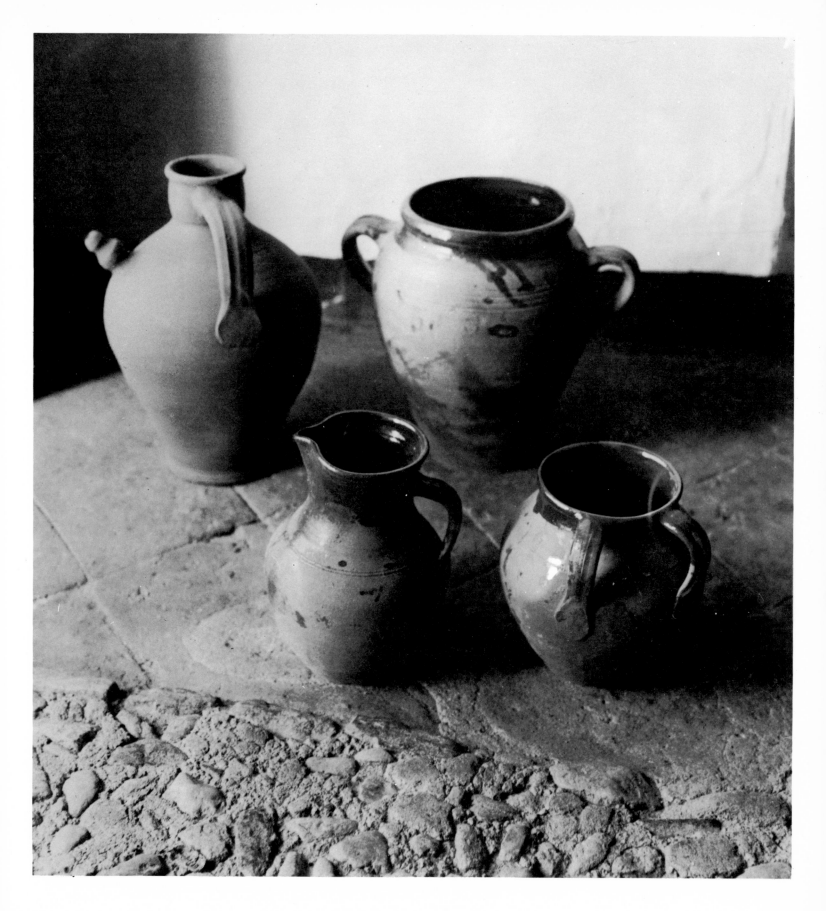

murcia

Very unsimilar regions are clustered in the "Kingdom of Murcia". The land comprising the province of Murcia is Mediterranean and forms a transition between Valencia and Andalusia. The Albacete district, whose interior is very complex, has a large part of its territory within La Mancha, and has a climate, vegetation and economy radically different from that of Murcia.

The main highway, coming from the French border and passing through Barcelona, Valencia and Murcia, characterizes the places along the road in a special way. There are many things which are done for the tourist business, including things which at times are done in imitation of the foreigners, or with the vague hope of profit. The pottery booths set up along the highway to sell the vessels are repeated with such frequency from Vendrell, near Tarragona, to Murcia, that it finally causes a feeling of disgust. It is a matter of bad reflections or aberrant derivations of the popular articles, exhibiting a bad taste that is truly impresive.

Upon occasion, a few of these stands acquire the reputation of a center of popular ceramics, though it has never been one, and is even stated as such in certain publications, especially the official tourist ones.

Mula, in the interior of Murcia, has three potteries which use very primitive procedures in their work. They make kitchen crockery, pots, and casseroles, few of which are sold; and for that reason, they are beginning now to produce flower vases and amphoras. The normal flowerpots and the large ones are, because of their easy sales, logically maintained better, as is also the little casserole which, because of its size, is used in the bars to serve appetizers. As a whole, the sales are good, as Andrés Boluda explains to us.

Aledo, where until recently pots and casseroles had also been made, has completely abandoned this type of ceramics and now dedicates itself primarily to a variety of small vases and spice boxes which are sold by the highway or in the province.

Totana is an important center of ceramics; eleven potteries devote themselves to making "cántaros", vases, crocks, and flowerpots; while three others primarily produce large jugs (the largest is of "seven cargas" — a "carga" being four "cántaras").

In **Lorca** two potteries maintain the traditional ceramics, while three others have changed to making tourist articles. They have recently begun to make some of the vessels characteristic of Vera, doubtlessly inspired by tehir great beauty.

Moving to the lands of Albacete we will begin with **Chinchilla,** which is some eight and a half miles from the capital of the province. The objects which have made the ceramics from this town famous, is the so called "cuervera" (in the border of which are placed small jars), used to serve "sangría" or "zurra". Normally many are made, on order, for small clubs or groups of friends, who have the name of the group written on the interior. The two potteries which remain are the property of the brothers Antonio and Luis Tortosa (to each of whom belongs one), who have set up shops on the highway to sell the articles. This ceramics is also in danger of being spoiled, and the "cuerveras" that we have seen in the last few years show a progressive loss in quality and the characteristic flavor of the traditional objects. They continue to make "perolas" (platters) and "pucheros" (jars), as well as yellow and greenish plates. In a trip we made to Chinchilla in 1962 we were able to see a few old type objects that Antonio Tortosa had just made: one of the Magi on horseback (a rather large figure), a bull, and a basin for holy water. These objects which are only made upon occasion, and always on order, preserved a delightful simplicity and naturalness. In the house of one the brothers, we were surprised to find an original drawing by Benjamín Palencia. They told us that the famous painter, born in this area, spent a few days here and became interested in the pottery being made. He bought some objects and ordered a few to be made according to the drawing that we had just seen.

There are other towns where earthenware is made, though the work is more insecure every day: **Albacete**, dedicated primarily to the production of tourist items; **La Roda**, where one of the potters from Chinchilla is working; and **Tobarra,** which produces washtubs and crocks. A few years ago Hellín ceased to be a pottery center; until then it had produced a two-handled "cántaro", but with a narrower base than the one from La Mota.

Finally, we encounter **Villarrobledo** a pottery center which

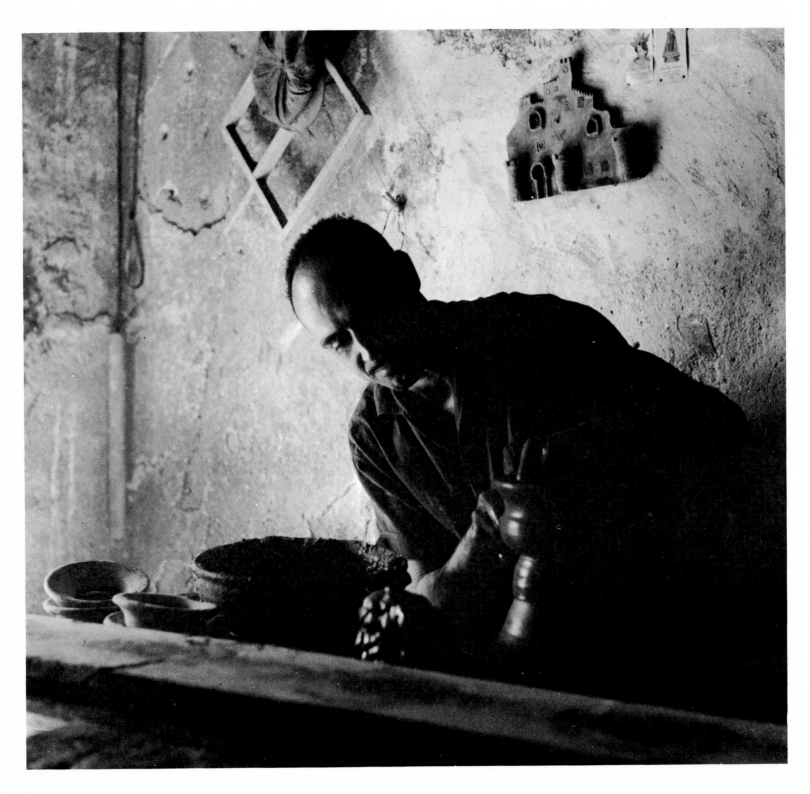

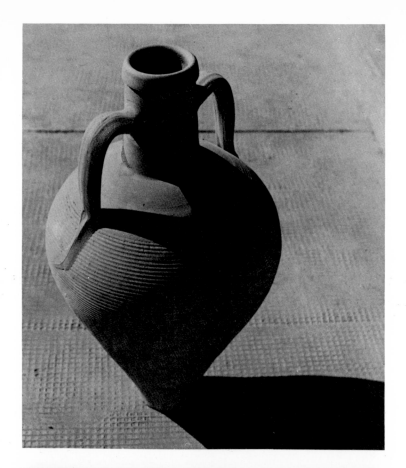

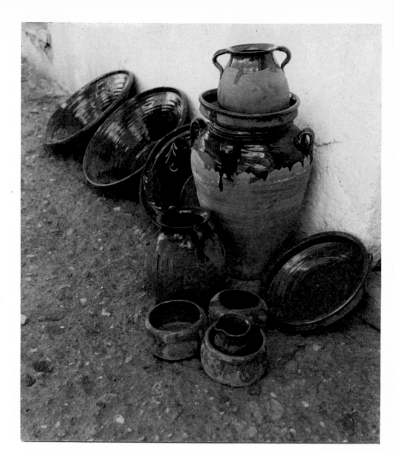

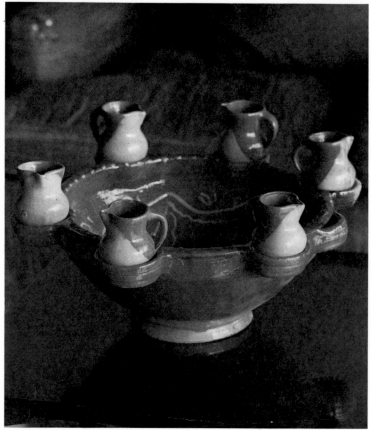

172. Pottery workshop in *Mula*
173. Cántaro, *Totana*
Crocks and washtubs from *Lorca*. The remaining objects are
from *Mula, Totana y Aledo*
Cuervera for sangría or zurra, *Chinchilla*

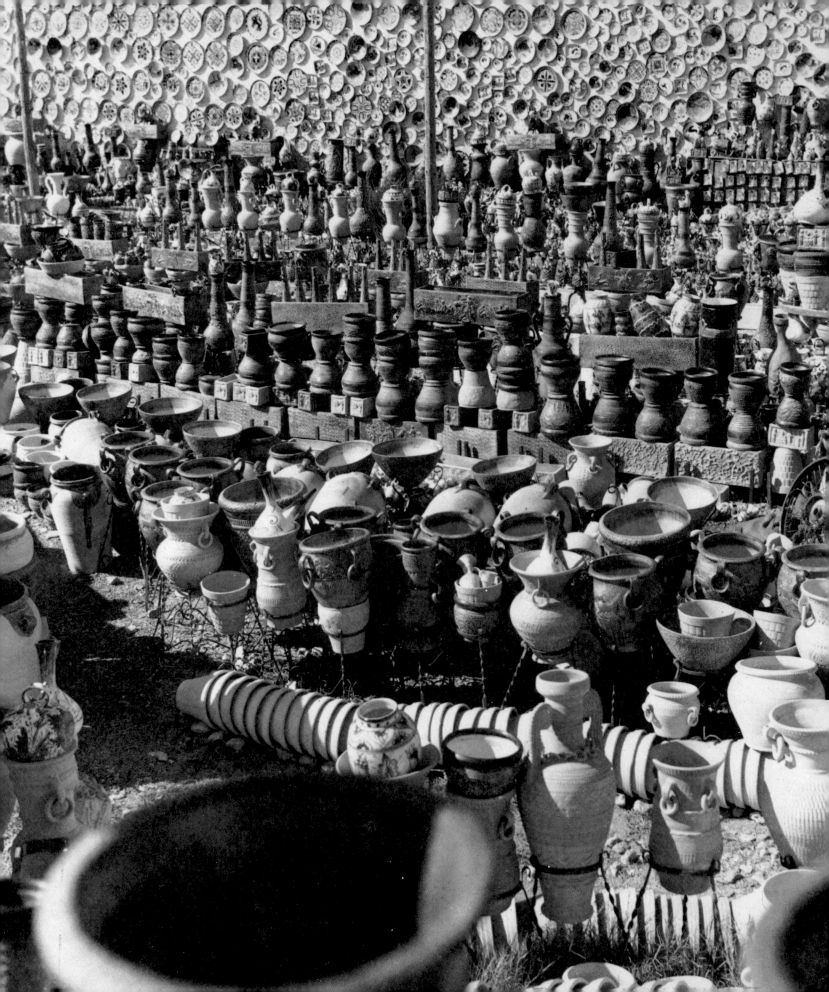

has been, and still is, extremely interesting. This is due, primarily, to its jugs. Even the song known through out La Mancha, points this out: "In Villarrobledo / there are delightful things / but they are the jugs / and not the girls", a strange compliment to the pottery in which the girls are unjustly sacrificed.

Six potteries continue to work here producing: casseroles, flowerpots, "cántaros", and "little cántaros"; as well as "artistic" vases: at least part of which are made, not with the traditional potter's wheel, but with a hand wheel. The large jugs are used to store wine in the wine cellars; there remains only one jug maker (described by Rafael Mazuecos in his recent study of the subject) named José Gimena. (We deal with this type of jug in greater detail in the section dedicated to Colmenar de Oreja.) At present, the making of the jugs is done on a small scale, and only when ordered, since the use of cement tanks made in the wine cellars themselves, have become so widespread.

174. Ceramic articles from several sources in a store by the highway dedicated specially to the tourist business. It has divorced itself almost completely from popular tradition, *Puerto Lumbreras*

valencia

The people in the "Kingdom of Valencia" are industrious and they have a rare capacity for rapidly fulfilling their possiblities. These conditions and abilities, together with the good qualities of the clay in some of the towns, logically had to produce a great ceramic wealth. Valencia did possess such a wealth at one time, and it still does (to the extent allowed for by the present circumstances) in the diverse pottery centers scattered from Traiguera, in the province of Castellón, to Agost in that of Alicante, passing by those towns which in former times were as illustrious as Manises and Alcora. We can still find great activity in this field throughout the area, and we can verify the diligence and organization with which the Valencians distribute their articles in the farthest corners of Spain.

We begin with **Traiguera.** Of the "cántaros" which can be found today, the ones made here are among those that best preserve the traditional flavor. There are four remaining potteries which do a considerable amount of work. In some of them one can begin to observe the decline of the popular forms, and the indications of a "craftsmanship" for tourist. The town earns its living from agriculture — olives, grapes, almonds and wheat — to which during two or three months the potters also devote themselves; there is also some complementary ceramics for construction purposes. Until two or three years ago they did not have running water. According to what we were told here, around 1930 the number of potteries had reached approximately thirty, and the firing was done in two communal kilns. The one who informs us of this is Hilario Marco Cabanes, forty years old, who works with three partners. He, especially, pays much attention to the "new craftsmanship". The four partners together bought the "machine" to make the flowerpots. The shape of the "cántaro" is very beautiful, as is it its decoration which is made with a few simple bands or small lines of clay that contains iron oxide, and which may remind one of stylized leaves. Aside from this "cántaro", whose capacity varies between 2¼ and 3½ gallons, they continue to make the "botijo" ("cantir"), the water troughs

for hens and rabbits (made in two parts linked by a siphon), "catúfols" (which as we already know are large pitchers for carrying water) and the flowerpots which are the only objects made with a mold.

The present-day ceramics from **Alcora** has nothing to do with that which made it famous. A few of the objects are glazed, with a green varnish made from galena from Linares. It is a simple and unadorned ceramics which has been made during the last few years by four potteries, but only one continues to operate. There are three brothers working together in it, and they have modernized the technical aspects: one of the two lathes is electric; the clay is ground by an electric grinder with two five-horsepower motors, and they also have a mechanical kneader to prepare the paste. They use a small truck in which to transport the materials and distribute the articles. The potters are named Vicente, Pedro, and Antonio Nomdedeu Medina, and are sons of a ceramist. The objects are sold through shops and markets within the confines of the region, although they have at times sent items to towns in Catalonia. The vessels, of a light color, are the ones which we already know so well from other towns: jugs, with the interior glazed, in various sizes from 2 quarts to 50 gallons, used to store olives, pork products, etc.; washtubs, also with only the interior glazed, measuring from 1 foot to 1 yard in diameter; "cántaros", with a capacity of 3 or 2 gallons; "cántara-botijo", "botijos", "cocíos", used in the farmhouses for washing clothes; various types of feed and water troughs; piggy banks and flowerpots made by hand or with a mold, according to the size.

In **Ribesalbes** and **Onda** we find a very industrialized ceramics. In the former, the pottery making is limited to copying old models from Alcora, almost all of which are made with a mold; they shape very few things on the lathe, as was explained to us. Although Onda applies new techniques to many phases of the work, it is more bound to the typical traditional chores. The majority of the produc-

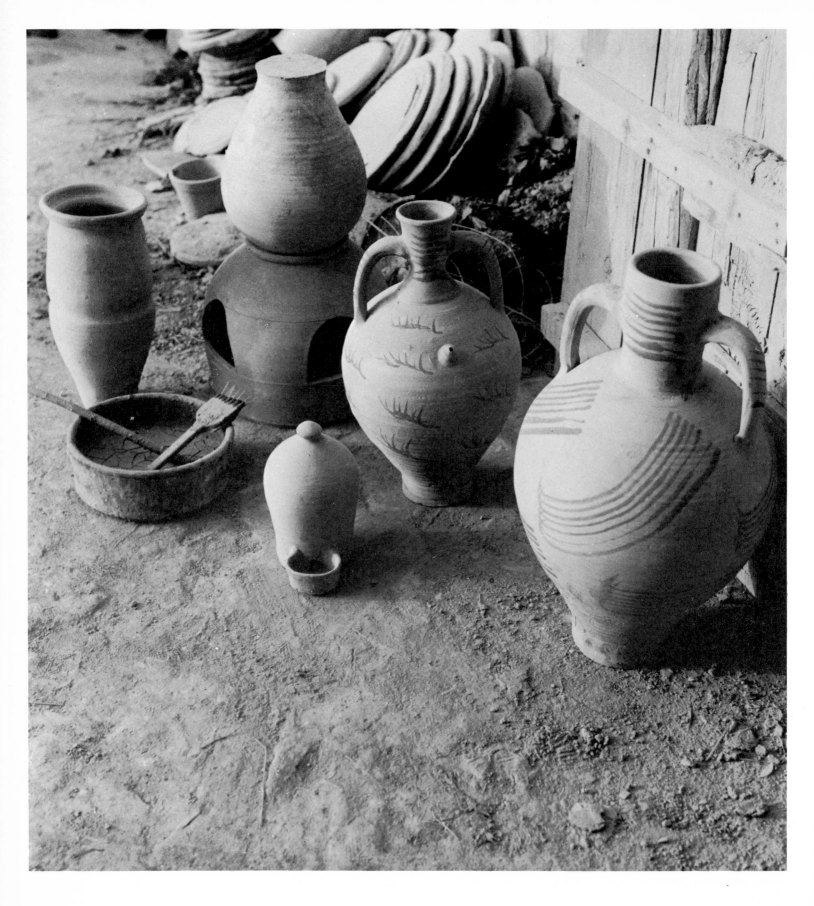

tion here is also made with molds, although they still make with the lathe: the "botijos" (in great quantities); "little--bird-botijo" (in smaller quantities for retail), jars (in the two types and conditions mentioned in reference to the "botijos") and large, decorative plates; all of which are glazed. The decoration is based on the style from Manises, with a few variations. We were fortunate enough to find a few successful objects, although as a whole the production was inferior. When requested they also make from a wooden press, very pretty tiles decorated by hand with flowers.

They assured us that, with the exception of Andalusia, they sell to all of Spain. This workshop devoted to glazed objects, belongs to the Sorolla Sansano brothers: José is the one who operates the lathe, and Antonio decorates the objects. In Onda there is also a pottery that make "botijos" and flowerpots.

In this area there is another interesting center which should be recorded: **Vall de Uxó**, which has nine kilns. The atmosphere was not pessimistic, in spite of the fact that four kilns have disappeared in the last five or six years; the objects are easily sold at wholesale or in the markets. The majority go to Valencia, but also to Castellón, Villarreal and Nules: "in short, to the nearby places", as José Tur Garcés, one of the nine potters, explains to us. The production consists of coarse crockery: pots and casseroles; "if a coffee service is requested it is made, but it is not usual; the normal articles are the pots and casseroles." They also make toys, which here are called "obreta" (in Valencia where they are sold, they are known as "escuraeta", because one must "escurar" (polish) them a lot.

On arriving at the main square of **Segorbe**, beside the

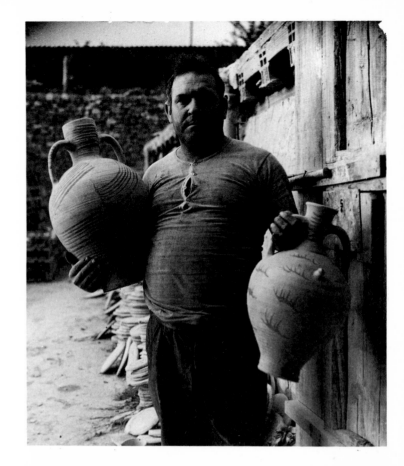

178. A variety of objects from *Traiguera:* Jar, water and feed trough for hens and pigeons, botijo and cántaro
179. Cántaro and botijo, *Traiguera*
Tools for decorating vessels, *Traiguera*

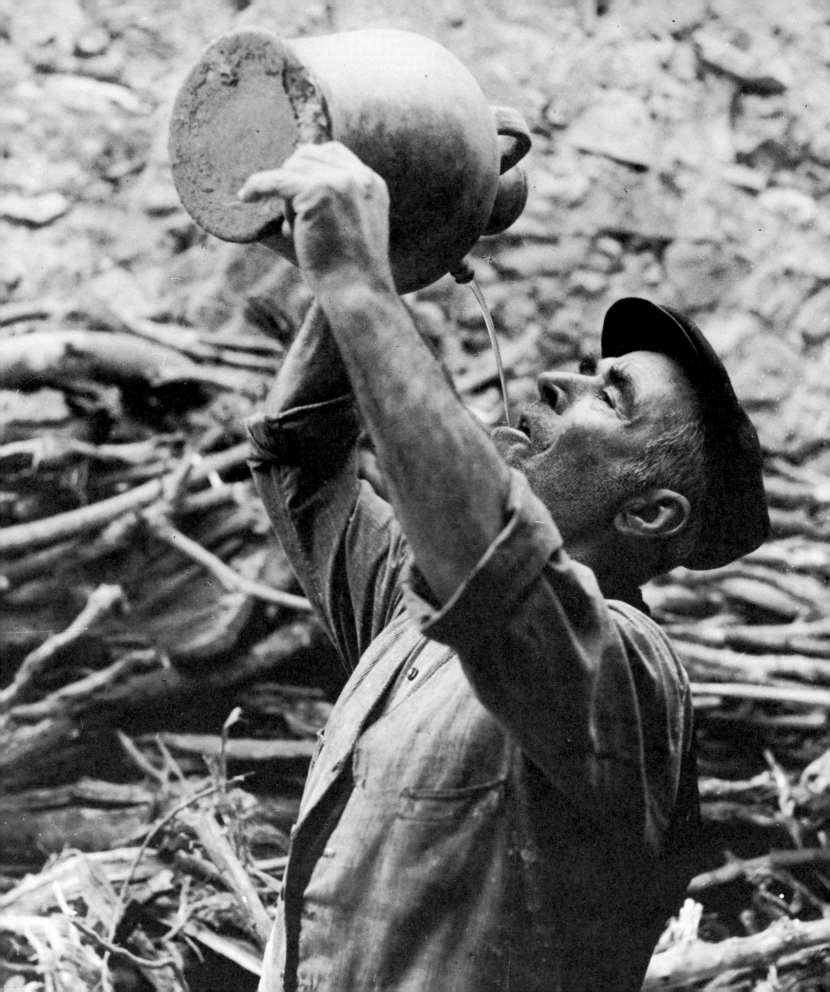

181. Washtub, cántara and botijo, *Alcora*
 Water and feed trough for hens and pigeons, *Alcora*

Cathedral, we find a pottery stand, where samples of the local production, as well as that from Vall de Uxó, are displayed: "cántaros", "botijos", vases, flowerpots, mortars, and bulls, all glazed in green. There are eight potteries still in operation here.

In other towns on which we had counted, the ceramic industry had already disappeared: **Castellón, Villarreal** — where the last pottery ceased to exist some twelve or fifteen years ago — while in **Alacuás**, there were still two potteries in 1971 which had produced glazed cooking vessels: casseroles and kettles.

Manises is the last word in ceramics. It carries a lot of weight, in as far as ceramics is concerned, and induces one to approach it with a certain respect. But with all the respect that the town and its history deserve, we feared the worst. The walk through all the places looking for what we are interested in was somewhat disheartening, but at last we discover it. It must be noted that on a whole the objects made here are common and in bad taste. After many steps we stopped in the workshop belonging to the brothers, Manuel and Vicente Gimeno Aguilera in which they, contrary to the others, reproduce the old style with authentic quality.

They are at the moment (with the exception of one other pottery, dedicated to coarse ware and to which we will refer later), the only ones in Manises who continue to make the traditional articles on the lathe; the others have now changed to the mold. The kiln, on the other hand, is not the "Moorish" one, but rather one that has a muffle. The old ceramics from Manises, beginning with the eighteenth century, at which point its decadence originated, has continued to survive, though without special brillance. José Gimeno Martínez, the father of the two brothers, has been one of the people in the present century, who has most stimulated the pottery making here. He was in Paris on a scholarship as a young boy, and it was there, on seeing the old pottery pieces from Manises preserved in the Louvre, that it occured to him that the pottery making could be attempted again.

The most striking object made in Manises today is the

182. Bird-botijo, *Onda*
183. Jar, *Onda*
 Cántaros, trick botijo and "don Pedro", *Segorbe*
184. Pottery stand, *Segorbe*
185. Pots and casserole, *Vall de Uxó*

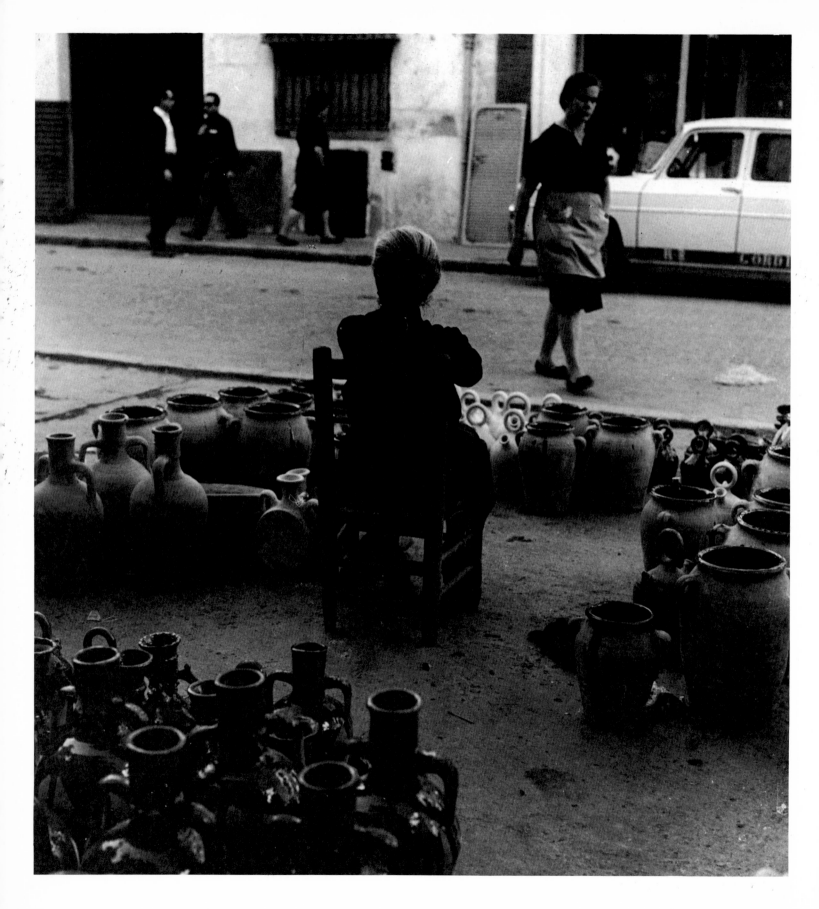

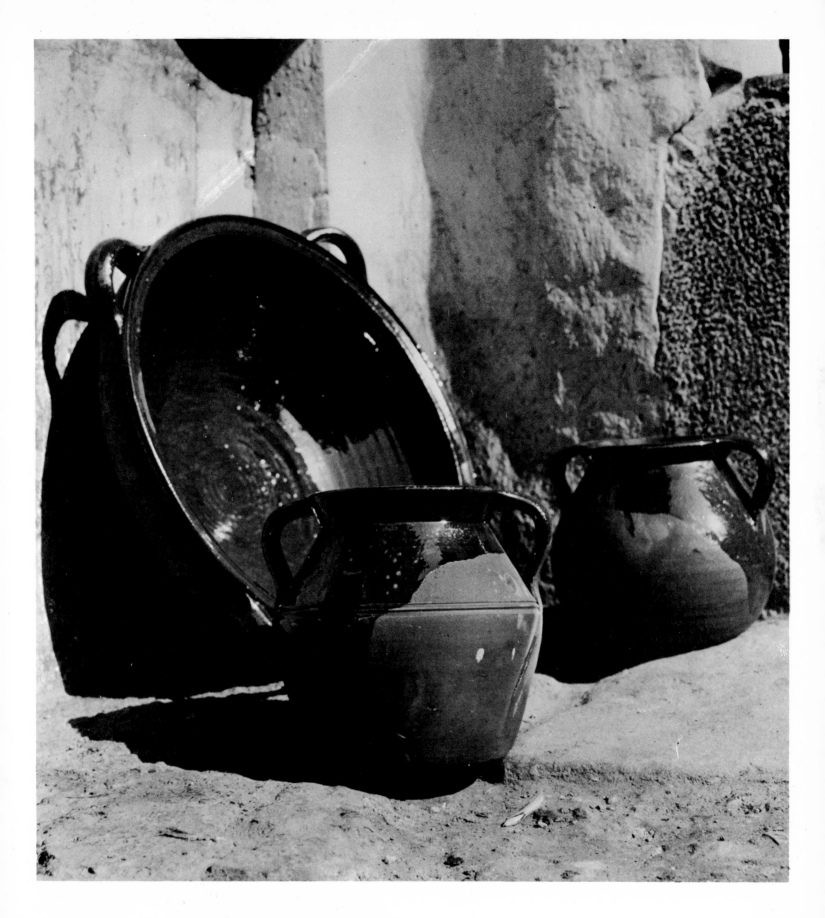

baroque "alfabeguer", of which we are able to see magnificent examples; as well as the jars, spice boxes, plates... with the famous blue and yellow decoration.

The enamel used, is the same as in other workshops in Manises, although here it is regulated according to taste: the blue from cobalt; commercially prepared compounds for the yellow; the white from tin, quartz, and arsenic; "artificial" green that they make themselves, and orange from chromium oxide.

The ceramics from Manises has had wide acceptance. It is sold throughout all the Peninsula and is exported, primarily to the United States, Switzerland, Great Britain, and Japan; "with the exception of Russia", they tell us "we export to almost everyone." "We ship a lot to Japan and among the most expensive objects."

We later visit Manuel Bertual, the only one in Manises dedicated to coarse ware. We will explain that he is not the owner of the business, but he interests us since he is the one who shapes the objects on the lathe.

He forms the articles on the potter's wheel, although a large part of the production (fired in a muffle) is made with a mold. With the lathe Bertual makes: the round jar, the "sangría" jar, coffeepots and teapots; cups and bowls; ashtrays and toys. This workshop for simple ceramics also shares the enterprising spirit that moves these people. It, too, sells to all of Spain, and abroad, to the United States, Belgium, and even Australia. "There is a lot to be done in the field of exportation", Manuel explains to us, "but what happens is that we aren't prepared."

Somewhat in the interior is **Chiva.** We find four potteries, and it deserves to being noted that in the last fifteen years only one has ceased to exist. We enter the one belonging to Juan Martínez Saus to see what there is here: jugs and crocks, glazed on the inside (with a capacity of, from three quarts to thirty-six gallons) used to store olives, pork sausages, and preserved food in general; washtubs, glazed on the inside varying from one foot to 3 feet in diameter, used during the slaughtering; "cántaros", glazed and unglazed; feed and water troughs for hens, pidgeons and rabbits; piggy banks, and also "things" which are ordered, such as decorative amphoras (very few these, since the basis of the business is the ceramics which is honey-colored when glazed)

186-187. Vessels put out to dry, *Vall de Uxó*
188. Polishing the objects already fired, *Vall de Uxó*
189. Botijos, *Agost*

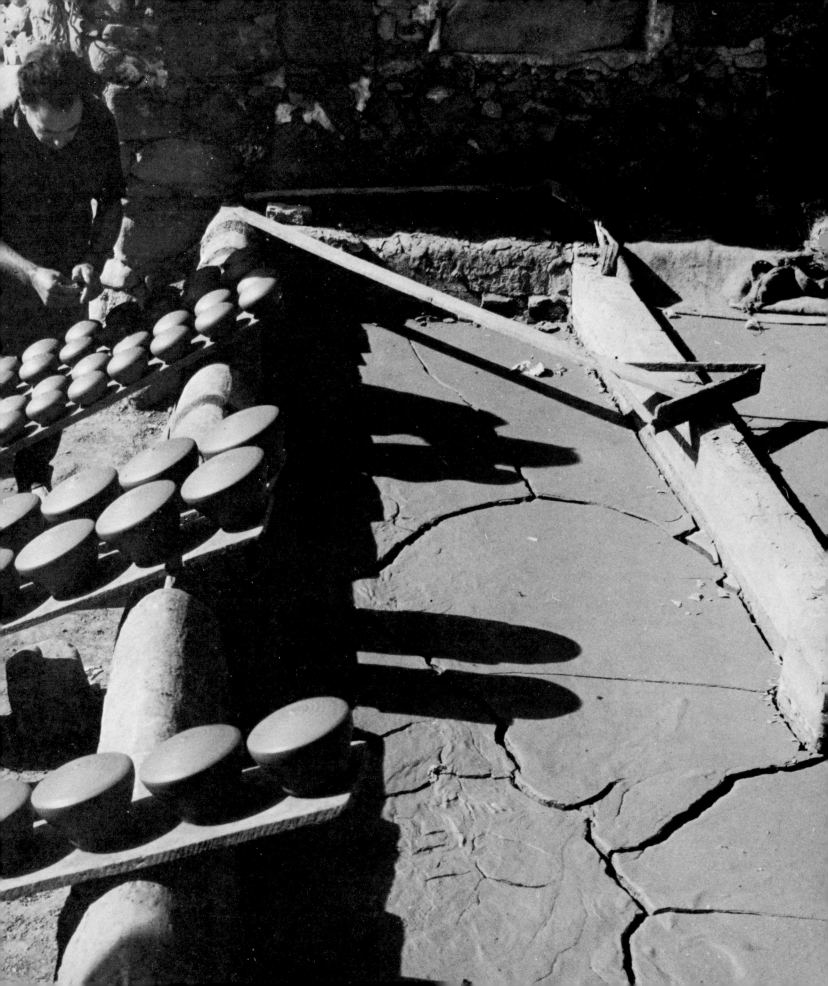

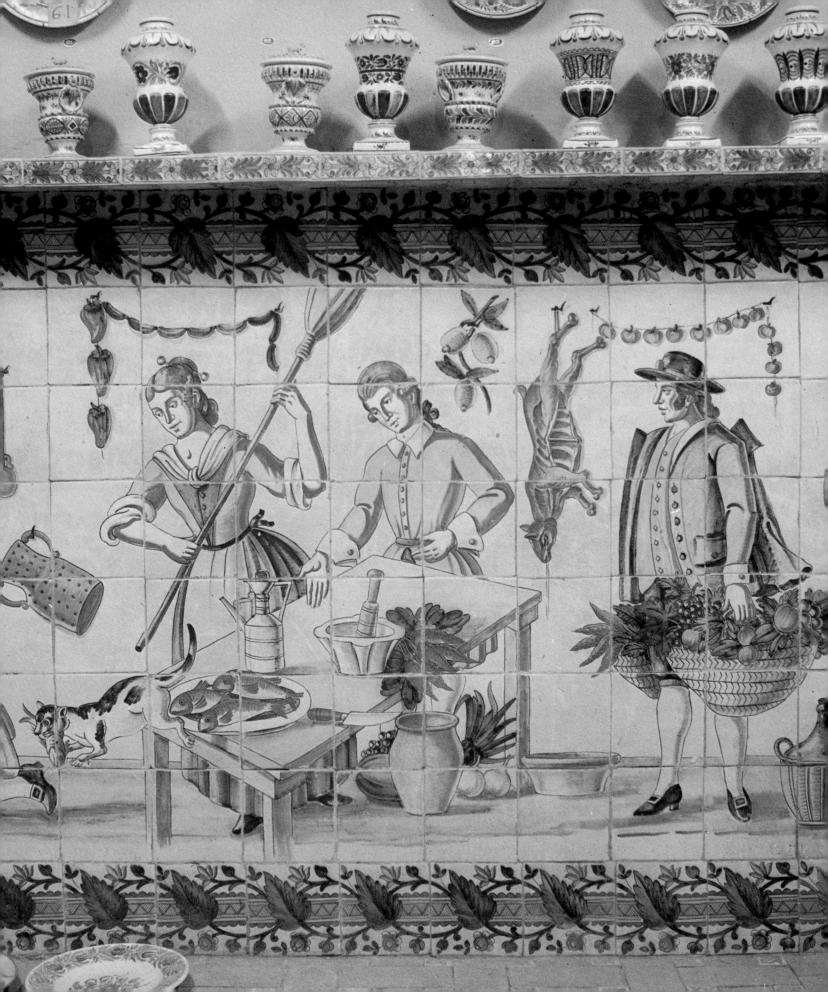

190. Mural ceramics, *Manises*
191. Cruets, *Manises*
192. "Alfabeguer", *Manises*
193. Kiln in *Chiva*

sold in the provinces of Valencia, Cuenca, Albacete, Ciudad Real and Toledo.

In this area there are many more towns dedicated to ceramics: **Alcira,** with two potteries working with a foot lathe, and producing: "cántaros", "botijos", "wagon botijos" and flowerpots, as well as forms similar to those in Agost; **Liria** which makes "cántaros", jugs, "botijos", feed troughs and flowerpots; **Villar del Arzobispo:** producing "cántaros" and jugs, "botijos" and flowerpots, with the glaze similar to that from Chiva; **Burjasot** which also makes: "cántaros", jusgs, "botijos" and flowerpots, of a greenish color and a large part of which are made by machine; the city of **Valencia,** where the one remaining potter alternates the lathe and the machine, in the production of washtubs and decorative objects; and **Canals** (whose clay is not of very good quality) which only works with "craftsmanship" for tourists. In towns like **Petrel,** where pottery work was done until just a few years ago, we did not find a single remaining potter, as was also the case of **Benaguacil** where this type work had likewise been abandoned in 1971. **Sax** which had mechanized its production not long ago, ceased to function as a pottery center in 1973. Their ordinary crockery vessels had had pretty shapes, similar to those from Agost, although they had also sold some enameled articles, made in the worst of taste.

In the Levantine area, the town of **Agost** is especially interesting and with it we will terminate the chapter. The forms have a restrained beauty enhanced by its whiness. Its enormous production is scattered over a large area, especially in Madrid, Barcelona, and Valencia. The different types of objects are: the "cántaro" (of 1 ¾ , 1,½ and ¼ gallons); the "wagon botijo", flat on one side, in order to be hung, also in four sizes, between ½ and 1 ¼ gal.; flowerpots, "gallos coronados" (crowned cocks) and the "nightingale" or "canary", which is a small "botijo", which, if blown into when full of water, "sings" like a bird. There are twenty potteries in Agost, with an average of four workers in each. We were told that in 1935 there were thirty odd, and that many of them later devoted themselves to making bricks and other construction material. It is an unglazed; very white pottery (they add salt to the paste when preparing it), which the people later paint, at times with very loud colors. Everything is made on the lathe, including the flowerpots (and one should bear in mind that the production is very large); the lathe is always electric.

Rüdiger Vossen mentions in his book *Töpferei in Spanien* (1972) two other pottery centers in this area where traditional ceramics can still be found: **Onil** and **Potríes,** and one, dedicated primarily to tourist articles: **Biar.** The potter in this last town comes from a family from Manises; his father, who married the daughter of one of the original potters from Biar, introduced here the mold and bisque techniques.

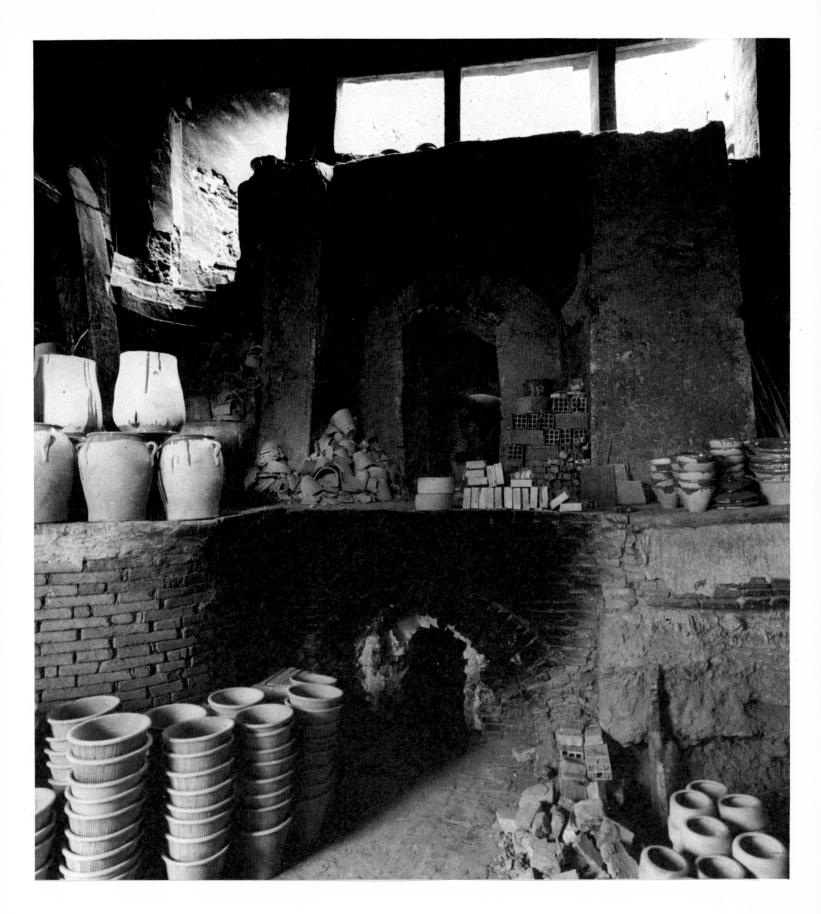

catalonia

The ceramic in Catalonia varies according to the regions. The role of Gerona, as a favored land, in being able to receive the Spanish or foreign visitors, contributes to the fact that the ceramics here is being substitued by ornemental objects and "souvenirs" of baked clay. In the rest of the "Principality of Catalonia", almost all the pottery making has been discontinued, although in the regions near the large city of Barcelona, the industrial development has allowed a few skillful, and well organized potters to maintain their work, endowing it with a new methodical order and a suitable distribution. The most genuine representation of popular Catalan ceramics, at present, is without any doubt, found in the pots and casseroles from Breda and the "botijos" from Verdú.

In the province of Gerona we were able to find three towns where the potter's wheel continues its work: La Bisbal, Quart, and Breda, all of which have large sales and wide diffusion of articles. Objects from La Bisbal, or imitations of the forms and decorations that have been introduced by the Catalan pottery center, are seen in all of Spain, and also on overwhelming number of samples of the green ceramics from Quart. On the whole, the result is unfavorable for everyone because the innovations have not only caused the beauty of the ceramics from these towns to be lost, but is also contaminating the rest. Alongside the excellent vessels that continue to be made in La Bisbal and Breda, there exists another type, almost always in bad taste, dedicated to the tourists; unfortunately it is the latter that tends to set the tone here.

Four potteries remain in **La Bisbal** dedicated to the "terrissa" and several more that produce "artistic ceramics" in large quantity, aimed primarily at the tourists. Currently there are more than a hundred people working with ceramics here, although formerly it, together with the cork industry, constituted one of the most important means of earning a living for the inhabitants. Before the civil war, there existed only what is known as "terrissers" (or true potters); then, through the action and influence of the ceramist and artist Díaz Costa, a new style was introduced

in the old forms (with little sucess in general, though there were worthy exceptions) and ended by modifying the forms themselves. The traditional decoration consisted of a flower or a bird; and the fish was introduced at a later date. The former production was composed of kitchen vessels, with red and white "engobes".

At Vilaclara, the pottery that has attained the most dignity in the new style, we are shown some of the "old" objects (and the expression is meaningful): the "gerra del greix" (to hold the parts from the slaughter of the pig); the "cantir" or typical "botijo" from La Bisbal; another type of shortening container. All are a green color, except the "cullerer" and the last "gerra", which are redish. The "cullerer" has the simple but charming decoration of a little bird. The oldest types of objects are the "cantir" and the "cullerer" which were made as much as eighty years ago. Here they also made, until recently, the famous "cántara": the object is glazed with lead and then decorated with colored "englobes."

We find examples of traditional ceramics at the pottery of Luis Cornellá, who continues to produce black ceramic vessels similar to those we will see in Verdú. The production is varied: the little heater known as "escalfallits" in Catalan (for warming beds) and the "maridet" (which women at the market used to wear under their skirts to keep them warm), and "botijos" in varied sizes; and they are again producing the typical "barral" (large flask). All of these articles are within the traditional ceramic realm and show great dignity; aside from these traditional articles, there are others in which they make innovations on the shapes and decorations. Other potteries that make traditional ceramics are Alfarería Daro, Moruny, and Solomó; in general these are glazed articles: the old, country soup tureens, plates (with a decoration of dots or spiral lines), "escurridoras" (drainboards for fish), "gibrells" or "concas" (both of which are washtubs, the latter having a more rounded border than the former), platters, mortars, chamber pots, "botijos" (the ordinary one, and the "cantir pescador", which the fishmen carry in their boats), all of which are glazed with lead enamel, in such a way that some turn red and others straw-

colored. The unglazed objects are: water and feed troughs for rabbits and hens, and the ordinary "botijos". The bowls have a very distinctive decoration of small, faint flowers. A chamber pot called, by reason of its function, "for midwives" is also made here. To support and separate the vessels when they are placed in the kiln, and so that they do not touch each other, the potters use an object called "fótil" which reminds one of a candlestick.

In La Bisbal we were informed on the last ceramist from **Figueras,** José María Cortada, and of his work. Until 1971 the "cántara" (a typical jar) was made in Figueras, together with various types of water and wine vessels and others to be used in cooking. The interesting jar is green with a lead glaze, and has no decoration.

We go to **Quart** with a certain consternation, almost fear, because of the assurance of contemplating the spectacle of the green ceramics in all of its splendor. We visit the Marcó house, and talk with the owner, Agustín Marcó, 80 years old. According to what we are told, and to what we are able to see, very few traditional objects are made: the "cossi" (a large vessel to be used for water, but now is applied to gardening purposes; it is of red clay and unglazed); the "gerra de les olives" (type of jug), the "gibrella", flower-pots; the "gerra de posar-hi vi" (a jug more or less like the "cossi", for storing wine or oil). The capacity of the "cossi" varies between 2½ and 130 gallons; the "gerra de les olives" between 26 and 52; the "gibrella" between 2½ and 8; and the jug for storing wine between 8 and 52 gal. All of these are unglazed, except the "gibrella" which is available both glazed and unglazed. Currently all are used in the garden. Together with these remains of the former pottery making (for which, fortunately, a valid and useful purpose has been found), they also make in Quart all types of amphoras, copies of Greek and Roman sculptures and other famous

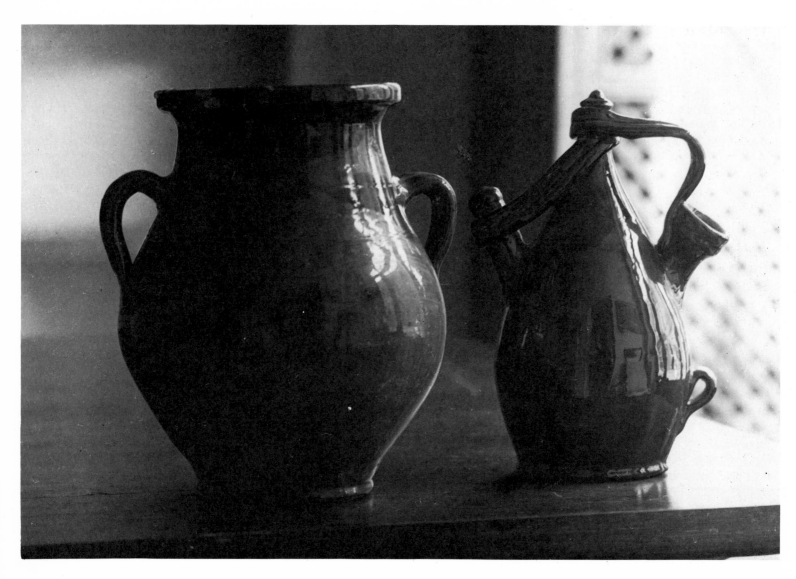

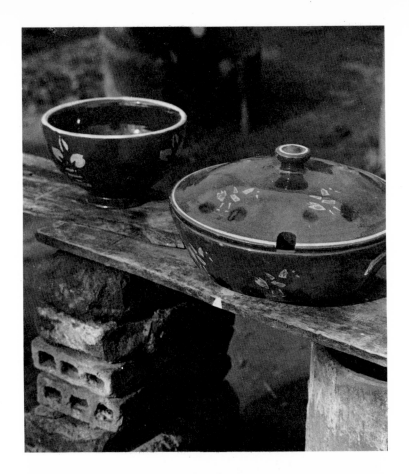

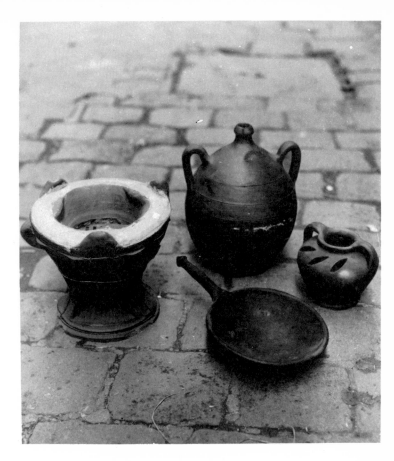

196. "Barral" and "gerra" for storing lard, *La Bisbal*
197. Bowl and soup tureen, *La Bisbal*
"Barral" and "escalfallits" (bed-heater), *La Bisbal*
Colander and "gibrell" or "conca" (washtub), *La Bisbal*
199. Casseroles from *Breda*

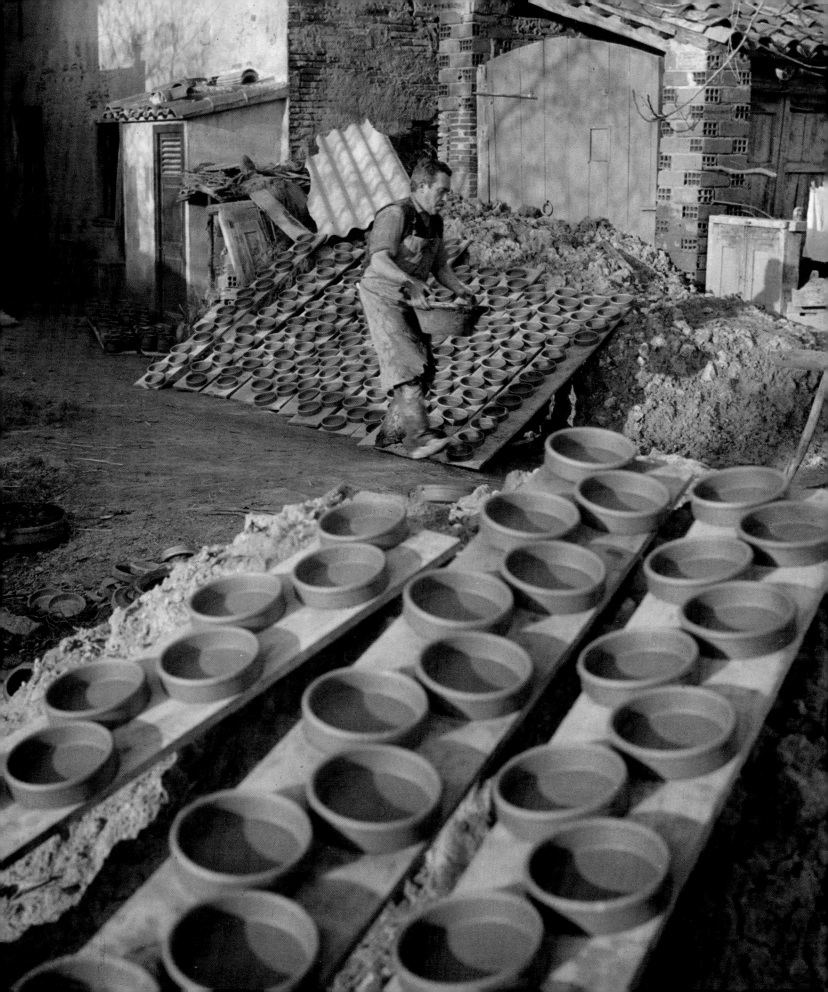

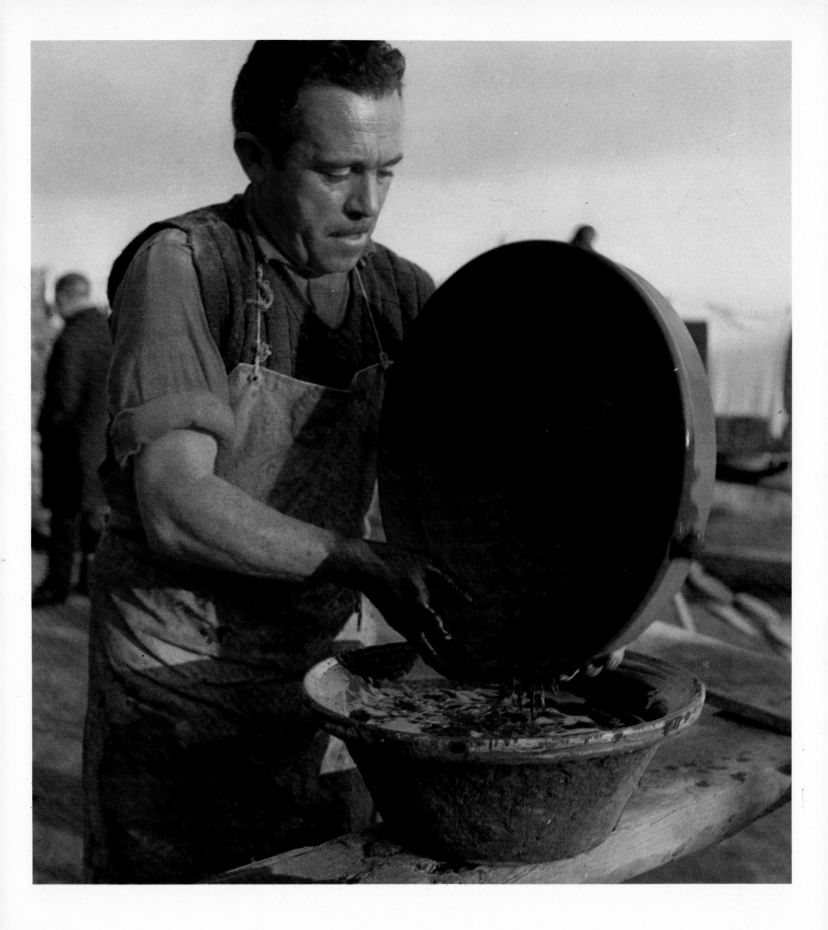

sculptures; and many other diverse objects, normally everything painted in green. Even señor Marcó confesses to us that thanks to him the ceramics in Quart has been reestablished. During his long life, he has been familiar with many potteries here; "there were more than fifteen, almost one in every house"; at present five potteries remain, counting his own.

In **Breda** one of the strong centers of Catalan ceramics, there are twenty-five potteries still in operation, with a hundred workers, almost all of whom are related to the owners. Things seem to be going well, but the young people do not want to dedicate themselves to this; there are several breweries nearby and many go there to work. The bulk of the production consists of coarse crockery, although sometimes they deal in "artistic craftsmanship". The one who provides us with the fullest information is Josep Regás. He shows us a pamphlet from the "Junta Reguladora de la Industria Alfarera de los Centros de Producción Breda, Cardedeu" where the "List of Measurements and Net Prices per Unit" is shown.

They make pots which here have very amusing names. There are "marsellesa" pots, "chatas finas" pots, the "cazuelas finas" the "xinos" (chinese); the "cocotes", and a type of "cocot" called "cremador" which is used to flame rum, many of which are bought by the tourists from the Costa Brava. All of this is, as the pamphlet says: "glazed merchandise (inside and out)". We can see them working. First they make the bottom of the casserole, which is called "bocha", and after it has been left to dry, they take away part of the clay in order to leave an opening. Breda ships kitchen vessels to many places in Spain, especially to the North, mainly to Bilbao, and abroad, to the United States, Denmark, Holland... A large number of ceramic pieces are brought in from other areas, primarily from pottery centers such as La Bisbal and Agost, for their later commercialization.

200. Adding the "bath" to an object, *Breda*
201. "Doll" (water jar), *Figueras*
 "Sitrell" for oil, *Figueras*

Breda is affiliated with **Cardedeu,** where primarily "botijos" are made; the rest of the production is similar to that of Breda. The two towns are associated for sales purposes.

In Breda we make contact with Joan Capdevila, from **San Julián de Vilatorta,** who has come to buy goods to be sold, especially pots, because in San Julián the clay "doesn't yield anything". He explains to us what is made in his town; we later have the opportunity of seeing his objects. His is the only workshop in San Julián; Joan, who is a rather young man, tells us that he has known of five potteries that existed there after the war. They made: "botijos", water and feed troughs (also with a siphon) for hens, a small oven for heating the beds, which is very interesting, all of which are unglazed, except the pitchers with three spouts, and the honey jars (glazed on the inside), and a few other items.

We will now examine three other important pottery centers: Piera, Esparraguera, and Verdú, each of which has its own distinguishing characteristics.

In **Piera** there are two remaining ceramists who, aside from the traditional vessels, attempt to make "modern" ones: José Mata, who searches with sensitivity for new forms and has a beautiful collection of plates of the letter M; and Francisco Mera Caldina, whose family we were told has been making plates for at least four hundred years. Some fifty years ago, there were ten or twelve ceramists, but their number decreased considerably after the 1930's. The current production consists of: plates, "torretes" (flowerpots), feed troughs for rabbits, water troughs for rabbits and hens, feed troughs for hens (which are round with an opening in the center), "pitxella" for wine, and "sangrías" (pitchers for sangría, just recently introduced). The following types of plates are made: "de murri", small and concave with an "M"; "de garber"; "soper"; "platillo" (in yellow); and "platero" (in red). Once again they are making in Piera the "plat de la mort" (death plate), used when family and friends come together for a meal after a funeral.

Esparraguera is a very active pottery center. There are thirteen traditional potters and another, from the Sedó family, dedicated to enameled ceramics. We visit the home of Alejo March, whose son represents the seventh generation of ceramists, an achievement of which they are very proud. Here, all the lathes are run by motor, and practically nothing is made with a mold. The rippled flowerpots are made on the lathe, while the unrippled ones may or may not be made with a mold. In the workshop we see: the "cantir", the "liquor barrel", "gibrella" (glazed on the outside), mortars, water troughs (with a siphon); water troughs for rabbits; other types of "cantirs"; the "gerra per oli" (a jug for oil) and the "citra per oli" (the last two of which are glazed on the inside). There are also the following glazed objects: ripled flowerpots, "guardiolas" (piggy

banks), "tramujas" or "menjador per colom" (feed troughs for pigeons), and "torretes de forma d'ou" (which are used to decorate gardens). Red, glazed plates with the letter "M" are still made in Esparraguera. The other plates are known as: "de grà d'ordi" (red with yellow spots), "de 5 sous" (yellow with spots of the same color), another large plate with the letter "M" (yellow with green spots), "de 3 sous", "plat de murri" (small and concave, also with the letter "M"), "plat de garber", "plat soper", and the "platillo" (yellow). Esparraguera is today the town in Catalonia which produces the largest quantity of "fireta" (toys).

Verdú, in the province of Lérida, is especially famous for its "botijos" or "cantirs", called "sillons" here. This is the only thing that formerly was made here. The production is large and the objects are seen throughout Catalonia. Of the fifteen potters working a few years ago, eight still continue, in spite of the fact that they complain, and justly so, that the circumstances are not favorable for the continuance of the craft. There are no foot lathes that remain in use; to the ones that did exist, they have attached "a very simple little motor" which does everything. The characteristic articles of the town, as we have already mentioned, are the "sillons" or "botijos" in various shapes, each with its own name: (from large to small) "bomba" (2½ gallons), "especial" (2 gallons), "gran" (¾ to 1 gallon), "mitja" (½ gallon), and "petit" (1 to 2 quarts). All of these types of "sillons" are black, from the smoke. The other types, which are no longer made, were known as: "silló de peu" (abandoned 40 years ago) and " de moda" (which suffered the same fate 25 years ago). The name did not depend on capacity, but on the shape. To the past (though the near past, some seven years ago) also belongs the "cantir" or "cantireta" (not the "silló") with two handles.

We subsquently discover vestiges of other pottery centers such as **Rubí,** where very little work is done: ("cántaros", flowerpots, casseroles and pots); **Martorell,** situated on the main highway between Madrid and Barcelona, and in a key spot for interregional communications, which until recently made feed and water troughs; **San Sadurní de Noya,** with one lone artisan who devotes himself exclusively to tourist articles. On our way through **Villafranca,** we were informed that the capital of the Panadés no longer makes even the flowerpots of a few years ago. In **Vendrell,** fortunately, something is left of the pottery industry, though not much. Of the two kilns that existed until recently, only one continues to be worked, that of the Fontanas, father and son. They make "botijos" similar to those from Verdú, the clay for which is brought from Piera. **Torredembarra** maintains very little of their traditional production, now carried on by Salvador Suñé Fortuny and his son Ramón: "botijos", washtubs, and flowerpots (the latter are made by machine).

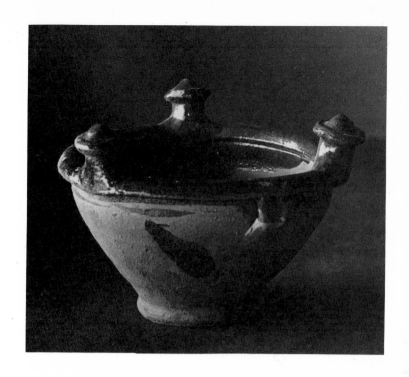

202. Various examples of the utilitarian production from *Quart* Green ceramics from *Quart*
203. Bed-heater, *San Julián de Vilatorta*

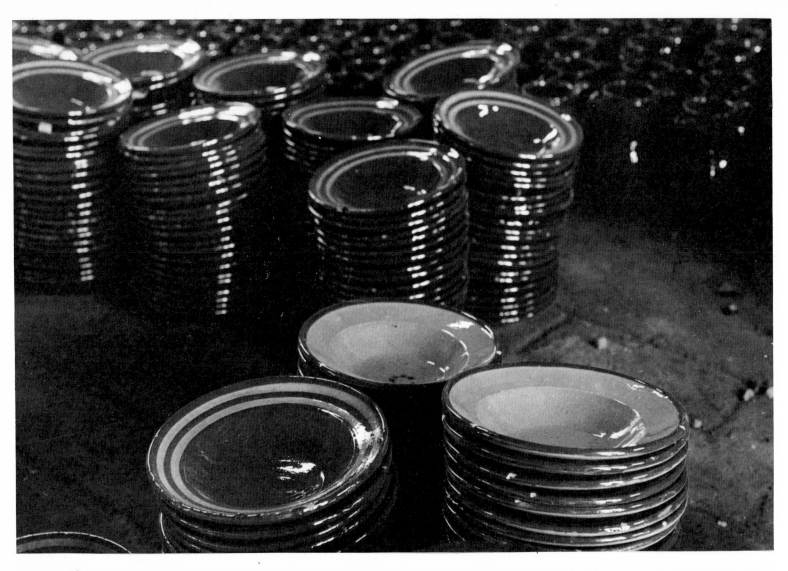

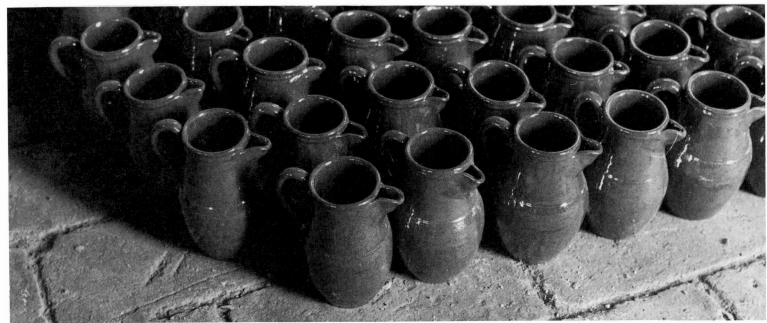

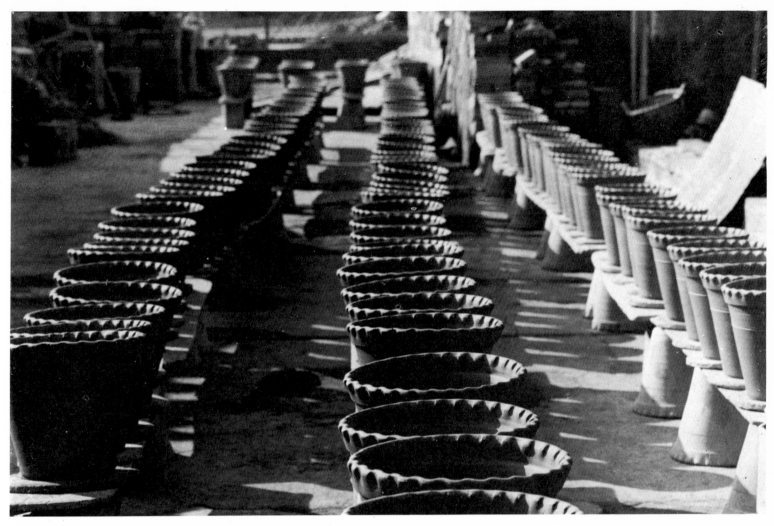

204. Plates and sangría pitcher, *Piera*

205. Rippled flowerpots, *Esparraguera*

We somewhat hopefully approached the last area we were to visit in Catalonia. To begin with, however, we found that the traditional ceramics was abandoned in **La Selva del Camp** some six years before we made our trip there: the one who continues with the pottery making devotes himself only to ceramics for decorative purposes. He is named Hipólito Martorell and very kindly gives us information concerning what was made here.

According to what he tells us, at the end of the Civil War, some potters from Breda were imprisioned in La Selva for their activities in the Republican camp. When they were released, they found themselves banished from their town. The judge from La Selva, the father of Hipólito Martorell, had the generosity to offer that they continue to work with their craft in La Selva. This caused the ceramics from La Selva to be influenced by that of Breda.

Returning to where we were, we will add that even the names of some of the objects are being lost in the memory of the people. And it is worth mentioning all of them:

"tupí" (a pot), the kettle, casserole, "vermell groixut" (peasant plate), of a subdued brownish red and completely glazed with lead. The most interesting names are those given the different varieties of "tupins"; they are, from small to large: "cargolí", "mitjancer", "de pessa", "entravessadet", "embroll", "avagason", "avançadet", "entravessat", "viude", "aturgat" and "mitja". The shape was substantially the same for all the sizes and varied only according to the ceramist who made it. Hipólito Martorell, the son of the commendable judge, brings out some "tupins", samples of the told production, that he gives to us so that we can attest to the authenticity of the ceramics from La Selva del Camp.

Tivenys was a famous pottery center, and from it came great quantities of earthware, but today none of the traditional articles are produced. In the past fifteen or twenty years they have stopped making the old type objects. Francisco Pino, the middle-aged potter with whom we talk, explains to us what the former ceramics was like, and suplies us with

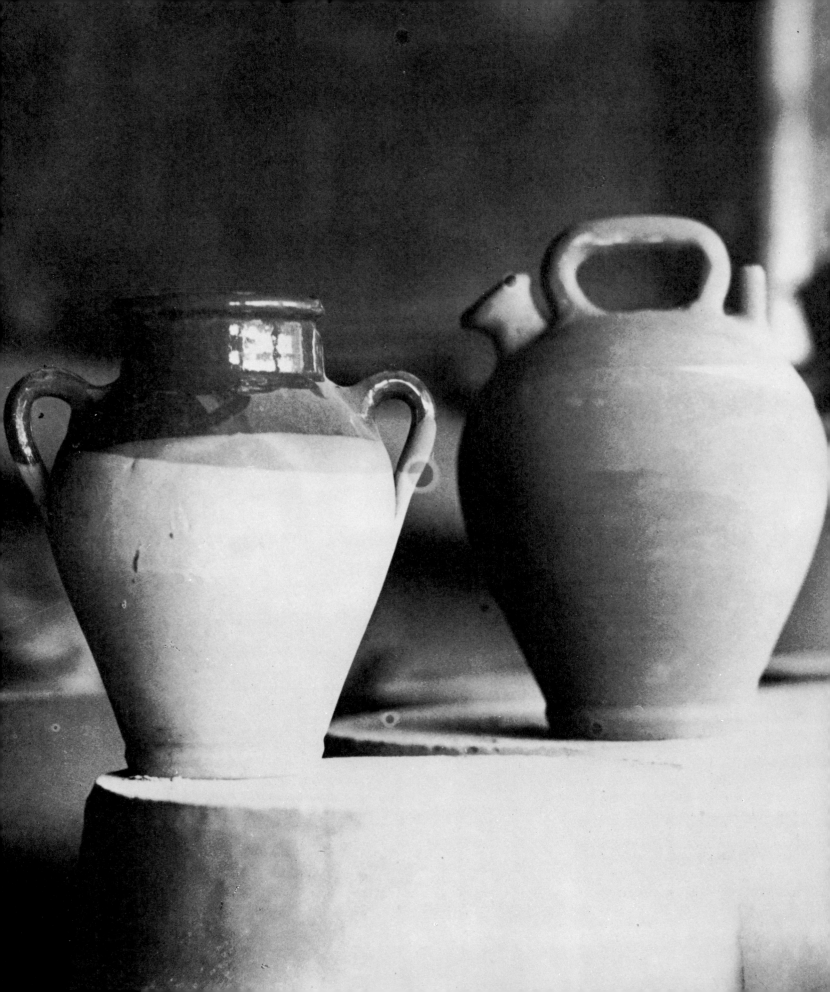

the names: the "setrill", for storing oil (its handle was attached with a cord to the handle of the basket that accompained it); the "pitança", a soup bowl for the "llagoters", who dedicated themselves to transporting cargo on the Ebro River; "rivella", "mig cantir" (a wine measure), "cuartillo" (another wine measure), "saler", "cullerer" and three types of "cantir". Upon occasion they still make a few of these objects, when requested, such as the ones prepared for the señores Güell and Noé, professors at the Escuela Massana in Barcelona.

La Galera is another of the rare places in this area where we can find traditional vessels. The potter died in December 1972 and was succeeded by his son Juan Cortiella. We were surprised to find here a "cántara" almost identical to that from Traiguera; perhaps the vessels are better formed, but the color and decoration are almost identical. We also find here "botijos", the "gerra" for olives, "caus de conills", "cantarets de gall" (for drinking directly from a spout), "pitxells", "abeuradors de dos peces", "pinyes" (water filter), "cadups" (pitcher), and "ratjoles xup" (filter for ·trench).

Before finishing our trip through Catalonia, we had the opportunity of passing through **Ginestar** and Benisanet. In the first town we find recently made "botijos" which are called "pitxells". The upper half is glazed in green; formerly the entire vessel was glazed, resembling a tree trunk with its knots. The flowerpots, known in other places as "torretes" but here as "parres", are still molded by hand. There is also a big-bellied "cántaro" which at present is only made to fill the orders from a store in Reus.

The potters or "cántaro makers" from **Benisanet** do not seem to be very encouraged about the perspectives of the pottery industry. One of them, who is very young and does not have any children yet says that when he does, "if they follow my advice...", while the other has one child but it does not appear that he will continue the work. In forty years, the number of potteries has dropped from eight to these two. The following objects are currently made: "gerra" (jugs), "torreta" (flowerpot), "cánter" [either svelte or bigbellied "botijos", one of which (called "gar-

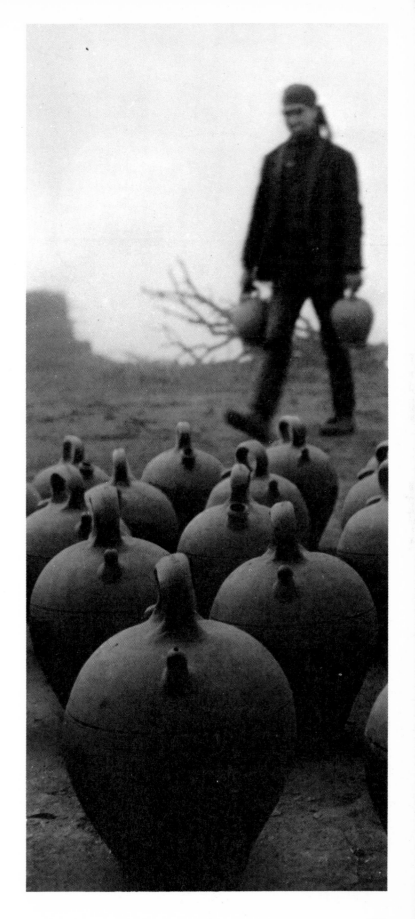

206. "Gerra" y botijo, *Esparraguera*
207. Botijos from *Verdú*

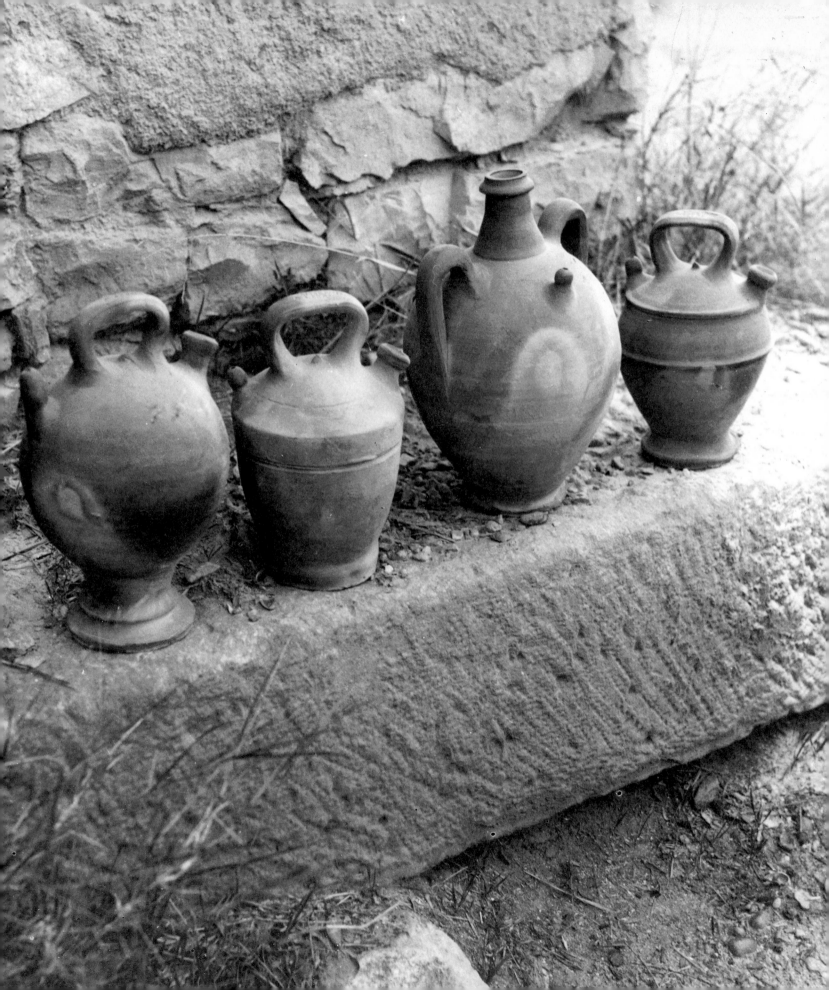

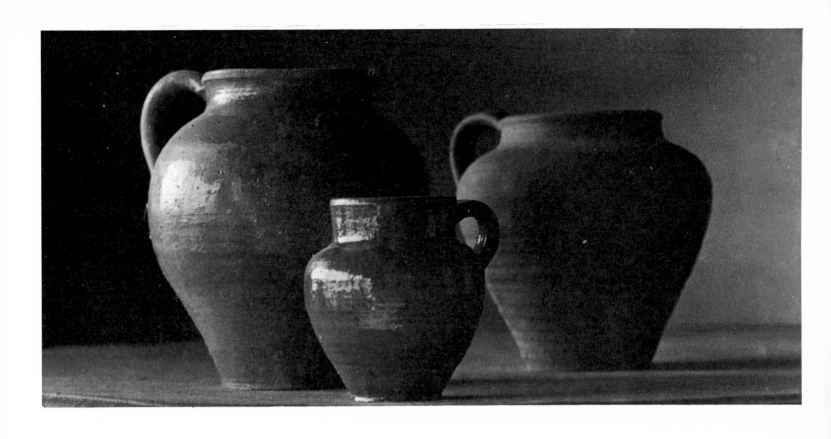

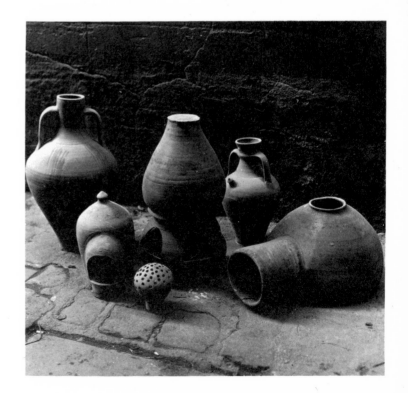

208. Four of the various types of botijos from *Verdú:* silló de peu, silló xato mitjá, cantir or cantireta and silló de moda.
209. Tupins (pots): entravessat, de pressa, and avançadet, *La Selva del Camp*
Cántaros, drinking troughs, strainer, and rabbit breeder, *La Galera*
210. Various objects from *Miravet:* tinajas, cántara, botijo and gargola (a cántara with two handles and a spout).

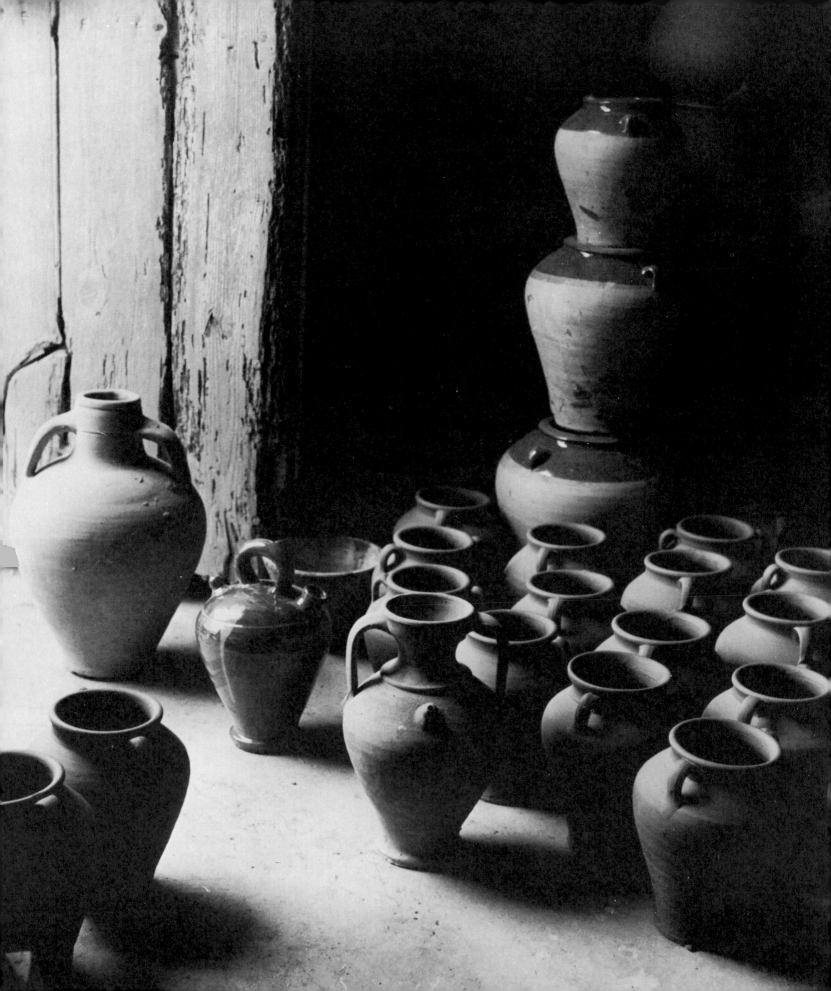

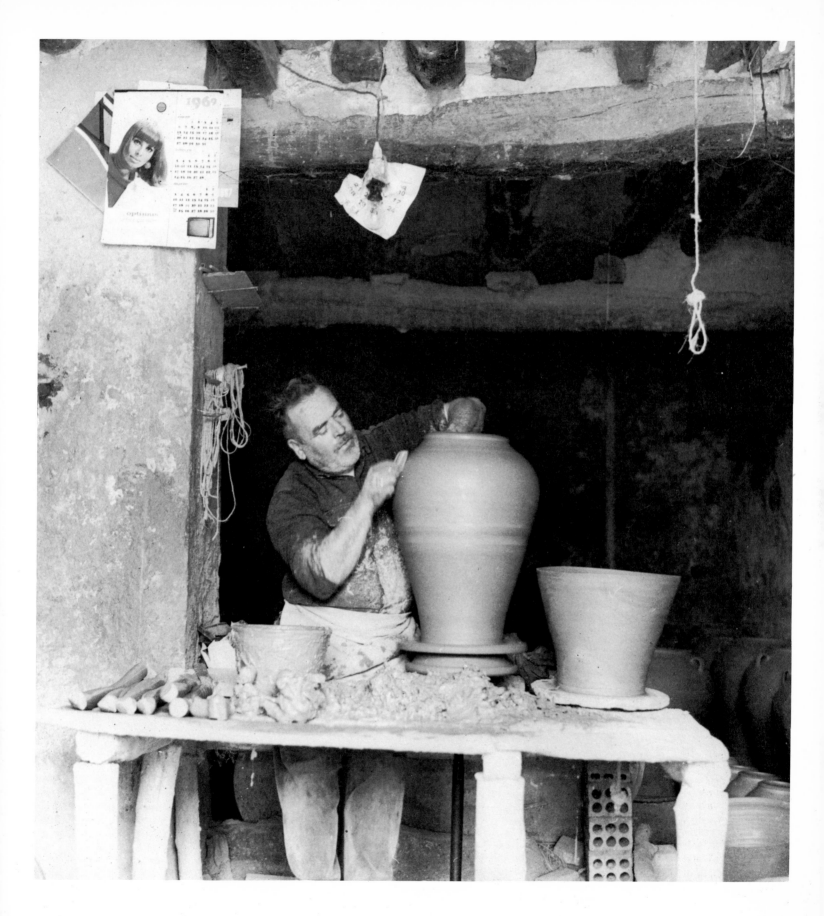

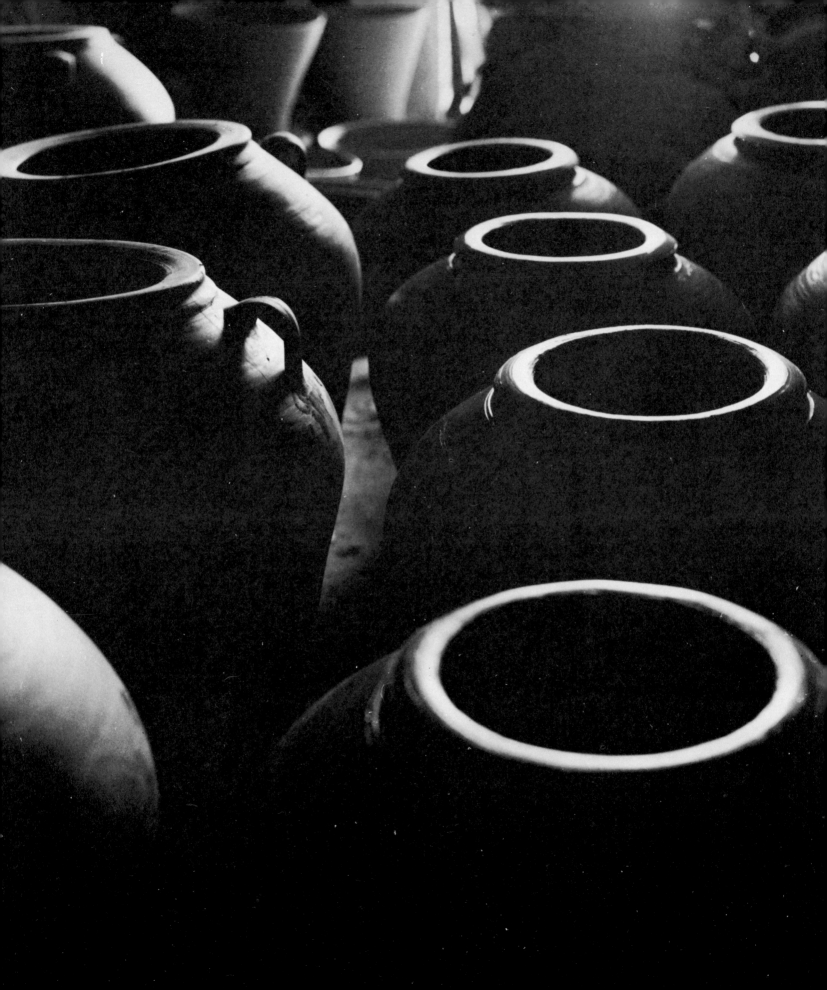

212. "Gerres" (tinajas), *Miravet*

213. The former pottery district, *Miravet*

gola") has a spouts], "gebrell", "pitxell", "pinya" (with holes for storing the water taken from the cistern), "catúfol" (a large pitcher) and the mortar.

And finally **Miravet.** The district of town where the people that interest us are found, is called "Potteries". There are ten workshops dedicated to the pottery industry, of the twenty known of by Joan Avante, with whom we are talking. In spite of everything the pottery "is in decadence", he confesses to us; "since it's such a poor craft the young people aren't interested in it." The craft is maintained with dignity, and they continue to work the foot lathe, without anyone daring to attach a motor to it.

We are already familiar with the names of the various types of objects: "cánter" (in several shapes and sizes, but it is gradually disappearing), "torreta" (also called "parra", part of which is made by machine), "catúfol" (virtually none of which are still made), "cántir", "gargola", feed and water trough for rabbits and hens, and the "guardiola" (piggy bank); all of these are unglazed. The upper part of the "gerra" or jug, the "pixtell" (when requested), and the "rivell" or washtub, as well as few "cantirs" are glazed.

The different types of "gerres" and "rivells" have special names. The "gerres" which, more than the other objects have made Miravet famous, are known as (from large to small): "solsera" (holding 26 gallons), "tófol" (also in several sizes, from 13 to 15 gallons), "solseró" (5¼ gallons), "petxin" (4 gallons), and "saboner" (¾ gallon). The "rivells" are known as: "mandonguer" (which is the largest, measuring 2 feet in diameter), "mitjancer", "sagna", "cuatre un" and "plateret" (which is the smallest measuring one foot in diameter).

balearic islands

The Islands have a remarkable ceramic production, but today the tourist business and industrialization have considerably reduced its production. Currently, pottery is made only in Mallorca and to a much less degree, Menorca. In spite of this, some of the objects which are still made have been very successful, especially those called "siurells" or whistles. They are small figures painted after they are baked (without being refired), and in the form of animlas (dogs, horses) and men who look like farmers. Some have a bizarre air about them, at times even disturbing, such as the horseman with large ears, which may represent the devil.

Our visit to the islands had to be limited to four pottery centers: the city of Palma, Pórtol, Inca, and Santamaría, as well as Consell and Sa Cabaneta, dedicated exclusively to making "siurells", and Felanitx, which has practically ceased to exist.

For this reason, we are surprised how active pottery making is maintained in **Palma**. Even if there are only four remaining potters — instead of the nine in Pórtol — the production is kept up well and with the hopeful bote that at present, the sales of the objects, just as they are, are good. We visit the "Antigua Casa C'an Batista", which is on Pottery Street, whose name alone indicates its former splendor. On the same street there is another of the workshops that remains open. It is surprising, in effect, to verify that in the middle of Palma, and as successful as they are, they still work with a foot lathe and use an Arabic oven. They make the "gerra borda" of which these are five sizes; "the cosiol" or flowerpot in 15 sizes, among them the ones known as "fregar grande", "fregar mediana" and "fregar pequeña"; "cossi" (dishpan); "botijo", "botija" or "botijo-canteen"; "rivell" (washtub): "de amasar", "en brec" (small and large ones), "de escurar", "de barca", "pequeño" and "de verdura"; the "aufabia" (either a crock or a jug): "borda", "de un cuartin", "de medio cuartin", "de comens"; the names of the types of articles are: "aufabion de pastor" (smaller than the "aufabia" and in the form of a can); "cubell" (unglazed washtub),"farrada" (flowerpot with two handles), "bebedor cántaro borda", "bebedor piqueta", "bolcador"

(which is like a plate, for feeding the hens and to put under the "cossiols"); piggy bank, "escudella", "pitxer" (small wine jar), "beguedor" (water trough for hens and pigeons) "beguedor amb gerra" (with a siphon). They also make glazed objects, such as kettles, jugs, jars, plates, and saltcellars; in addition, there are some purely decorative objects, in which we are not interested.

In **Pórtol** there remain, as we have already mentioned nine potters. We are told in the workshop we visit, the Son Ros pottery, located in the La Escuela district of town, that not many years ago there were thirty potters. Pórtol is part of the municipality of Marratxi, to which also belongs, among others, the town of Sa Cabaneta to which some erroneuously attribute the crockery vessels made in the potteries of Pórtol.

We find various indications of the general decline of this activity. There are very few sons of potters who wish to continue the craft; and dangerous signs of modernization of shapes and decoration can be observed, aside from the fact that many have attached motors to the foot lathes.

The production is similar to that of the rest of the island, though some of the objects here are given special names. The simple kettles have very amusing names, according to the size: the number 0 is konwn by the name of "cassolí"; the 1 "treset"; 2, "malaguenya"; 3, "borda"; 4, "mitja mà"; 5, "perol"; 6, 'kilos' and 7, "sexa". The "greixonera" is a casserole used for making rice, and for cooking potatoes (which is known as "greixera"); they are made in the same sizes as the kettles and given the same names, with the exception of the smallest, the number 0, which is called "bombero". The "greixonera", which is the same size as the kettle, is known as "sa femella". Some of the "cossiols" are made on the lathe and others with a mold. They also make "siurells".

In **Inca** there are two families that continue to make pottery, the Piritis and the Can Torrents, from whose kilns come plates, platters, "escudelles amb orelles" (with ears), "pitxells", cups, and coffee sets, made by the men; the

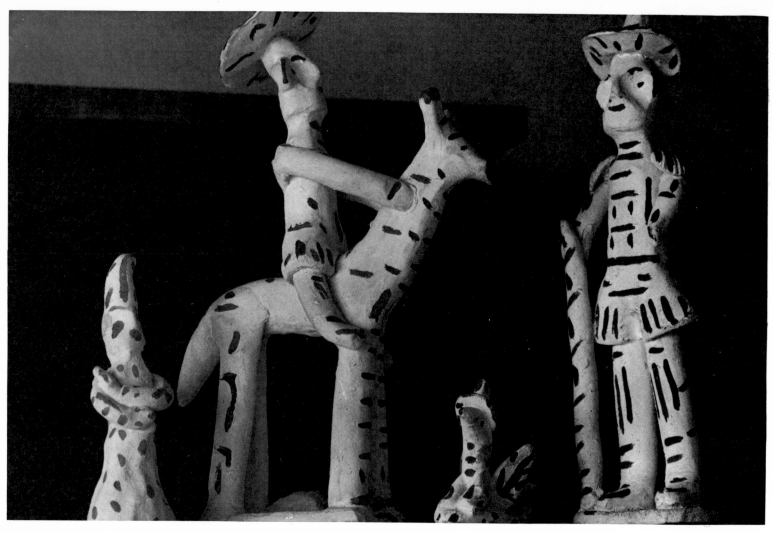

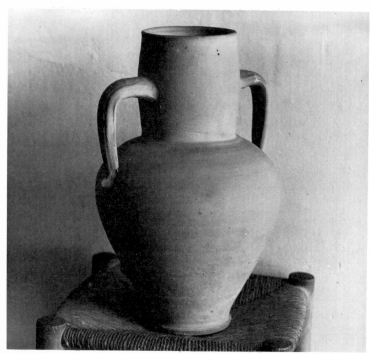

216. "Siurells", *Sa Cabaneta*
"Gerra", *Palma de Mallorca*

women are charged with molding the "siurells" and crèche figures. The majority of the production from this town consists, however, in adapting in their own way the old forms to new times. In this manner they make "escudelles", typical of Mallorca, with the familiar shapes, but the decoration and enamel work deprived of their charm. The "siurells" made here are of two types: the traditional one, as well as another large one, the head of which is made with a mold, while the body is turned on a wheel.

We will terminate with **Santamaría**. The one potter, Miguel Serra Pons, does not recall there ever being other kilns than his. He has two lathes: one operated by foot and the other with a little motor. Part of his production is oriented toward the type of green ceramics, with raised figures, that causes such horror and damage in all of Spain. What traditional objects he does make are unglazed: the "gerra", which is like a "cántara", in various sizes; a jar with a narrow neck, with a handle and a spout, called "gerra de brec", as well as the "cossi", water troughs for hens and pigeons (the "beguedor"), the "botilla" or "botijo" to be hung in wagons; and what is known as a "cadufe", which is a small jar for water or wine. Almond shells are used for fuel.

In **Consell** "siurells" can only be seen in Casa Amengual, and in **Sa Cabaneta**, only at the pottery of Madò Bet. In **Felanitx** the traditional production is now disappearing. Until recently this place had been famous for its "gerra felanitxera", with baroque adornment and fretwork. In 1972 no more than half a dozen of these objects were made, all on special request. One can still find here unglazed small baskets and decorated jars.

There is still one potter on the island of Menorca. He is Sebastián Febrer and lives in **Ciudadela**, on the "Potters' Street." This ancient industry is known here as "teulerías"; and in truth all the ceramic work, with the exception of that of Febrer, has been reduced to producing "terulos" (roof tiles) and "rajoles" (bricks). The ceramic production which had disappeared, has recently been resumed, though not much is made. The articles that are produced are inspired, in general, by those from other pottery centers. We would mention the "cantirs", very similar to those from Mallorca, one of which is used for watering plants — it has a small flat spout full of holes like those of a water sprinkler. They also make a jar for water or wine, a casserole known as "aunt", and a "radiola" (a small jar sold in Ciudadela at the time of the festivities of Saint John). In addition to these vessels, part of which are made with a mold, various other articles dedicated to the tourist are produced here, such as the "Greek" and "Roman" amphoras.

canary islands

There remains very little of ceramic interest to be recorded in the Canary Islands, and even more deplorable, what does remain has greatly deteriorated. A mere ten or fifteen years ago there were other existing pottery centers; and all the articles that were made preserved the remarkable spirit of a time-honored tradition. Even when the first volume of *Tradiciones populares* was published in 1944 by the Institute of Canary Island Studies, the authors faced difficulties in gathering material on a culture at that time very much alive. Since then, this art has been disappearing even faster, and its inherent values are being lost. Luis Diego Cuscoy was thus able to affirm in his book on ceramics from Tenerife, published in 1971, that "the ceramic techniques, as a native industry and art, are being lost. Fewer and less qualified hands are laboriously introducing not just changes in form, but also innovations in the treatment of material and in specific technical details". The result of this is that not only is "the ceramics losing value technically speaking", but also their beautiful, coarse forms are being abandoned for others with no charm to them at all, ones that at times are even in bad taste and of low quality.

There are still three pottery centers in Grand Canary: **La Atalaya, Los Lugarejos** and **La Degollada de Gáldar,** hamlets difficult to be reached, near the caves of the Guanche aborigines. In Tenerife we should mention La Victoria de Acentajo. And finally there is Chipude on the island of Gomera, where without a doubt we find best preserved traditional ceramic vessels. On the other hand, ceramic work has apparently disappeared in a relatively short time from the island of Palma.

219. Vase, fancy decorative vessel (not traditional) and "talla" molded by hand, *La Atalaya de Santa Brígida*

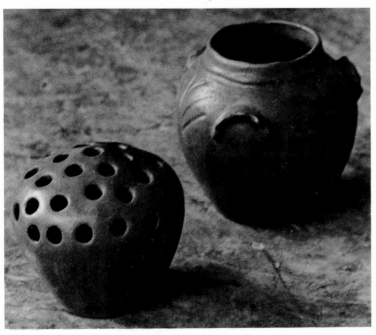

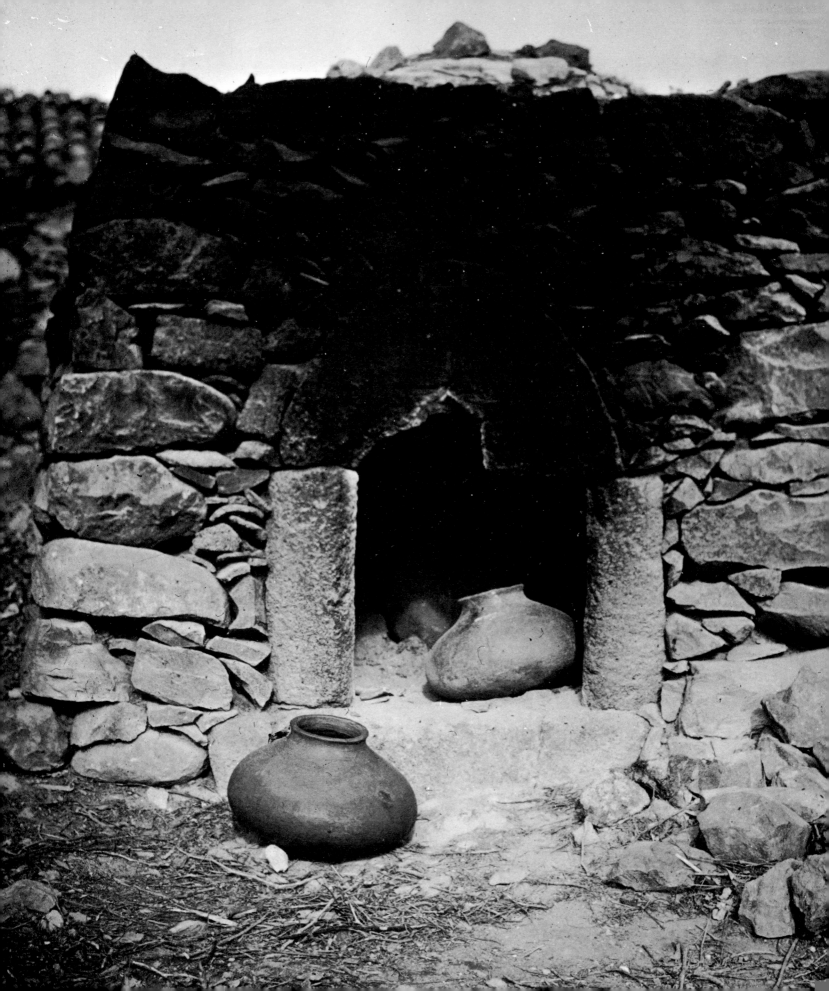

A few years ago the isolation of the islands forced the potteries, in many aspects, to be self-sufficient. Ceramic producing areas were specialized to such a degree that the mayority of the population was employed in one of the many tasks of working the clay. In general the women are the ones who carry out this work, as occurs in other purely agricultural regions. Here the women were the ones who normally sold the goods througout the island, taking them not only to the large towns, but also to hamlets scattered through the mountains. The living system was until recently so primitive that in some areas the crockery was exchanged for other goods such as potatoes or corn. With the passing of time, the potters continued to produce the old ceramic forms, transmitting their simple "secrets" from mother to daughter, generation after generation.

In Grand Canary the clay is brought from the mountains or from "enclosures". Once it has been crumbled and kneaded, it is mixed with sandy earth. The potter's wheel is not known in this region: all of the articles come straight from the potter's hands; only pebbles are used to smooth the vessels and canes to scrape them. The articles are given color by the red ocher, which consists of a reddish clay obtained by pulverizing certain stones. The powder is dampened and applied to the vessels, being sure that it holds well. Later a little oil is added to make the article shine; for this they use "lisadera" (a simple pebble), which can have several shapes according to its use. The articles (with the exception of some of the ornamental pieces and toy items) then go to the kiln, where after firing them, the reddish color becomes paler and the shine disappears somewhat. (We would also remind you that the kiln was introduced here at the time of colonization). Primarily Spanish broon is burned for fuel, although also shrus and brushwood.

One of the most typical vessels is the "talla", a container for transporting and storing water and for keeping it cool. Other characteristic pottery pieces are the "gánigo" (old sacred vessel used for water and other liquids), and the "vernegal" (for storing water from the cistern). Although the ceramic production offers very interesting forms and an ancient tradition, it does not show much variety. In addition to the articles mentioned above, they also make: milk pans, casseroles (for roasting coffee), jars for storing gofio, corn toasters, kettles, vapor warmers, flowerpots, candlesticks, "artesas" for kneading bread, as well as large vessels used for storing goods. Many of these pieces are made in miniature as toys, a large number of which are sold at Cristmas.

In Tenerife Luis Diego Cuscoy mentions the following recently disappeared pottery centers: **San Andrés, Candelaria, San Miguel, Arguayo,** and **Icod de los Vinos.** At present only **La Victoria de Acentejo** remains, though it too is fast disappearing. The technique here is similar to that followed in other places, although there are always some differences. Here the clay is beaten with a stick, while in Gomera it is done with stones. Other processes, such as the dryin of the vessels or the heating of the kiln, vary from one Canary Island pottery center to another; but they are too lengthy to be enumerated here. The vessels, however, are fundamentally the same, although there are some exceptions in their forms and even in their names. In La Victoria the one remaining potter no longer applies red ocher to the vessels, thereby causing them to lose part of their beauty. There are various articles, or variations of them, known in Gomera that are not used elsewhere, such as the "carabuco", the "barquineta", or the "tibor". It is also interesting to note, for example, that in La Palma, in contrast to other places, the vessels were not colored and the finishing touches were made with an ordinary knife.

220. Kiln in *Chipude*

The pottery that proves to be the most interesting is that of **Chipude,** on the island of Gomera. It is without a doubt the one that best preserves the ceramic tradition, although there is apprehension as to its survival and a great difference exists in the articles produced now and those of a few years ago. The famous "gánigo" still preserves here a large measure of its rude beauty, and we may say the same of the remaining articles: the "talla", the two-part brazier, the plate with holes for use as a colander, the "carabuco" for collecting milk from the cow, the "tiesto" for roasting coffee —today used as a washbasin, casseroles, platters ... The work weigts heavily on the women potters from Chipude. "The two dirtiest jobs that a woman can have" they declared to Antonio Mederos Sosa, "is that of a potter and a 'helecha-dera' (one who digs for the roots of the fern)... Yet these two disdained jobs constitute our means of living."

222. Collection of toy items from the pottery of *Chipude*

typos of 'cántaro'

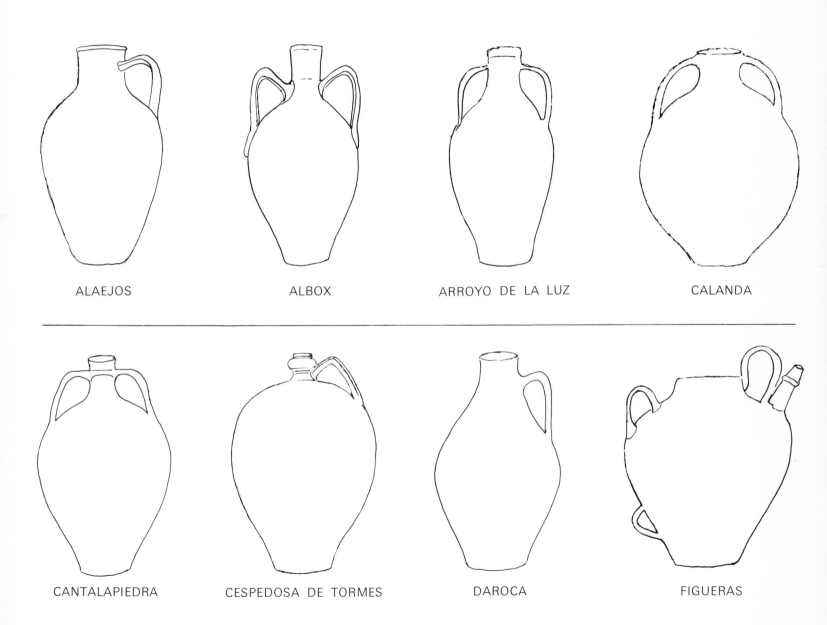

ALAEJOS ALBOX ARROYO DE LA LUZ CALANDA

CANTALAPIEDRA CESPEDOSA DE TORMES DAROCA FIGUERAS

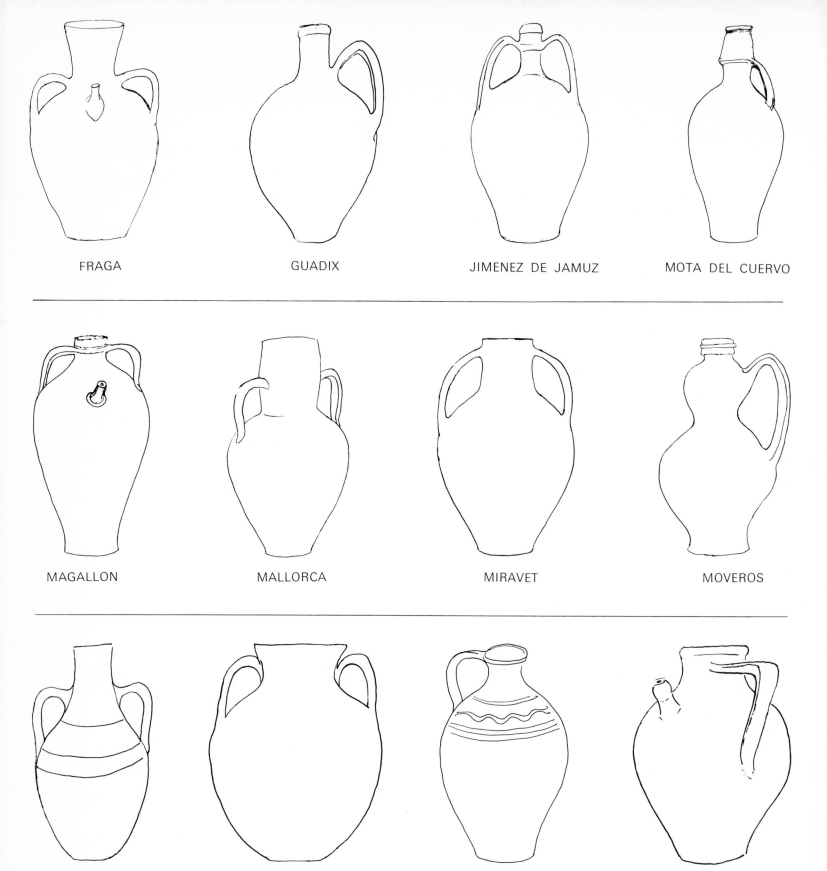

FRAGA

GUADIX

JIMENEZ DE JAMUZ

MOTA DEL CUERVO

MAGALLON

MALLORCA

MIRAVET

MOVEROS

NIJAR

NIÑODAGUIA

OCAÑA

OLIVENZA

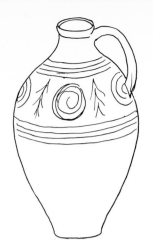

PRIEGO DE CUENCA

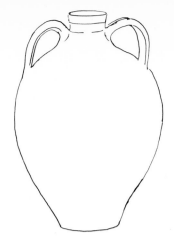

TAMAMES DE LA SIERRA

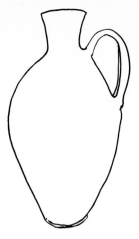

TAMARITE DE LITERA

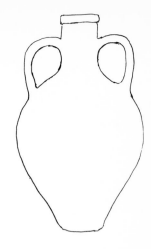

TOTANA

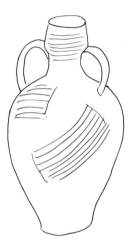

TRAIGUERA

TRIGUEROS

UBEDA

VERA

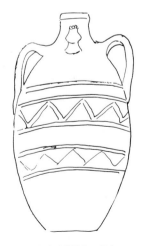

VILLAFRANCA
DE LOS CABALLEROS

topongmic index

229

Figueras
Gerona
San Julián de Vilatorta
Quart
La Bisbal
Breda
Cardedeu
Esparraguera
Piera
Rubí
Martorell
Sadurní de Noya
nca del Penedés
Vendrell
embarra
Barcelona
Tarragona

Menorca
Ciudadela
Mallorca
Consell
Pórtol
Inca
Santamaría
Sa Cabaneta
Felanitx
Cabrera
Ibiza
Formentera

Lanzarote
Palma
Fuerte Ventura
Tenerife
La Victoria de Acentejo
Icod de los Vinos
San Andrés
Candelaria
Gomera
Arguayo
Gran Canaria
Hoya de Pineda
Chipude
Los Lugarejos
La Atalaya de Santa Brigida
San Miguel
Hierro

bibliography

Almagro, Martín and **Lluis Mª LLubiá Munné**, *C.E.R.A.M.I.C.A.* (1 st. fascicle : Aragón Muel). Barcelona, 1952.

Almagro, Martín and **Lluis Mª Llubiá Munné**, *La cerámica de Teruel.* "Instituto de Estudios Turolenses". From the Goverment of the Province of Teruel, 1962.

Almagro, Martín, *Catalogue for the exposition Cerámica popular española de la prehistoria a nuestros días.* "Dirección General de Bellas Artes". Madrid, 1966.

Corredor-Matheos, José, *La cerámica als països catalans,* in "Serra d'Or" n° 139. Montserrat, April 1971.

Corredor-Matheos, José, *Dos conferencias sobre cerámica.* From "Museo Carlos Maside". Edicios Castro. Sada. Corunna, 1972.

Cortés Vázquez, Luis L., *La alfarería popular salmantina.* "Centro de Estudios Salmantinos". Salamanca, 1953.

Cortés Vázquez, Luis L., *La alfarería de Pereruela;* in "Zephyrus", Volume V. Salamanca, 1954.

Cortés Vázquez, Luis L., *La alfarería femenina en Moveros;* in "Zephyrus", Volume IX. Salamanca, Jannuary-June 1958.

Diego Cuscoy, Luis, *Gánigo. Estudio de la cerámica de Tenerife.* From "Museo Arqueológico". Santa Cruz de Tenerife, 1971.

Dumpierrez Rodriguez, Marina, *La alfarería en Gran Canaria.* "Tradiciones populares". From "Consejo Superior de Investigaciones Científicas" and "Instituto de Estudios Canarios", 1944.

Gómez Figueroz, José, *Adiós a las tinajas.* In the newspaper "ABC", February 4, 1966.

González y García-Mayorga, Enrique, *Nueva etapa de la cerámica de Muel.* In "Zaragoza" XIII; from the Goverment of the Province of Zaragoza, 1966.

Hormigón, J.A., *La cerámica un arte popular en peligro;* in "Triunfo". Madrid January 1974.

Lezcano Montalvo, P., *Visita a la Atalaya Superior de Gran Canaria.* "Tradiciones populares". From "Consejo Superior de Investigaciones Científicas " and "Instituto de Estudios Canarios", 1944.

Mazuecos, Rafael, *Alfarería manchega;* in "Hombres, lugares y cosas de la Mancha", XXXV fascicle. Alcázar de San Juan, November 1972.

Maderos Sosa, Antonio, *La alfarería chipudense y sus relaciones con la de Tenerife.* "Tradiciones populares". From "Consejo Superior de Investigaciones Científicas" and "Instituto de Estudios Canarios", 1944.

Mulet, Antonio, *Obra de barro mallorquina;* in "Panorama Balear" Palma of Majorca, 1969.

Seseña, Natacha, *Pucheros de Alcorcón;* in "Revista de Dialectología y Tradiciones Populares", Volume XXII 1 st. and 2 nd. notebooks, 1966.

Seseña, Natacha, *Producción popular en Talavera de la Reina y Puente del Arzobispo;* in "Goya", 78, 1967.

Seseña, Natacha, *La alfarería en Mota del Cuervo;* in "Revista de Dialectología y Tradiciones Populares", Volume XXIII 3 rd. and 4 th notebooks, 1967.

Seseña, Natacha, *Alfares de Extremadura;* in "Triunfo". Madrid, November 10, 1973.

Seseña, Natacha, *Cerámica popular en Castilla la Nueva;* Editora Nacional. Madrid.

Subía Galter, Juan, *El arte popular en España;* Editorial Seix Barral. Barcelona 1948.

Violant Simorra, R., *El arte popular español;* Aymà. Barcelona 1953.

Vossen, Rüdiger, *Töpferei in Spanien.* Hamburgisches Museum für Volkerkunde und Vorgeschichte. Hamburg 1972.